YPHOTOGRAPHY EARBOOK

1 9 9 8

JAHRBUCH DER FOTOGRAPHIE

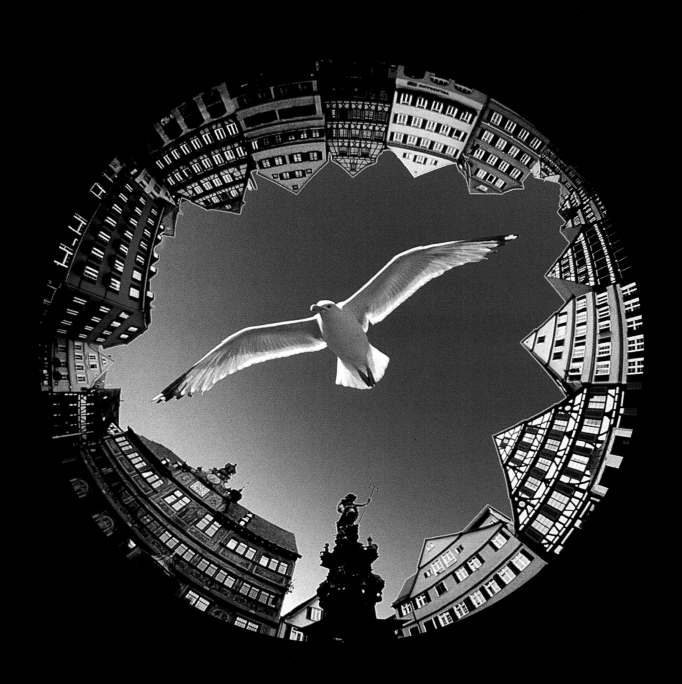

YPHOTOGRAPHY EARBOOK
1998
JAHRBUCH DER FOTOGRAPHIE

Joseph Meehan
EDITOR

Chris Hinterobermaier
INTERNATIONAL EDITOR

Grant Bradford
DESIGNER

FOUNTAIN PRESS

YPHOTOGRAPHY EARBOOK
1998

PUBLISHED BY
Fountain Press Limited
Fountain House
2 Gladstone Road
Kingston-upon-Thames
Surrey KT1 3HD

EDITOR
Joseph Meehan

INTERNATIONAL EDITOR
Chris Hinterobermaier

DESIGNER
Grant Bradford

DESIGN ASSISTANT
Alisa Tingley

PAGE PLANNING
Rex Carr

REPRODUCTION
Gallery – Global Colour
Portfolios – Primary Colours

PRINTED BY
Supreme Publishing Services

© Fountain Press 1997
ISBN 0 86343 342 1

Deutsche Ausgabe
© 1997 Wilhelm Knapp Verlag,
Niederlassung der Droste Verlag GmbH,
Düsseldorf

Photograph opposite title page by
Michael Weber, Germany

CONTENTS

EDITOR'S MESSAGE

This 1998 edition of the Photography Yearbook contains 216 pages of black and white and colour photographs whose themes touch on all the major areas of photography including: landscape, portrait, still life, nature, action, and humour along with many forms of innovative image making. The presentation is divided between an opening collection of six special portfolios from seven highly accomplished photographers followed by 128 pages of the International Gallery which contains the works of individual photographers from 25 countries. Thus, the reader has the opportunity to understand and appreciate the vision of seven photographers in the Portfolio portion as well as seeing the range of what photographers are doing around the world in the International Gallery.

This year, in the Portfolio section, we have selected photographers who present us with very different visions.

First, we acknowledge the passing of one of Great Britain's best known photographers, Terence Donovan, a contributor to Photography Yearbook, in the past and one of the most colourful personalities in Photography.

Our first Portfolio is a tribute to Peter Wilkinson who died in a tragic accident earlier this year. A constant and tireless enthusiast for photography from his early experimental work through to his later photographs which combined colour and monochrome in the same print. Peter was Editor of Photography Yearbook for ten years.

We then change pace by showing the work of American George H. H. Huey, who takes us to the sprawling southwestern portions of his country to capture brilliant landscapes born of pure light as well as taking a closer view of the plants and flowers that can briefly inhabit these desert areas during certain times of the year.

From Ukraine, comes the somewhat unconventional photography of Igor Karpenko, who uses his commercial studio not only to earn a living but as somewhere to escape from the rigours of daily life in order to show us that human beings are never more than a pose away from becoming sources of humour. Next, we move under water to see the combined work of Chris Newbert, an American and his Danish wife, Birgitte Wilms. Here is a body of work that emphasises striking forms and colours within unique compositions, rather than concentrating primarily on the animal and plant life that are the mainstay of this type of photography. Manfred Kriegelstein of Germany, a dentist by profession and a very successful salon photographer by reputation, is now fully engrossed in the digital form of photography. His portfolio demonstrates how this medium is serving to give his creative talents new outlets. And finally, there is the work of one of America's most influential fine art photographers, Jerry Uelsmann who continues to show how the conventional darkroom is still a place of enormous creativity with his extraordinary forms of merged multi-image photography.

The Yearbook has undergone some important changes in the past few years as it responds to and reflects the transformations occurring throughout photography. This development continues as we consider how to reflect the importance of an event which will be upon us shortly; the turn of the millennium. We at the Yearbook are working on ways to celebrate this occasion in the pages of the 2000 edition, which will also mark the Yearbook's 65th anniversary year.

But we also thought it would be appropriate to ask photographers to contribute to this effort directly by setting a task to all of our contributors: namely, to produce images that express the passage of this century into the next. To capture in photographs what they see as the end of one era and the beginning of another. This is, by no means, an easy request, but who better to ask to visually represent the turn of the millennium, than photographers who produce the calibre of work that appears in the Yearbook.

Speaking of changes, we have noticed that this year's crop of pictures contained fewer quality still life images than previous years and there were less black and white prints in general. We did seem to have a good sample of humourous pictures and a few more quality action pictures while there were only a few pictures that repeated a style or treatment that appeared in a previous Yearbook, all of which we were happy to see.

Finally, it needs to be said that it is a demanding task to select the best photographs from the many that are presented each year and then organise them into a coherent presentation within the Yearbook's covers. The fact is, the Photography Yearbook owes its existence not only to the talented photographers whose work appears in its pages, but also to those who work to compile and present those pictures. Here, the efforts of the International Editor, Chris Hinterobermaier, need to be fully acknowledged as does the talents of our designer, Grant Bradford, and also the foresight and sustaining energy of the publisher, Harry Ricketts.

The result of all these efforts is the 1998 Photography Yearbook which is the single most complete sampling of high quality and creative international photography gathered into one annual anywhere in the world.

Joseph Meehan,
Editor

VORWORT

Die neueste Ausgabe des Jahresbuches der Fotografie dokumentiert auf 216 Seiten alle Aspekte der Fotografie; Landschaft, Portrait, Stilleben, Natur, Action und Humor sowie die zahlreichen Möglichkeiten innovativer Fotografie. Das Buch teilt sich wieder in eine Kollektion von Portfolios herausragender Fotopersönlichkeiten und die internationale Galerie, welche Bilder von Fotografen aus aller Welt zeigt. Somit hat der geschätzte Leser die Möglichkeit, einerseits die Visionen und Ideen der in der Portfolio-Sparte vertretenen Künstler zu verstehen als auch andererseits einen tiefen Einblick in das internationale fotografische Schaffen rund um den Erdball zu gewinnen. In diesem Jahr repräsentiert der Portfolioteil sehr differenzierte Ansichten zur Fotografie.

Zunächst möchten wir das Lebenswerk von Peter Wilkinson, dem kürzlich verunglückten ehemaligen Präsidenten der Royal Photographic Society und langjährigen Herausgeber des Jahrbuches der Fotografie würdigen.

Dann wechseln wir das Genre und zeigen Arbeiten des amerikanischen Fotografen George H. H. Huey, der uns in die faszinierende Landschaft des amerikanischen Südwesten entführt, von wo er uns hinreissende Bilder brilliant gesehener, im puren Licht badender Landschaften ebenso zeigt, wie er einen detaillierten Blick auf die Pflanzen und Blumen der Wüste wirft.

Aus der Ukraine kommt die unkonventionelle Bildwelt von Igor Karpenko, der sein Fotostudio nicht nur zur Gestaltung seines Lebensunterhaltes verwendet, sondern es auch als Fluchtmöglichkeiten vor den Härten des Alltagslebens seiner Heimat nutzt. Er zeigt uns eindringlich, daß wir Menschen stets ganz knapp an der eigenen Lächerlichkeit vorbeibalancieren.

Dann tauchen wir unter Wasser und lassen uns von den Arbeiten von Chris Newbert, USA, und seiner dänischen Frau Birgitte Wilms begeistern. In ihren Arbeiten fangen sie ein Universum der Farben und Formen ein, konzentrieren sich mehr auf fast abstrakt erscheinende Kompositionen als auf die Tier- und Pflanzenwelt, die üblicherweise in diesem Segment der Fotografie vorherrscht.

Der Deutsche Manfred Kriegelstein, Zahnarzt von Beruf und überaus erfolgreicher Fotograf von Berufung, widmet sich voll und ganz der digitalen Bildbearbeitung. Sein Portfolio demonstriert, wie dieses neue Medium seiner eigenen kreativen Begabung neuen Ausdruck zu verleihen im Stande ist.

Und zum Schluß zeigen wir Arbeiten von Amerikas wohl einflußreichsten Fotokünstler Jerry N. Uelsman. Der Meister beweist, daß die konventionelle Dunkelkammer immer noch ein Hort enormer Kreativität sein kann.

Das Jahrbuch der Fotografie hat in den letzten Jahren einige wichtige Veränderungen erfahren, die Hand in Hand mit den Veränderungen in der Fotografie gingen. Wir wollen flexibel bleiben und uns nunmehr auf ein ganz besonderes Ereignis konzentrieren: den Jahrtausendwechsel. Das Team des Jahresbuches arbeitet bereits daran, wie wir dieses Großereignis in das Jahrbuch 2000 integrieren können. Aber wir meinen, daß es sinnvoll ist, auch jene Fotografen, die mit ihren Arbeiten die Existenz des Jahrbuches erst ermöglichen, direkt zu fragen. Wir wollen allen Fotografen der Welt eine Aufgabe stellen: zeigen Sie in Ihren Arbeiten, wie man den Wechsel von einem Jahrtausend ins nächste am besten darstellen könnte. Zeigen Sie das Ende einer Ära und den Beginn einer neuen. Keine leichte Aufgabe, aber wer könnte den Jahrtausendwechsel besser visualisieren als so kompetente Fotografen, wie jene, die im Jahrbuch veröffentlicht werden.

Wenn wir schon von Veränderungen sprechen, so muß festgestellt werden, daß in der heurigen Ausgabe weniger starke Stilleben und auch weniger starkes Schwarz/Weiß-Material als in den Vorjahren eingereicht worden ist. Auch kamen viele Bilder, die als bloße Remakes von Werken gelten können, die bereits in früheren Ausgaben des Jahrbuches abgedruckt waren. Dagegen scheint es so zu sein, daß wir diesmal einige sehr starke humorvolle Bilder und auch etwas mehr an hochqualitativen Actionaufnahmen inkludiert haben.

Schlußendlich muß gesagt werden, daß es eine harte Anforderung darstellt, die besten Aufnahmen aus den so vielen guten eingereichten Werken auszuwählen und diese dann in die Seiten des Jahrbuches zu integrieren. Das Jahrbuch der Fotografie hat nicht nur den talentierten Lichtbildnern aus aller Welt für Ihre Beiträge zu danken, sondern auch jenen, die daran arbeiten, diese Bilder aufzutreiben und zusammenzustellen. An dieser Stelle ist den Bemühungen des International Editors, Chris. Hinterobermaier aus Österreich, besonderer Dank auszusprechen. Ebensolches gilt für die Qualitäten des Grafikers Grant Bradford und ganz besonders natürlich dem Vertrauen und der Energie des Herausgebers Harri Ricketts.

Das Resultat all dieser Anstrengungen ist das Jahrbuch der Fotografie 1998, welches sich als die kompletteste Versammlung hochqualitativer und kreativer Fotokunst weltweit darstellt.

Joseph Meehan
Editor

Peter WILKINSON

1928–1997
A TRIBUTE

Peter Wilkinson's life ended tragically earlier this year after an accident at his home. Peter became a design draughtsman on leaving school and was soon managing an engineering works in South London.

His early interest in photography led to membership of the Royal Photographic Society where he served as Chairman of the Distinctions Panel of the Pictorial Group for many years culminating in his election as President of the Society in 1972.

In 1983 Peter took on the Editorship of the Photography Yearbook and produced eleven editions before retiring in 1994. During this period he encouraged submissions from around the world, which led to his making a selection from nearly 16,000 entries in 1993. But he insisted on seeing every submission, often going through them a number of times before making his final decision. Peter felt strongly that every submission deserved his expert consideration. He loved photography and looking at photographs and a quote from his introduction to the 1984 edition *"I have been asked on numerous occasions if I enjoyed putting this edition of the Yearbook together and the answer is a definite yes. To me photography has always been magic and I always get enormous pleasure from looking at photographs."* Not only did he love to see photographs, he was a very good photographer and enjoyed working in his darkroom, Peter experimented with high contrast papers, tone separation prints and solarisation. Some of his earlier and latest work is included in this tribute.

Not only have we lost a meticulous and imaginative photographer, but a friend who brought a sense of fun to editorship of the Yearbook.

Harry Ricketts
PUBLISHER

Das Leben von Peter Wilkinson endere völlig überraschend durch einen tragischen Unfall in seinem Heim. Peter interessierte sich schon nach seinem Schulabschluß für Design und war als Unternehmer im Süden London tätig.

Schon bald faszinierie ihn die Kunst der Fotografie, er wurde Mitglied der Royal Photographic Society, wo er in zalreichen Ehrenämtern agierte und 1972 sogar zum Präsident gewählt wurde.

1983 übernahm Peter Wilkinson die Position des Herausgebers beim Jahrbuch der Fotografieund war in der Folge für 11 Ausgaben verantwortlich. Er war äußerst aktiv, nutzte seine Kontakte und brachte im Rekorjahr 1993 aus aller Welt 16,000 Einreichungen zum Jahrbuch. Peter sah sich jede einzelne Einsendung ganz genau an; gewissenhaft und mit viel Liebe betrachtete er das Material, bevor er seine Entscheidungen traf. Zwar dauerte es seine Zeit, bis die Bilder wegen dieses exakten Auswahlverfahrens wieder an die Einsender gelagien, aber Peter nahm dies in Kauf, um den Mühen der Autoren, die hinter jeder Einsendung steht auch wirklich grecht zu werden. Peter liebte die Fotografie und das Betrachten von Bildern. 1984 schreib er in seinem Vorwort zum Jahrbuch der Fotografie:
„Oft werde ich gefragt, ob es mir Spaß macht, das Buch zusammenzustellen und die Antwort ist eindeutig: jawohl! Fotografie ist für mich einfach zauberhaft, ich empfinde enormes Vergnügen beim Betrachen von Bildern."

Peter Wilkinson war selbst auch ein exzellenter Fotograf, der sich auf die Arbeit in der Dunkelhammer spezialisierte. Er experimentierte mit Hochkontrastpapier, Tontrennungen und Solarisationen. Einige seiner Frühwerke sind in diesem Tribut ebenso inkludiert, wie Werke, die erst in den letzten Jahren entstanden sind.

Harry Ricketts
VERLAGER

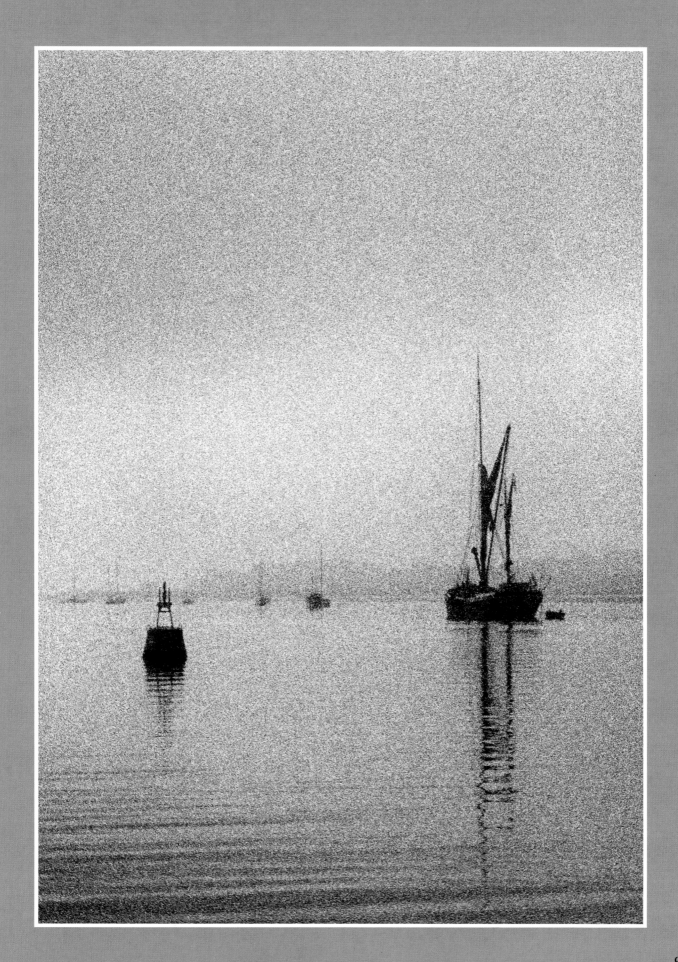

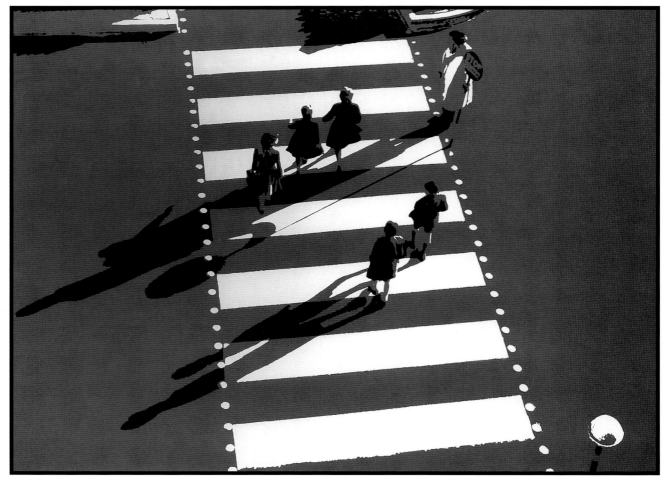

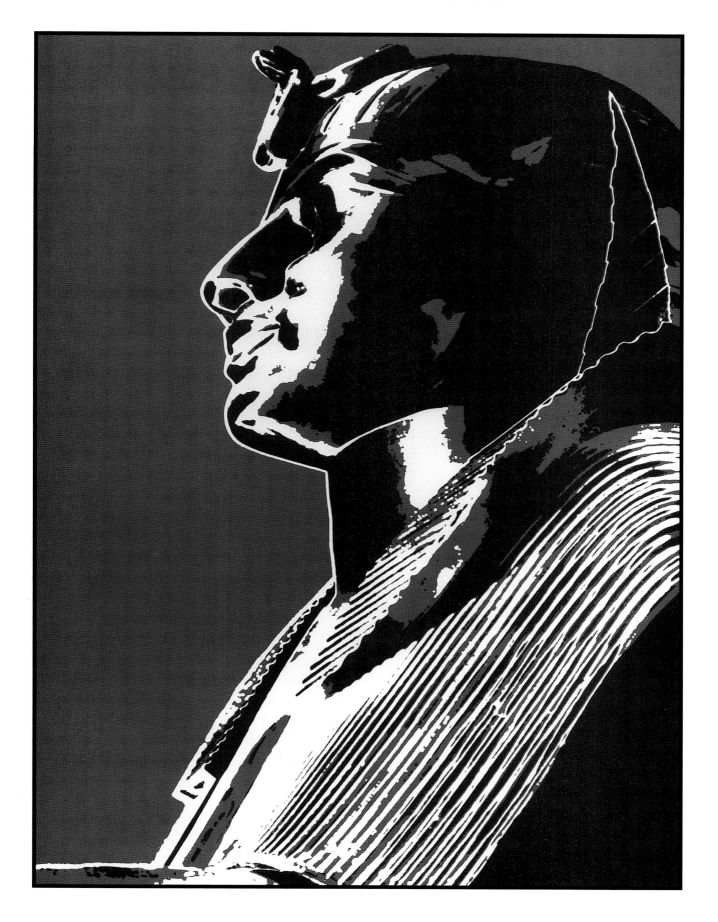

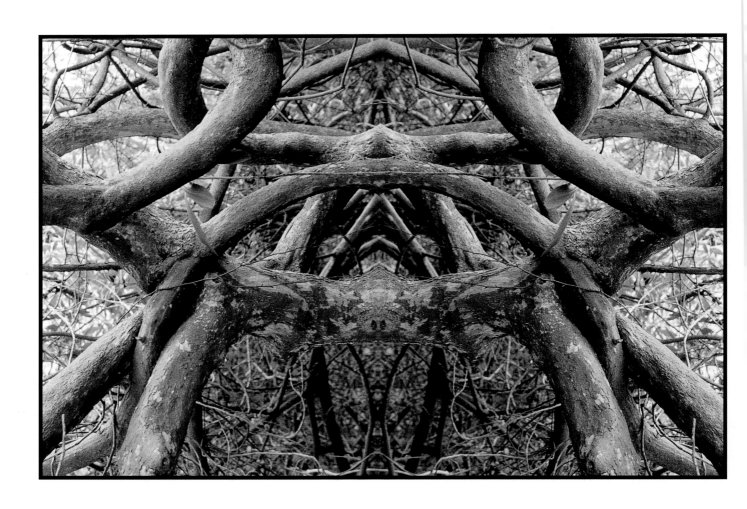

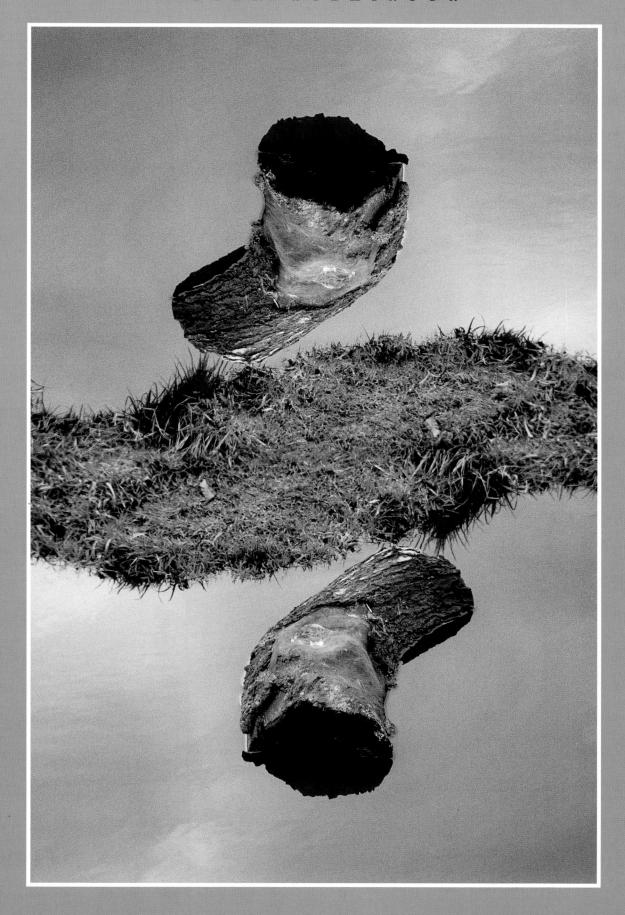

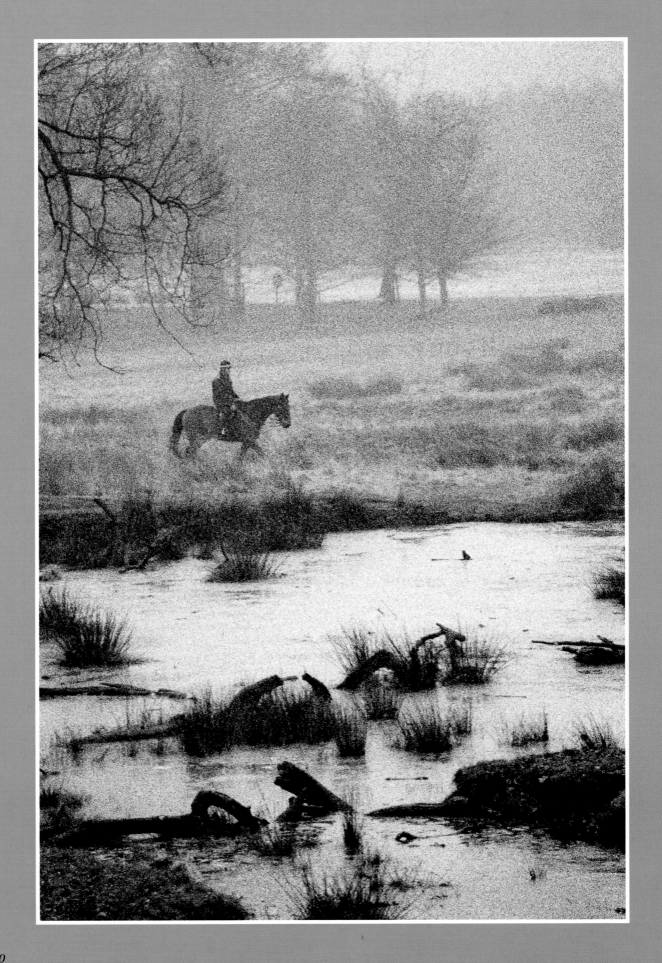

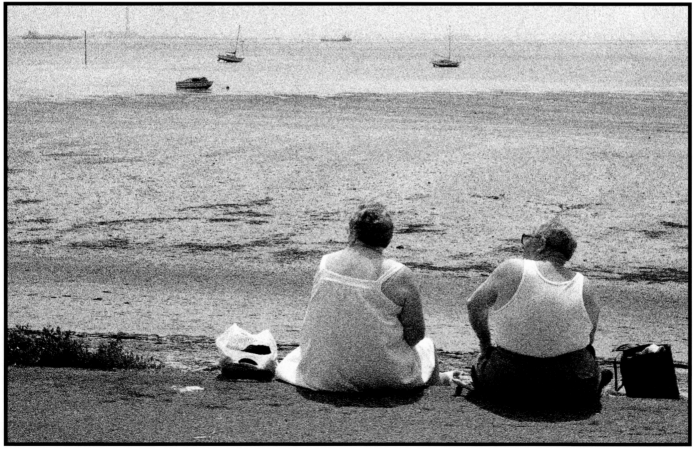

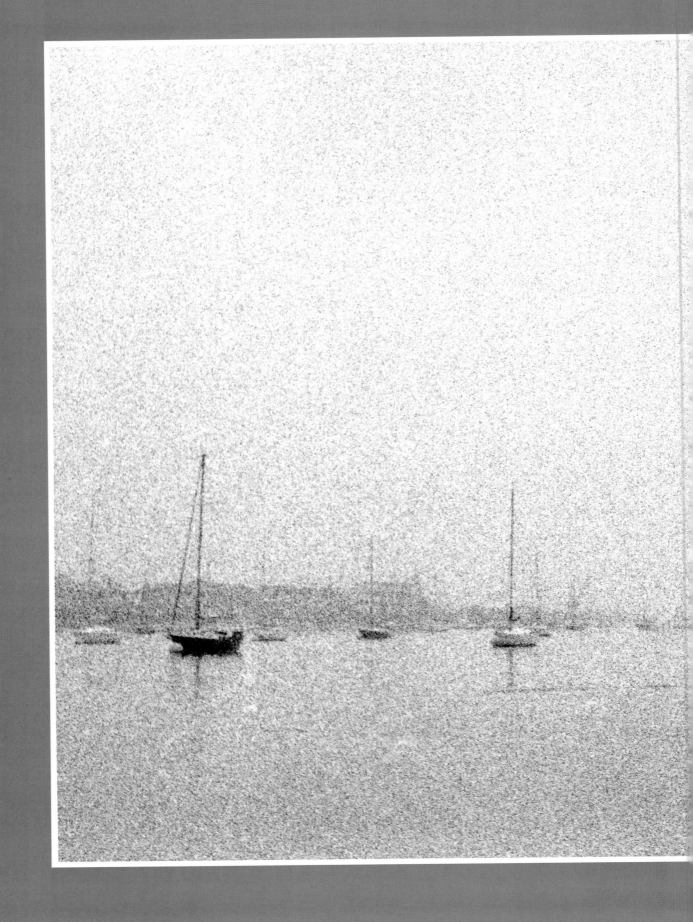

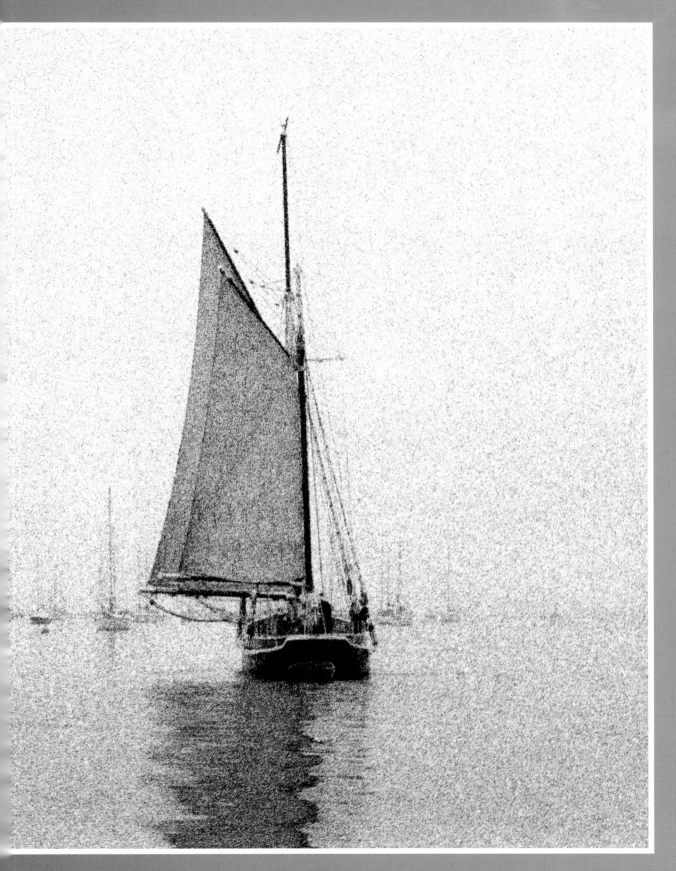

Peter Wilkinson frps

GEORGE H.H. HUEY
Constructs of Desert Light

A professional photographer living in Prescott, Arizona near some of the most spectacular landscape settings in the American Southwest, George Huey's photographs of these areas have appeared in such publications as *Newsweek, Time, Natural History,* and *The New York Times,* as well as in books published by the Smithsonian Institution, The Sierra Club and National Geographic Book Division. Huey grew up in New York City but 25 years ago moved to Arizona to study the arts at Prescott College. Upon arriving, he recalls a sense of *"being set free"* and he has made this area his home ever since.

Observers of Huey's work have pointed out that his images often appear to be constructs of pure light. In addition, one can also sense a deep respect for the land in the imagery as well as for the many life forms that have evolved with these landscapes through the millenniums. Indeed, Huey actively supports efforts to protect and preserve what is, despite all of its extremes of temperature and geography, a fragile land.

Working with a 6x7cm view camera for the control of perspective as well as a 6x7cm SLR and a 6x17cm panoramic camera, Huey has been able to produce a range of images which are both pictorially impressive while disclosing the complexities and variations of the American Southwest. In doing this, he sensitises the viewer to the need for defining the relationship between humans and the land which he feels has been expressed with blunt simplicity by the early American conservationist, Aldo Leopold:

"We abuse the land because we regard it as a commodity belonging to us. When we see land as a community to which we belong, we may begin to use it with love and respect."

George Huey ist Berufsfotograf und lebt in Prescott, Arizona, somit ganz in der Nähe einiger der spektakulärsten Landschaften des amerikanischen Südwestens. Seine Bilder aus dieser Gegend erschienen unter anderem in *Newsweek, Time, Natural History* und *The New York Times,* wie auch in zahlreichen Büchern, die vom Smithsonian Institution, The Sierra Club und dem National Geographic Book Division herausgegeben wurden. Huey wuchs in New York auf und wechselte aus Studiengründen vor 25 Jahren an das Prescott-College nach Arizona. Das unglaubliche Gefühl von Freiheit, das er dort erfuhr, veranlaßte ihn, diese Gegend zu seiner neuen Heimat zu machen.

Beobachter seiner Arbeit streichen oft hervor, daß seine Bilder als Produkte puren Lichtes gelten können. Dazu kann man den tiefen Respekt des Künstlers für die Landschaft, aber auch für die vielen Lebensformen, die mit dieser Gegend verbunden sind, spüren. Tatsächlich unterstützt Huey sehr aktiv den Schutz dieses, trotz all seiner Extreme in Klima und Geografie, sehr zerbrechlichen Landes.

Die auf diesen Seiten gezeigten Fotografien teilen sich in die grandiosen klassischen Ansichten, die jeden Besucher des Südwestens der USA auf Anhieb beeindrucken und in Detailaufnahmen einer kargen Pflanzenwelt, welche in ihrer besonderen Schönheit den verwundbaren Charakter der Wüste dokumentieren. Huey arbeitet mit Großformat- und Panoramakameras. Mit diesen Geräten gelingt es ihm, Bilder zu gestalten, die sowohl in ihrem künstlerischen Ausdruck beeindrucken als auch den Variationsreichtum des amerikanischen Westens betonen. Huey geht es darum, den Betrachter der Bilder auf die Beziehung zwischen Mensch und Land intensiv hinzuweisen, was ganz besonders gut durch den amerikanischen Naturschützer Aldo Leopold ausgedrückt wurde:

"Wir mißbrauchen dieses Land, weil wir es als unser Eigentum ansehen. Wenn man es umgekehrt betrachten würde; wir Eigentum dieses Landes sein würden, dann würden wir es vielleicht mit mehr Liebe und Respekt sehen"

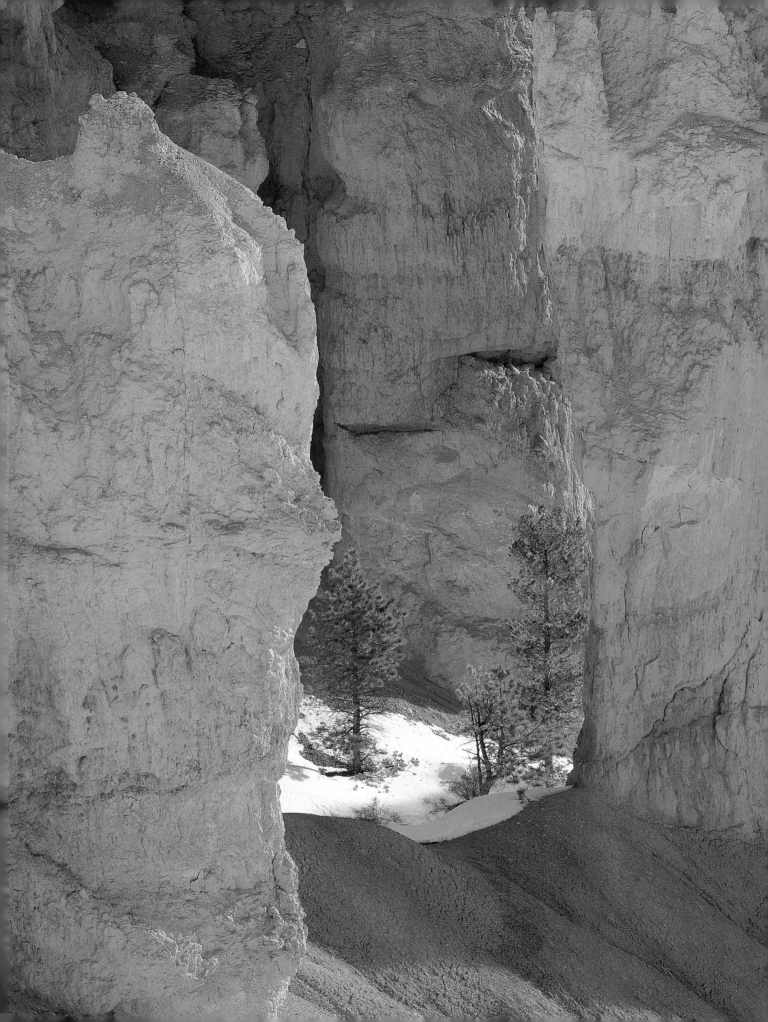

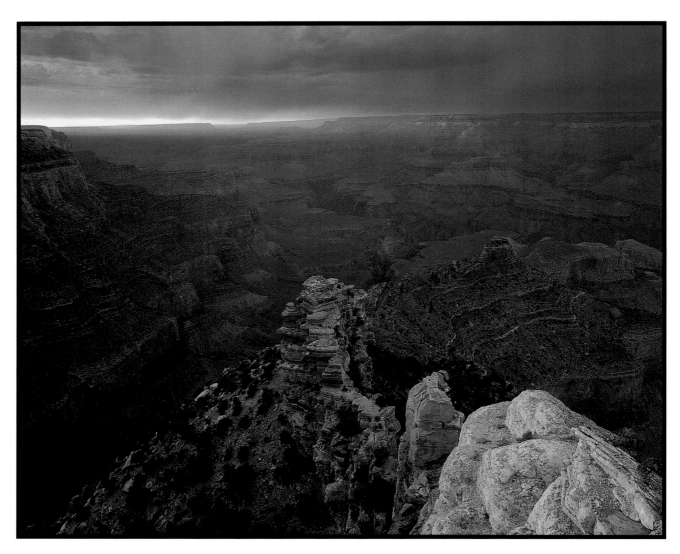

View from Yaki Point at sunset from
the South Rim, with storm over the
North Rim at right. Grand Canyon
National Park, Arizona.

PREVIOUS PAGE

Ponderosa pines *Pinus ponderosa,*
winter. Bryce Canyon National
Park, Utah

Agaves on the South Rim of the
Chisos Mountains, with the Sierra
Quemada below, and the Rio Grande
and Mexico in the distance.
Big Bend National Park, Texas.

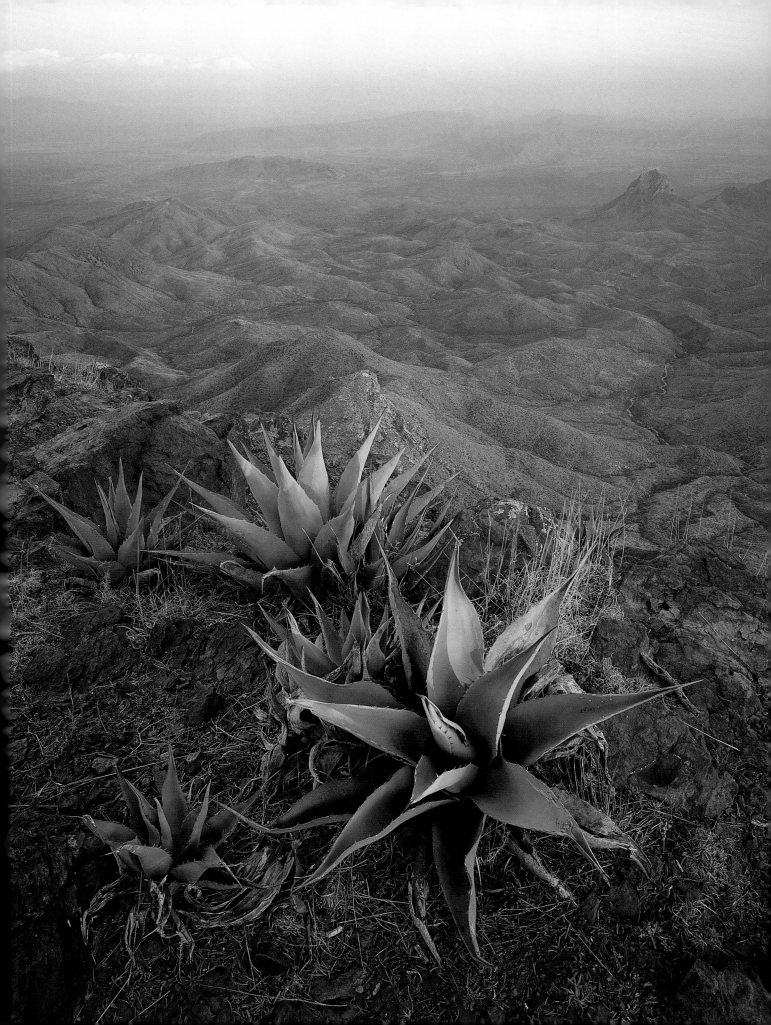

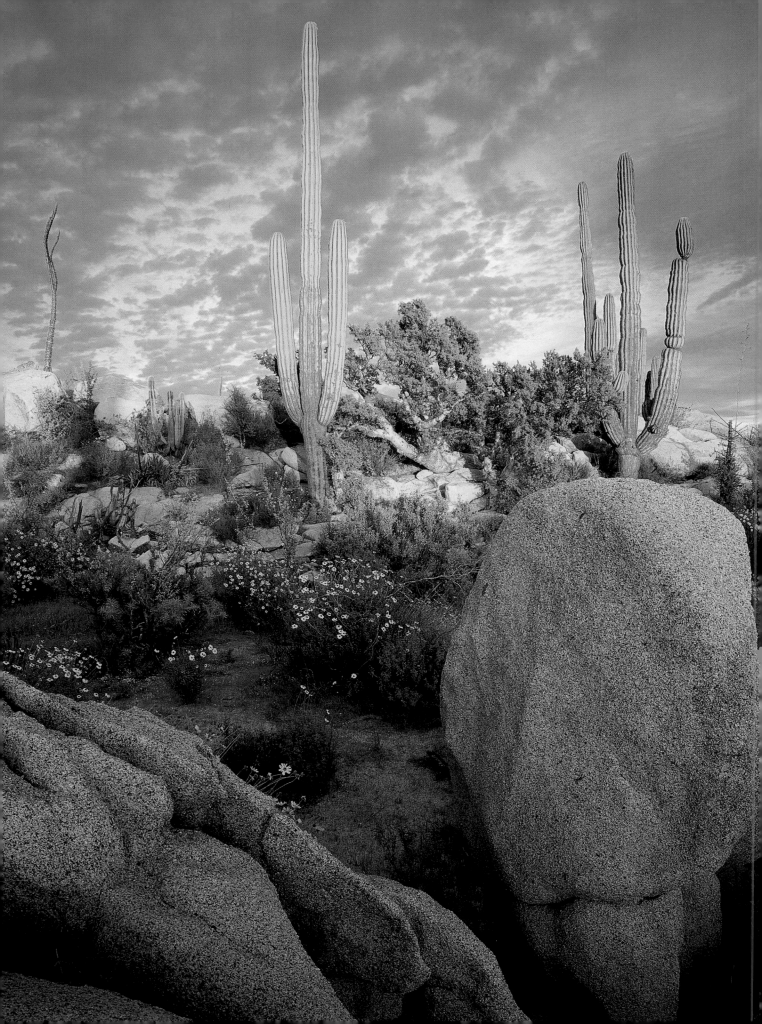

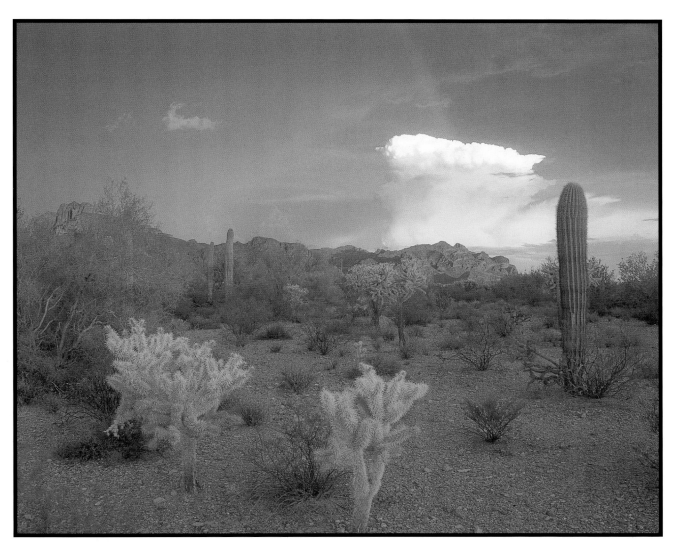

Summer thunderstorm over the Ajo
Mountains with jumping cholla
Opuntia fulgida, saguaro cactus
Carnegiea gigantea. Organ Pipe
Cactus National Monument, Arizona.

Cardon cactus with elephant trees,
boojum tree and yellow flowering
brittlebush. Sunset, Catavina Boulder
Field. Baja California, Mexico.

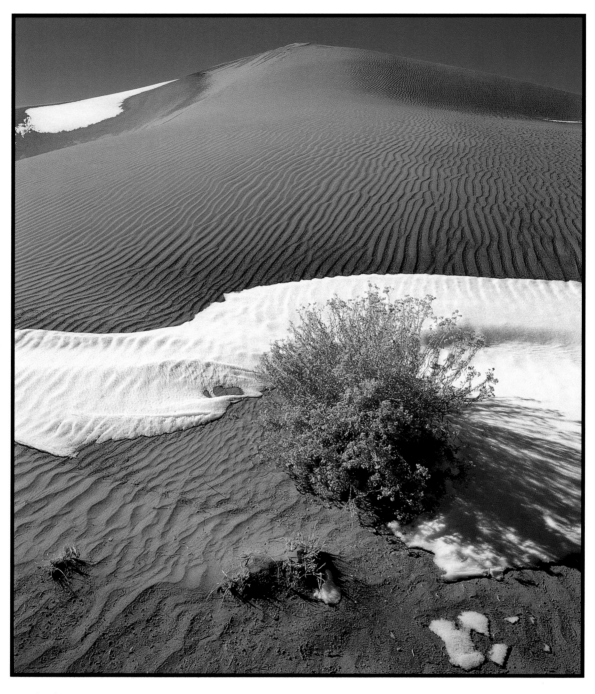

Wind ridges in snow and sand dunes,
with snakeweed *Gutierrezia sarothrae.*
Western Painted Desert. Navajo
Indian Reservation, Arizona.

Soaptree yucca *Yucca elata* covered by
drifting gypsum dunes. White Sands
National Monument, New Mexico.

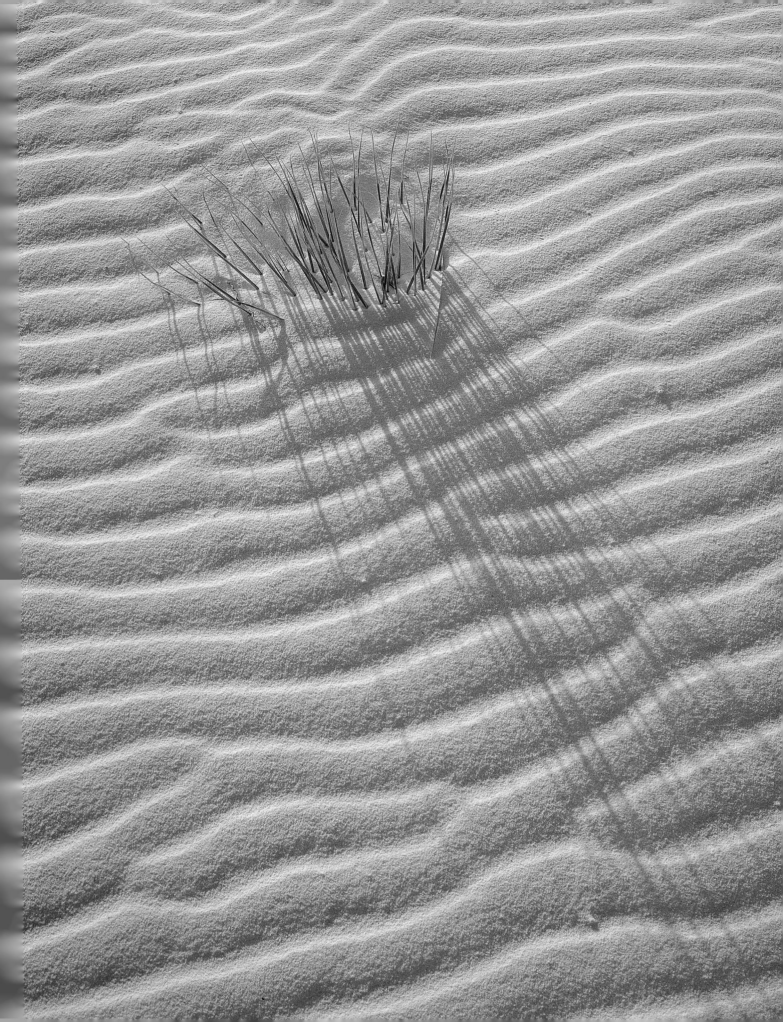

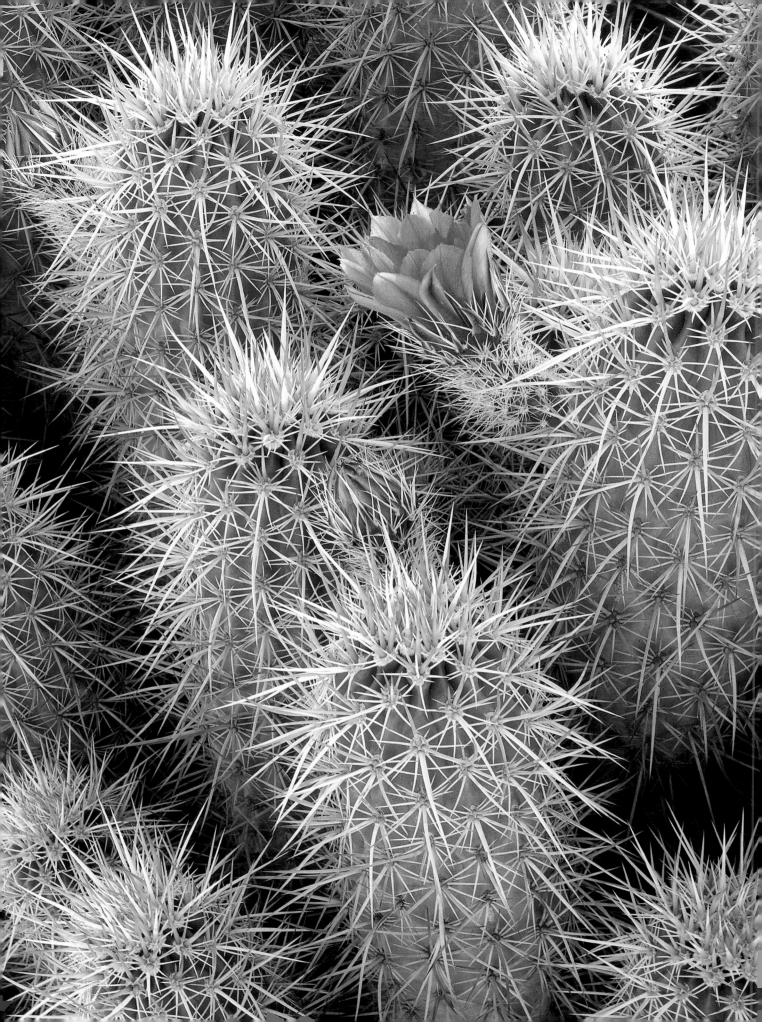

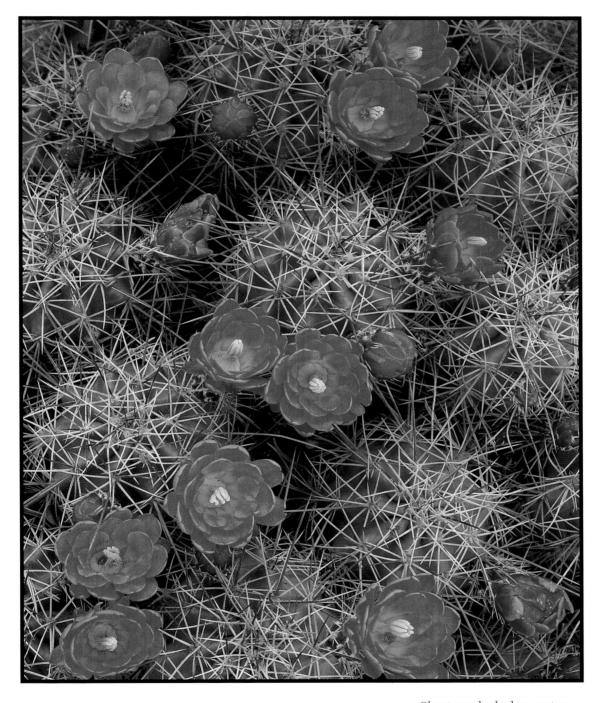

Claret cup hedgehog cactus
Echinocereus coccineus. Chisos
Mountains. Big Bend National
Park, Texas.

Hedgehog cactus *Echinocereus
engelmannii* in bloom. Vallecito
Mountains. Anza-Borrego State
Park, California.

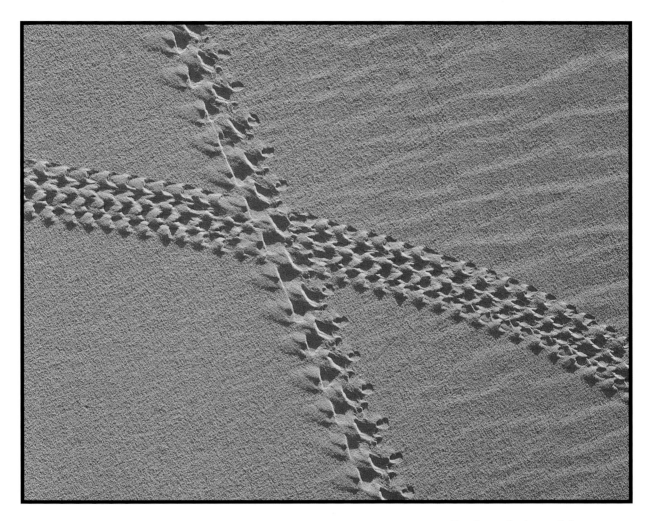

Beetle tracks in sand dunes .
Monument Valley, Navajo Indian
Reservation, Arizona.

Decaying cardon cactus on Isla Datil.
Sea of Cortes, Mexico.

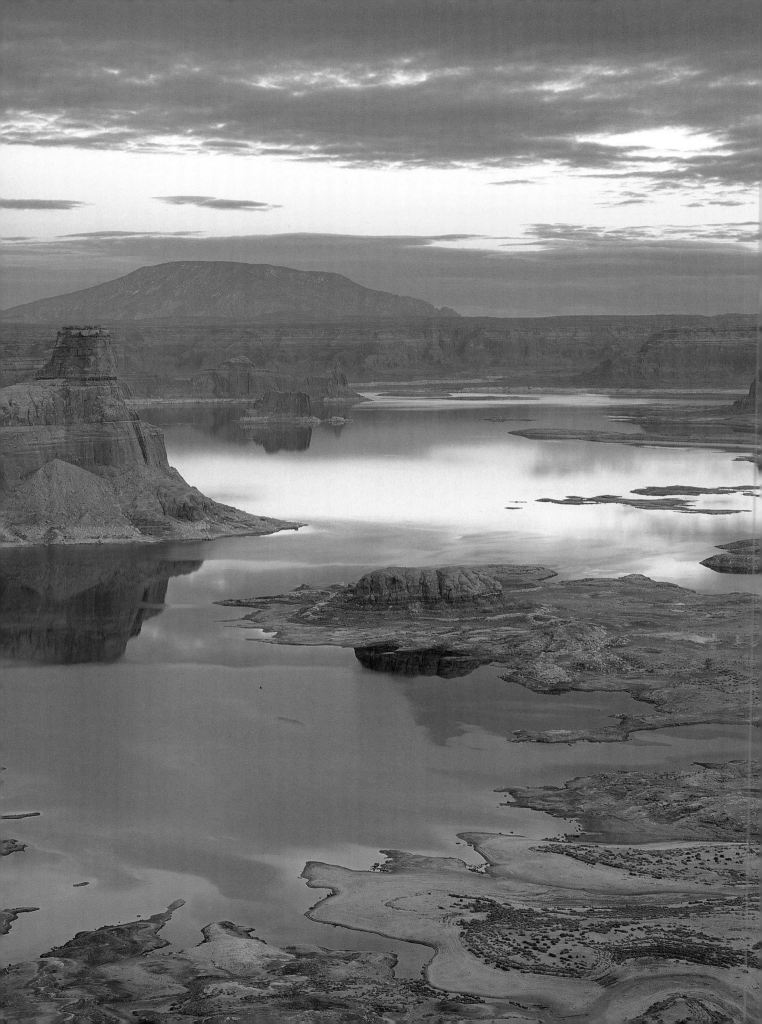

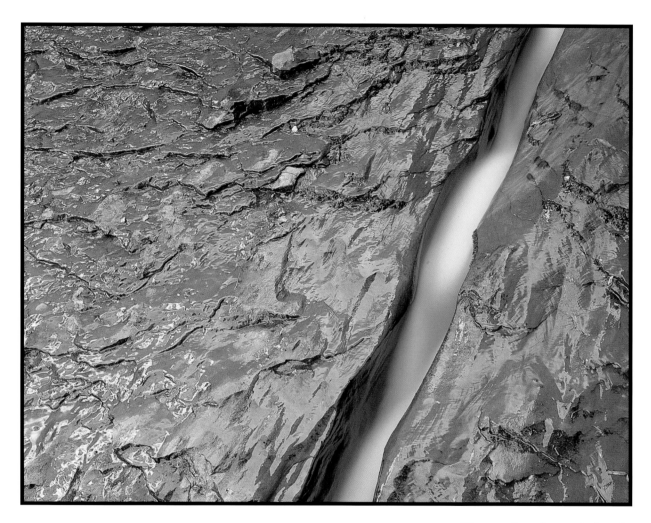

Water and sandstone, Left Fork
of North Creek. Zion National
Park, Utah.

Lake Powell at dusk, Padre Bay, with
Gunsight Butte, and Navajo Mountain
(sacred to Navajo Indians) in the
distance. Glen Canyon National
Recreation Area, Utah.

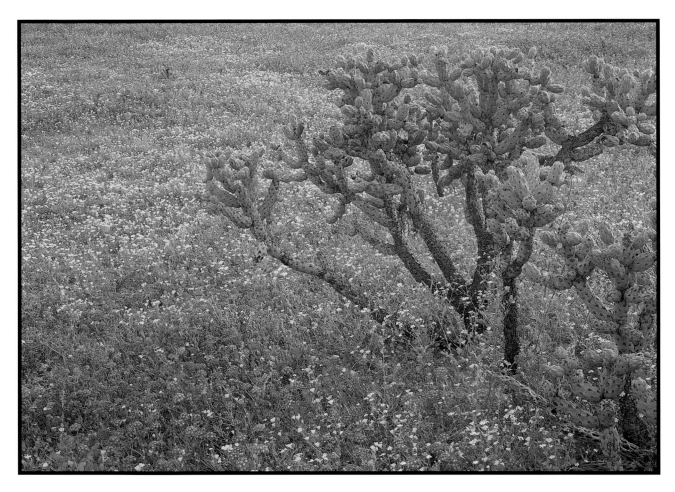

Chain link cholla cactus *Opuntia cholla,* with poppies *Eschscholzia minutiflora,* sand verbena *Abronia gracilis* Vizcaino Biosphere Reserve. Sonoran Desert Baja California, Mexico.

Sand verbena, cardon cactus and tree cholla in morning fog. Vizcaino Desert Biosphere Reserve Sonoran Desert. Baja California, Mexico.

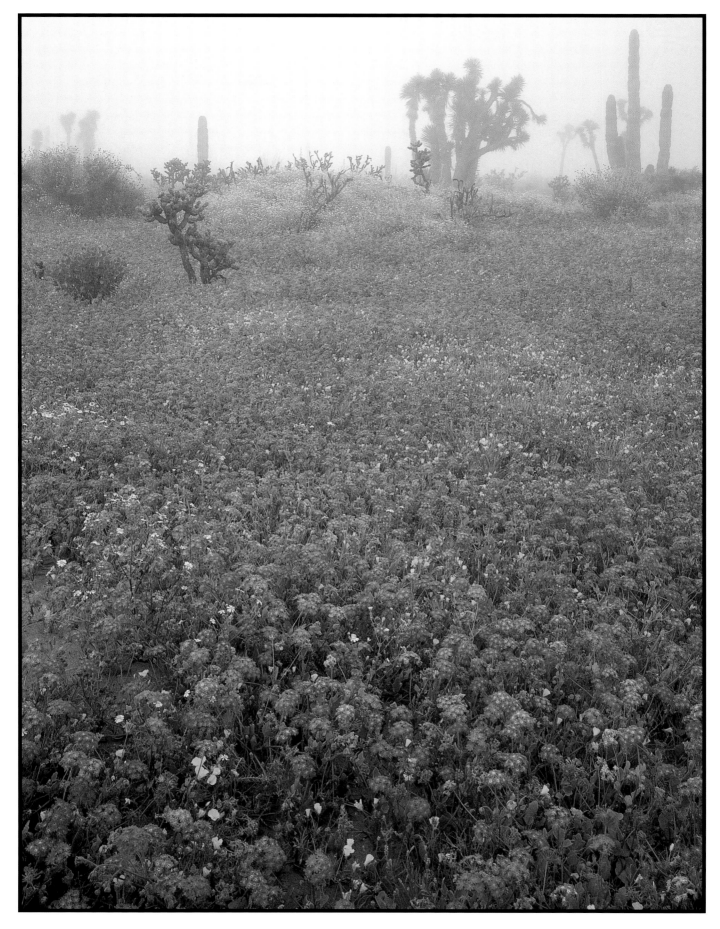

IGOR KARPENKO

THE IRREVERENCE OF HUMOUR

Making a photograph that will bring a smile to people's faces or even make them laugh out loud is one of the more difficult tasks in photography. Certainly, most photographers have been able to capture a funny moment on film because they were at the right place at the right time with camera ready. But what does it take to intentionally make photographs that have humour as their main theme? That is certainly a real challenge and one that Igor Karpenko of Ukraine has taken up seriously.

Igor Karpenko is a Professional photographer in the Ukrainian city of Kharkov which is one of the centres of photographic interest in his country. He has taken his skill as a portrait and advertising photographer and combined it with a strong interest in the fine art of photography to produce a comic opera-like world within his studio. His models are often fellow artists and actors, as well as family members, who all share his love of humour; especially its irreverent aspect. Karpenko admits to using his studio as a refuge from the rigors of daily life where he (and his models) can escape to a world where all the foibles of human nature are fair game for his humourous camera.

At times, his images take on a veil of black humour which make us wonder if it is appropriate to laugh at what we see. But Karpenko has honed his skill as designer of images to a point where we are pulled out of our indecision by some visual element he has placed in the picture to make us laugh at ourselves as much as we laugh at his models. For in the end, the source of Karpenko's staged humour is the way he cleverly reminds us that we are all but one pose away from becoming objects of humour ourselves.

Es gehört zu den schwierigsten Aufgaben in der Fotografie, ein Lächeln auf das Gesicht der Betrachter zu zaubern oder diese sogar lauthals lachen zu lassen. Freilich sind die meisten Fotografen in der Lage, lustige Momente auf Film zu bannen, weil sie eben zum richtigen Zeitpunkt am richtigen Ort waren. Aber wieviel mehr gehört dazu, einen Fotostil zu kreieren, der Humor als den Hauptbildinhalt ansieht? Das ist tatsächlich eine Herausforderung und dieser widmet sich der Ukrainer Igor Karpenko mit äußerster Ernsthaftigkeit.

Karpenko lebt als Berufsfotograf in Kharkov, welches als das Zentrum der Fotografie in seinem Land gilt. Der Fotokünstler hat seine Ausbildung als Berufs- und Werbefotograf mit seinem starken Interesse an der Kunst kombiniert und inszeniert eine an Comics, die Marx Brothers und an Federico Fellini gemahnende Welt der Fotografie. Seine Modelle sind zumeist Künstler und Schauspieler, aber auch Familienmitglieder, die alle seinen Sinn für Humor, speziell seinen respektlosen schwarzen Humor teilen. Karpenko nutzt sein Studio als Refugium vor den Härten den täglichen Lebens. Hier flieht er in eine Welt der Abgründe der menschlichen Natur, die der Ausgangspunkt für den humorvollen Gebrauch seiner Kamera sind. Manchmal erschrecken die Bilder in ersten Anschein, manchmal dauert es einen Moment, bis der Humor in ihnen zündet. Aber Karpenko gelingt es durch sein Können als Bilddesigner durch Integration verschiedener, oft vorerst unpassend erscheinender visueller Elemente, die Unsicherheit der Bildbetrachter bis zu jenem Punkt zu steigern, an dem sie über die Bilder und damit oft auch über sich selbst zu lachen beginnen. Letztendlich ist es die Quelle von Karpenkos inszeniertem Humor, daß er uns daran erinnert, dal3 wir alle oft nur ganz knapp daran vorbeigehen, selbst das Opfer des eigenen Humors zu werden.

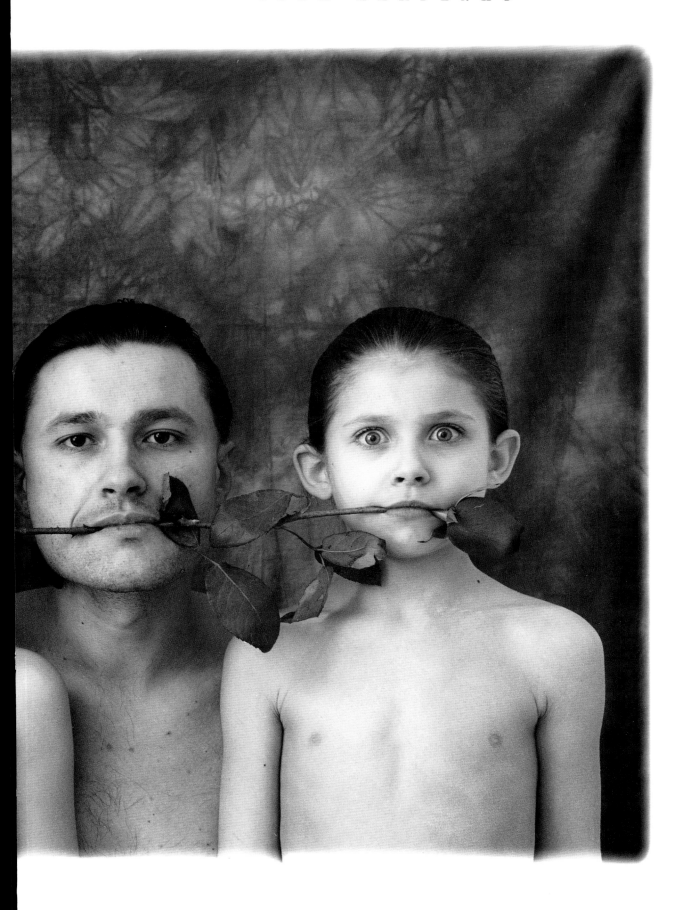

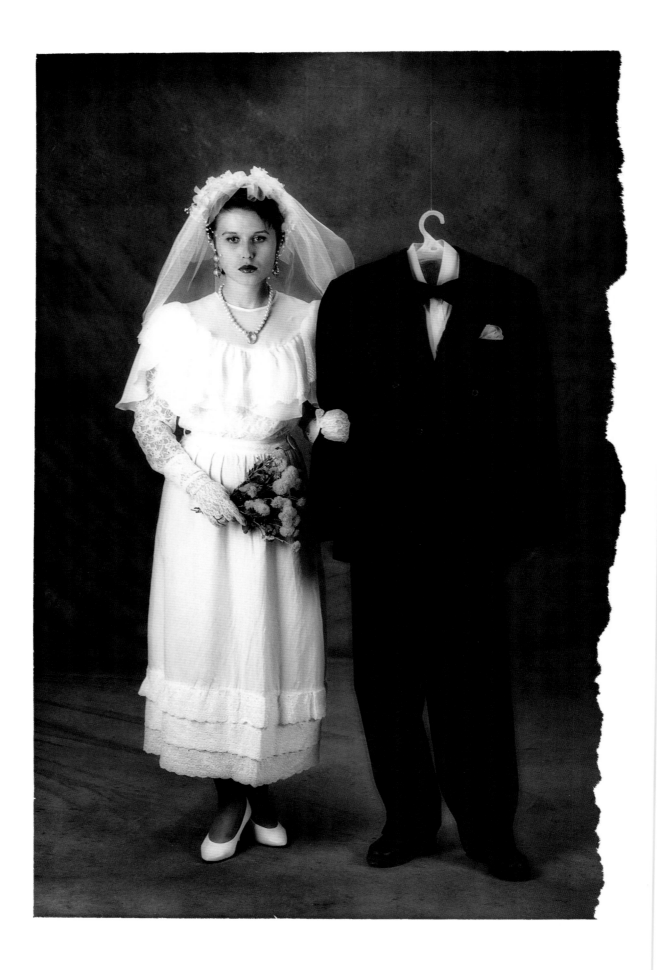

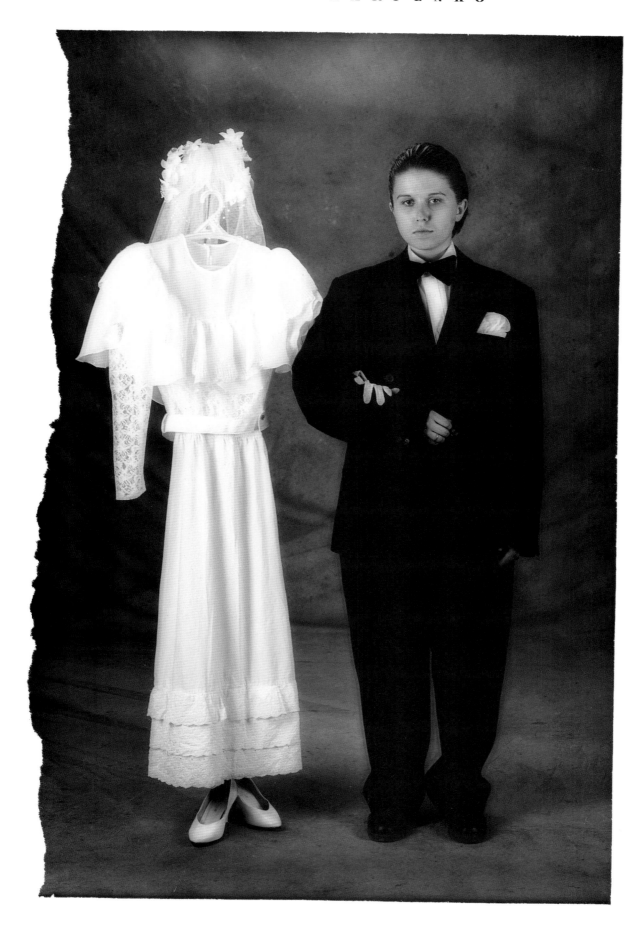

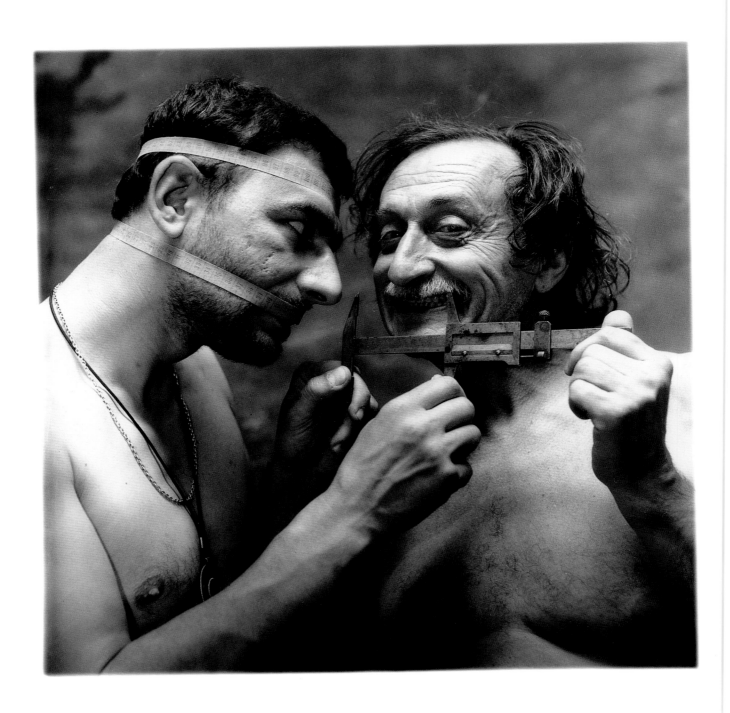

48

Newbert & Wilms

FROM A RAINBOWED SEA OF DREAMS

Christopher Newbert and Birgitte Wilms are both professional photographers living in the Rocky Mountains of the United States from where they operate Rainbowed Sea Tours, a company that offers international dive tours with a speciality in photography. Prior to his marriage to Wilms, Newbert, an American, had been acknowledged as one of the top underwater photographers in the world, winning over 30 awards in international underwater photographic competitions. He operates an active photographic library his work having appeared in more than 250 books and countless magazine articles.

Newbert's first solo book publication, *Within a Rainbowed Sea* was described as *"one of the most remarkable photographic books ever published"* by *Publishers Weekly* and among the many accolades it has received through the course of its 10 printings was to be selected as an *Official Presidential Gift of State* to be given by the American White House to visiting dignitaries.

Birgitte Wilms, a native of Denmark, is a former underwater photographic model who took up underwater photography seriously in 1988. Since then, a wide range of magazines in the US and Europe have featured her remarkable work and she has joined her husband, Chris, as Vice President of Rainbowed Sea Tours while operating her own stock photography business. In 1994, she and her husband published the book, *In a Sea of Dreams,* as a joint collection of their work and it was awarded the World Grand Prize as the BEST BOOK OF UNDERWATER PHOTOGRAPHY, Antibes, France.

For both Chris and Birgitte, the underwater world is a place of solitude and that makes certain demands on those visitors who hope to capture its life on film. As they point out in their introduction to *Sea of Dreams:*

"Alone, deep in the sea, self-reliant by necessity in a foreign, sometimes hostile environment, an underwater photographer develops an intimate connection with those creatures which materialise in the camera's viewfinder. The situation invites introspection, and introspection lies at the core of good photography."

Christopher Newbert und Birgitte Wilms leben als Berufsfotografen in den Rocky Mountains, von wo aus sie - paradoxerweise - ihre Firma "Rainbowed Sea Tours" betreiben. Eine Firma, die Reisen in internationale Tauchreviere anbietet! Schon bevor Chris Newbert Birgitte Wilms heiratete, galt er als einer der besten Unterwasserfotografen der Welt, der in zahlreichen Spezialwettbewerben zu den Preisträgern zählte. Er unterhält ein großen Archiv, aus dem Arbeiten in 250 Büchern und unzähligen Zeitschriften Verwendung fanden. Sein erstes eigenes Buch *Within a Rainbowed Sea* wurde von *Publishers Weekly* als eines der bemerkenswertesten Unterwasserbücher, das jemals auf den Markt kam, bezeichnet. Und unter den vielen Auszeichnungen, die es gewann, ragt eine ganz besonders hervor: es wurde zum *offiziellen Präsidentengeschenk,* welches vom Weißen Haus an ausländische Staatsgäste übergeben wird.

Birgitte Wilms stammt aus Dänemark, begann als Unterwasserfotomodell und arbeitet seit 1988 auf der anderen Seite der Kamera. Zahlreiche ZeitschriPten in Europa und den USA haben ihre bemerkenswerten Arbeiten veröffentlicht und sie begleitete bereits ihren späteren Gatten Chris als Vizepräsident der gemeinsamen Firma, während sie noch an ihren eigenen Unterwasseraufnahmen arbeitete. 1994 produzierten die beiden gemeinsam das Buch *In a Sea of Dreams.* Dieses meisterhafte Buch wurde in Antibes, Frankreich mit dem WELTPREIS ALS BESTES UNTERWASSERBUCH ausgezeichnet.

Für beide, Newbert wie Wilms, ist die Unterwasserwelt ein Platz der Einsamkeit und der Erkenntnis. In ihrem Vorwort zum Buch *Sea of Dreams* führen sie dies wie folgt aus:

"Tief unten in Meer, auf sich allein gestellt, in einem fremden, manchmal sogar feindlichen Element, kann ein Unterwasserfotograf die intensive Verbindung mit den Tieren erfahren, die sich im Sucher seiner Kamera befinden. Diese einzigartige Situation lädt zur Selbstprüfung ein und in der Selbstprüfung liegt der Schlüssel zu erstklassiger Fotografie."

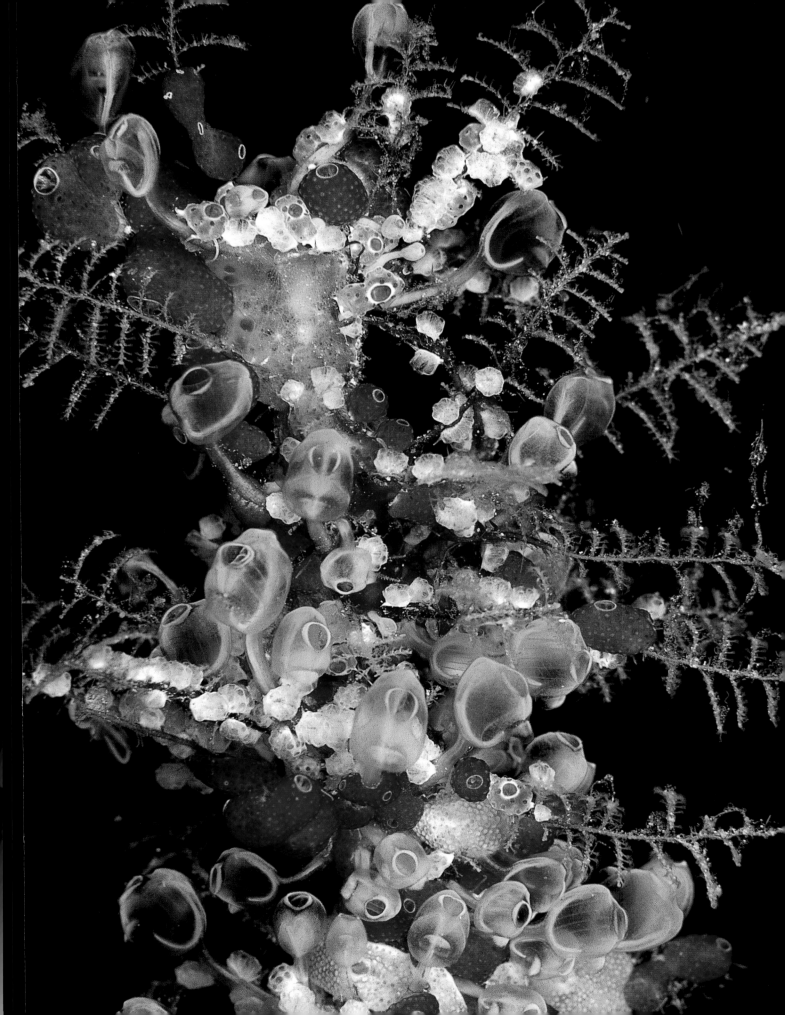

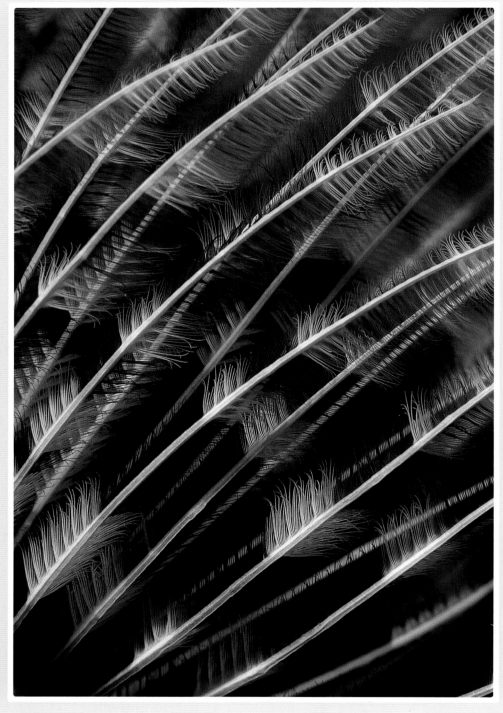

Above
FEATHER DUSTER WORM DETAIL
Sabellastarte indica, Palau

Feather worms construct tubes out of sand and debris cemented together by mucous-like secretions. CN

Previous page
ASCIDIANS AND HYDROIDS
Pycnoclavella detorta, Solomon Islands

While appearing like a colourful bouquet of flowers, this cluster is comprised of individual animals, formed of numerous ascidian species. Sharing many characteristics of the sponge, ascidians represent perhaps the next evolutionary step beyond the sponge. CN

100m macro lens Velvia 50. All photographs Canon F-1, Canon FD lenses. Oceanic housings and strobes.

Right
RUGOSE CORAL
Pachyseris rugosa, Great Barrier Reef

Coral is a co-operative venture by thousands of individual polyps, each a single animal attached to and supporting its neighbouring polyp. CN

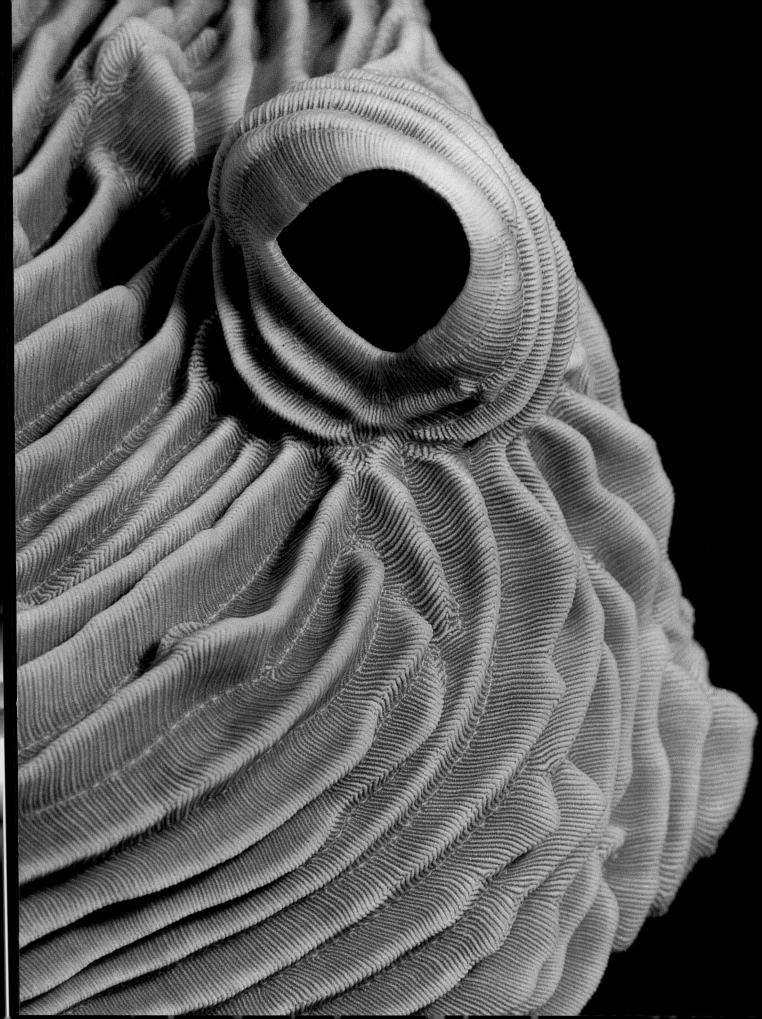

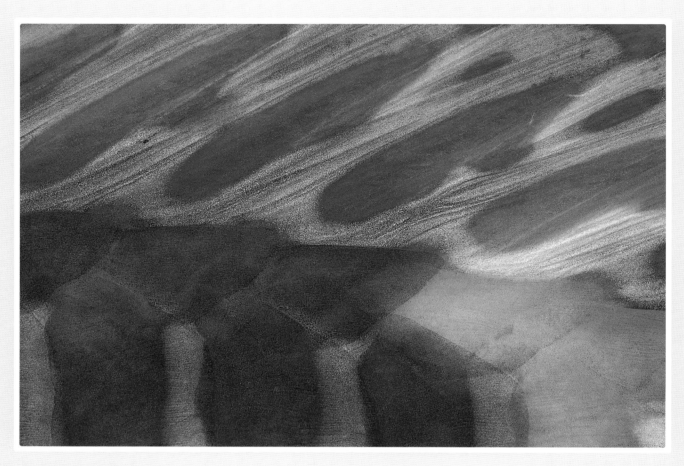

PARROTFISH PATTERNS
Scarus longiceps
Solomon Islands

When parrotfish sleep, they frequently
secrete a mucous cocoon around their
bodies. Scientists have suggested this
mucous sac might confine the parrotfish's
scent, providing some protection from
predators which hunt by smell.
When I hope to make images of the
endlessly interesting patterns found on
the parrotfish, it is necessary to find one
which has no distracting cocoon. BW
100mm macro lens Velvia 50

PARROTFISH PECTORAL FIN
Scarus oviceps
Solomon Islands

Photographing the patterns found on fish is
for me a little like photographing sunsets.
Every new one seems more beautiful than
the last, so I keep on shooting. The camera
has a great power to isolate detail and
manipulate perception, and the results
always remind me of the parable of the
blind men and the elephant. Individually,
the sightless old men touch different parts
of the animal. They each describe from
their separate experiences what the whole
elephant must be like, and of course each
forms a radically different understanding
of what an elephant is. In making such
photographs, I am visually feeling selected
areas of my subjects, the details of these
small parts holding a larger experience of
their own. CN

100mm macro lens Velvia 50

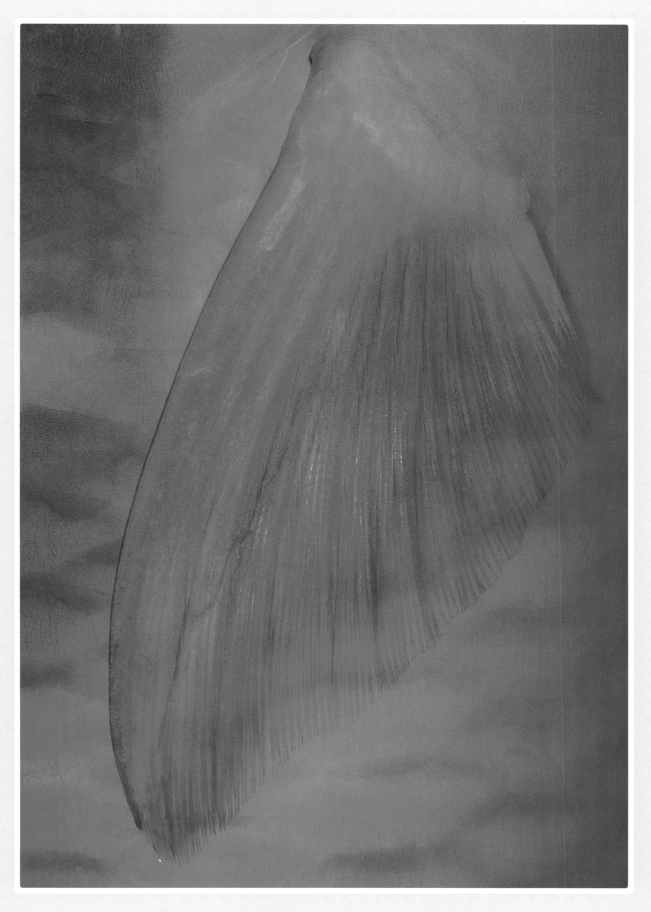

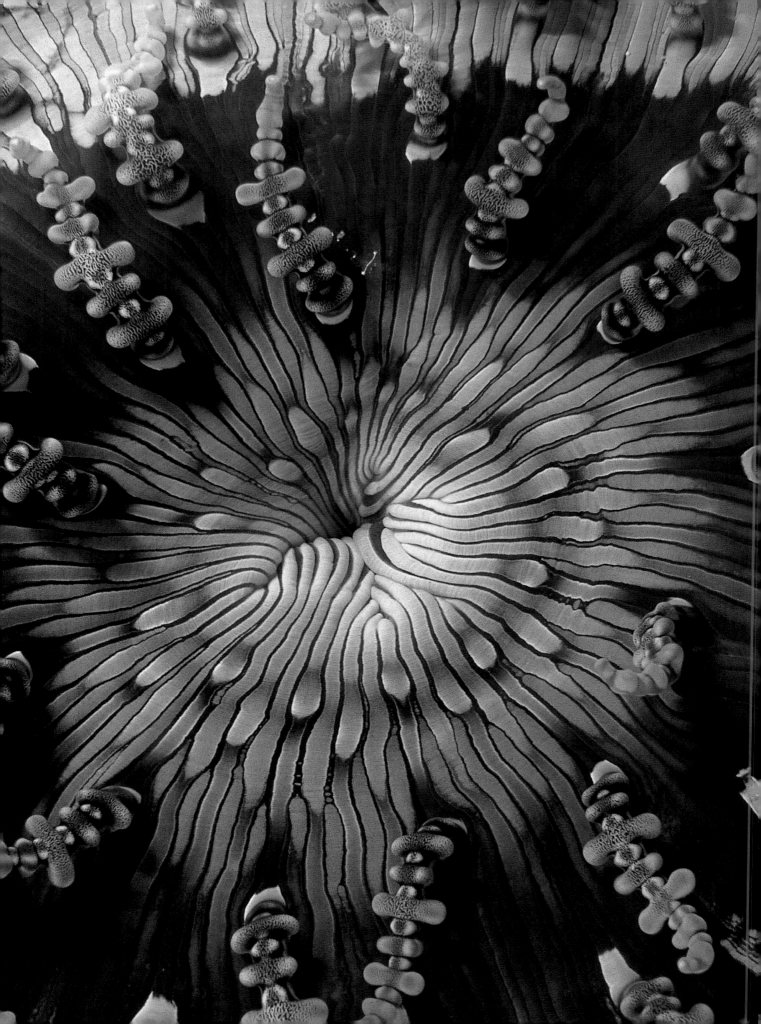

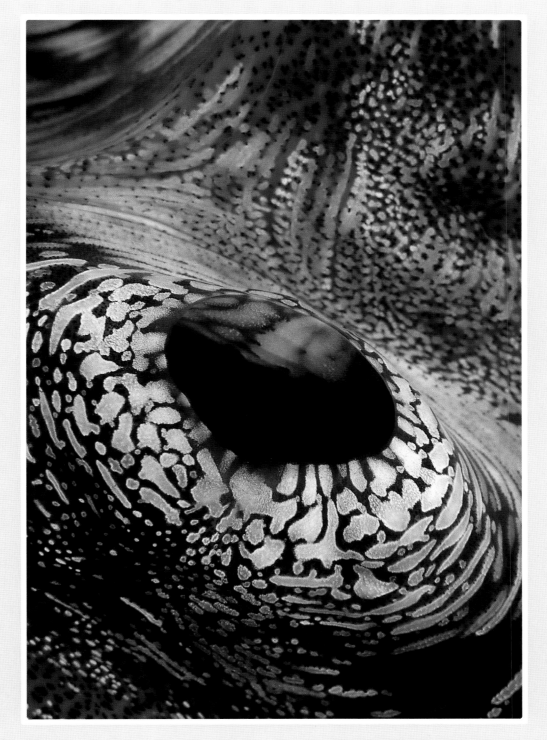

Left
BEARDED SEA ANEMONE
Heteractis aurora
Solomon Islands

While this species would usually host a
family of anemonefish, I found this
individual deserted. But looking ever
closer through my macro lens, I discovered
a tiny shrimp hidden behind one of the
tentacles. For the sheer strength of its
graphic patterns, no other anemone
species compares with this one. BW
100mm macro lens Velvia 50

TRIDACNA CLAM SIPHON
Solomon Islands

A feeling of something cosmic came over
me as I composed this image of a tridacna
clam siphon. Many astronomers say there
may be a black hole in the centre of all
galaxies. As I composed this photograph in
my viewfinder, I felt my macro lens had
been transformed into a telescope, and that
I was peering at just such a celestial
phenomenon. CN
100mm macro lens Velvia 50

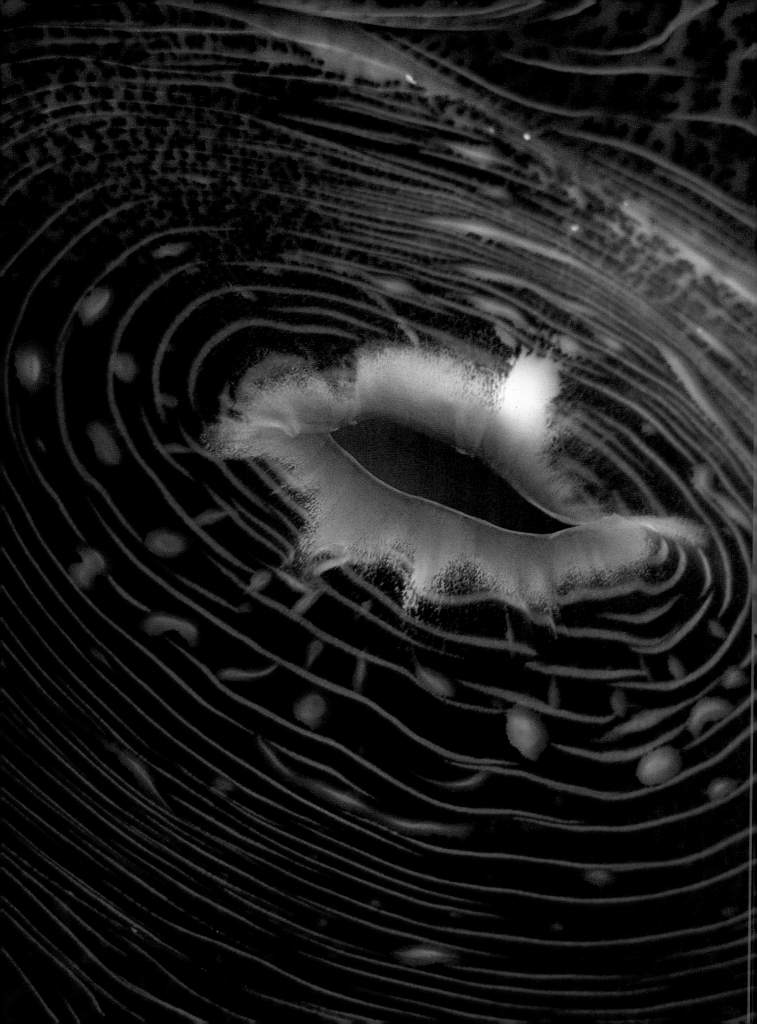

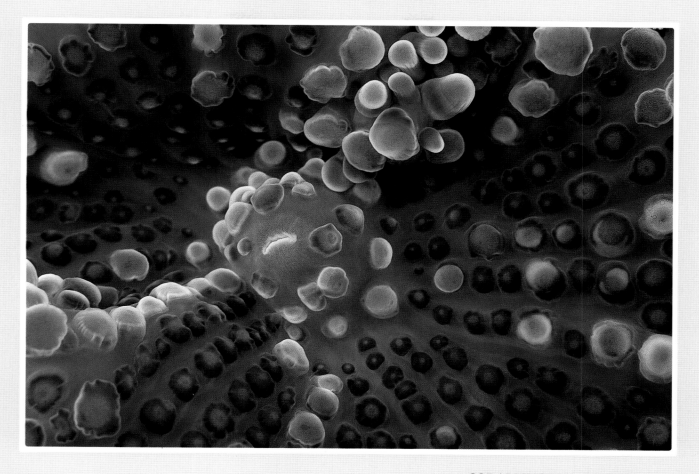

CORALLIMORPHARID DETAIL
Solomon Islands

After thirty years of exploring the oceans of the world, I continue to be entranced by the stunning designs nature has created beneath the sea. When the patterns from this tiny anemone-like creature emerged in my viewfinder, I felt a sense of something fundamental, something molecular. Photographed at a depth of ninety feet. CN

100mm macro lens Velvia 50

TRIDACNA MANTLE
Tridacna Maxima
Coral Sea

The mantle of a giant clam again suggests images from beyond our planet. I found this subject at 90 feet on Bougainville Reef. The actual size of the area represented by the photo is only a few square inches.

100mm f4 macro lens. ASA 25 film.

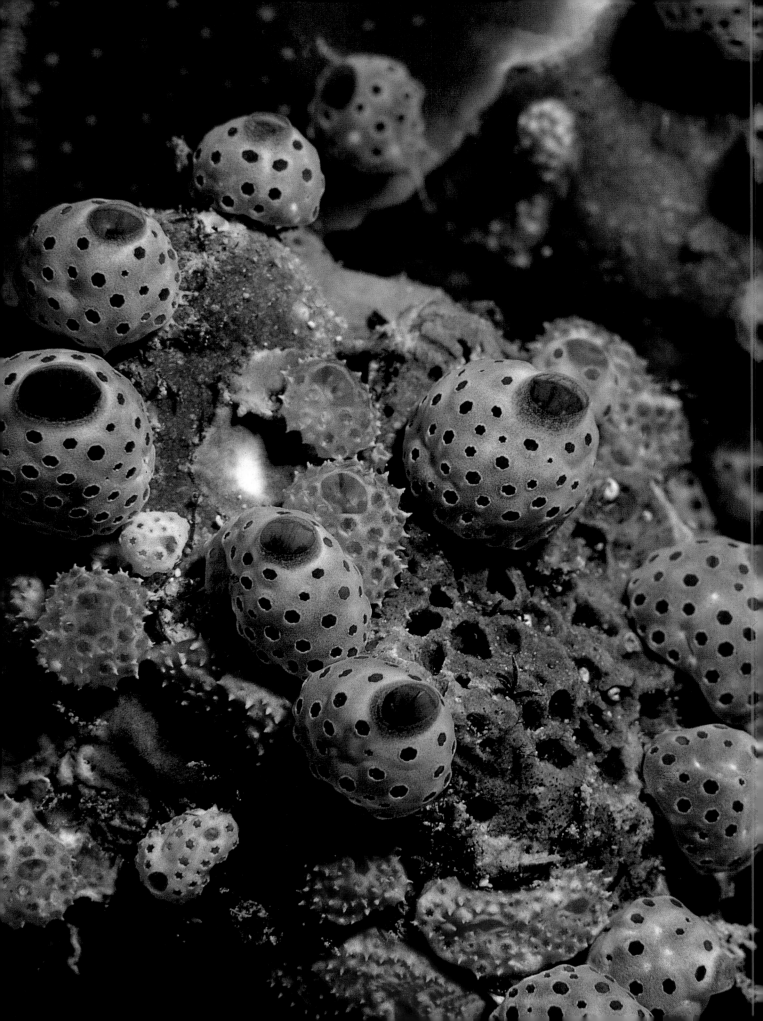

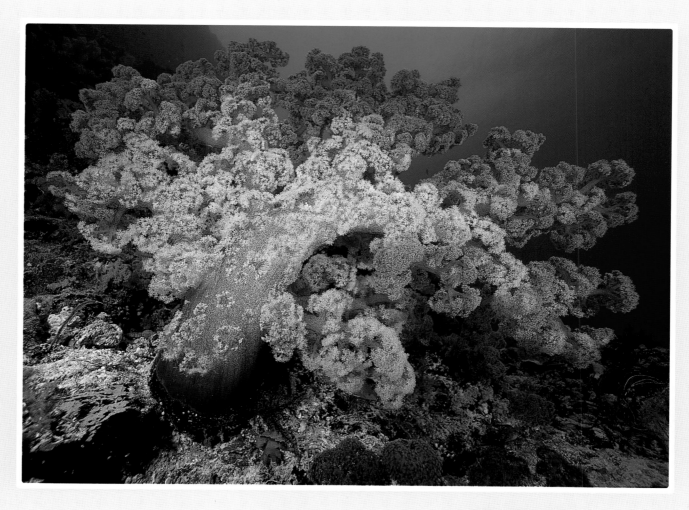

SOFT CORAL TREE
Dendronephthya sp.
Solomon Islands

Nearly one hundred and forty feet deep in a reef pass connecting the Solomon Sea to an inner lagoon, soft corals bloom luxuriously in the food-rich current. Such reef passes are like arteries in a massive circulatory system, bringing open sea water and nutrients into the lagoon with the incoming tide, and carrying out fresh water river run-off, vegetation, and warmer, algae-rich water on the outgoing tide. Visibility is generally better as clean sea water pours in, but the action can be great either way as long as the tide is flowing swiftly. CN
14mm lens Velvia 50

TUNICATES
Didemnum molle and Didemnum nekozita
Palau

Tiny filter-feeding tunicates dot the reef like hundreds of miniature amphorae. While appearing more like plants, tunicates are primitive animals which never move once anchored to the bottom.
100mm f4 macro lens. ASA 25 film.

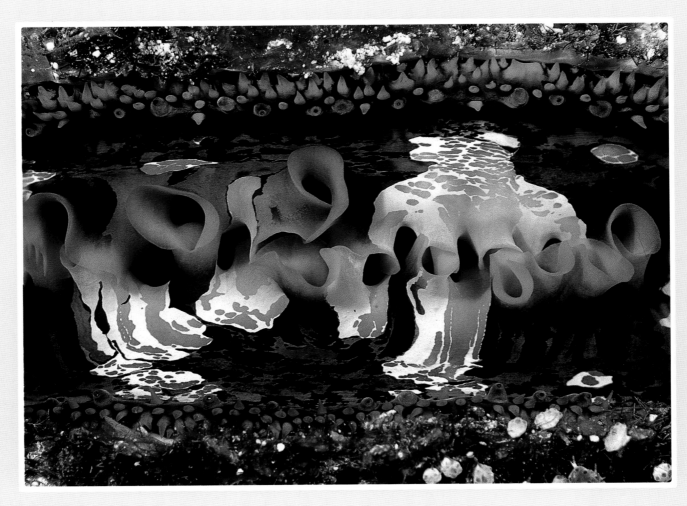

THORNY OYSTER MANTLE
Spondylus sp.
Solomon Islands

The beautiful mantles of the thorny oyster
beckon the underwater photographer, but
these creatures are so extraordinarily
sensitive to light and motion, they are
quite difficult to approach. When disturbed
in the slightest way, the two halves of the
shell will quickly slam shut. The upper
and lower edges of the mantle are lined
with dozens and dozens of "eyes" detecting
only light or shadow. Such animals are
filter feeders, and must remain open for
extended periods of time for nourishment
and respiration. CN

100mm macro lens Kodachrome 25

NUDIBRANCH LAYING EGGS ON
SEA SQUIRT
Nembrotha lineolata on Polycarpa aurata
Solomon Islands

Nudibranchs of many species often choose
to lay their egg on on the surface of these
common sea squirts. This nudibranch has
nearly completed its delicate egg ribbon.
Each spiral cluster may contain thousands
of eggs, but only a few of the eggs will
survive and mature into colourful sea
slugs. Curiously sea squirts are our closest
invertebrate cousins, a point many might
consider less than flattering. BW

100mm macro lens Velvia 50

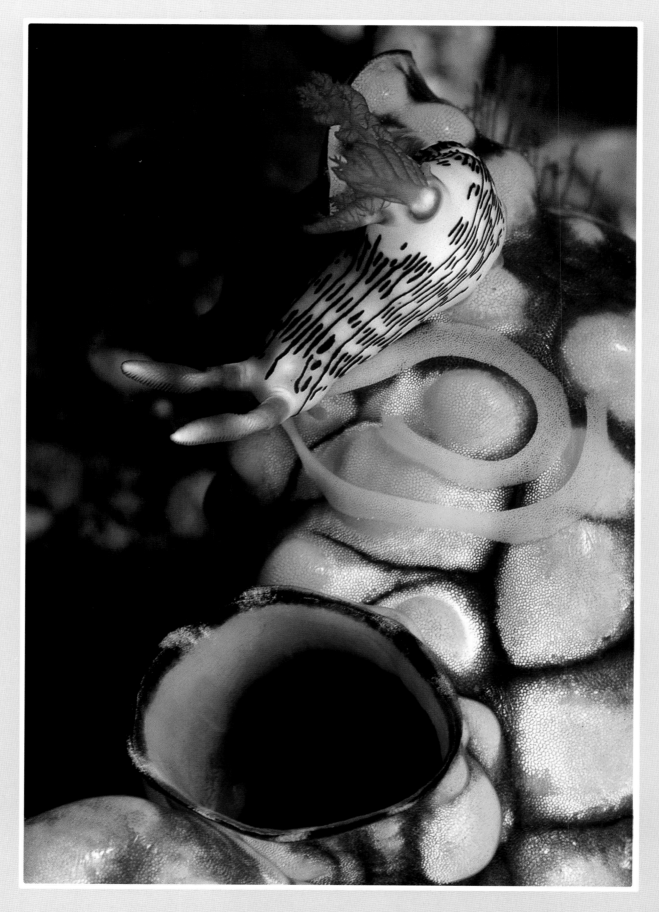

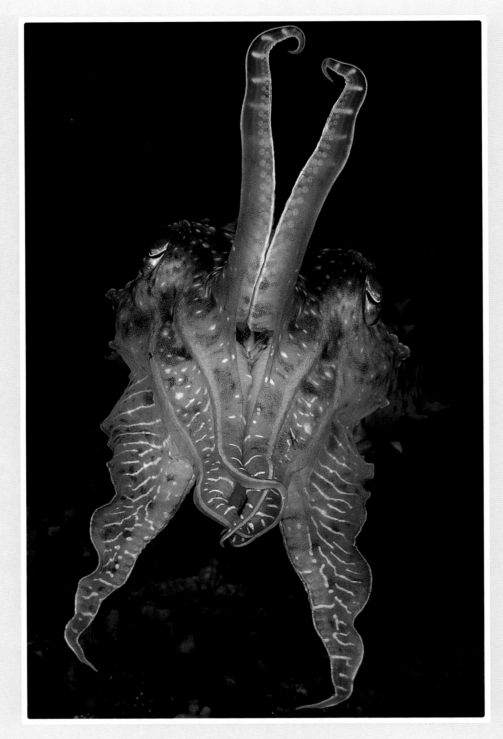

CUTTLEFISH
Sepia
Solomon Islands
I watched the cuttlefish approach a small, hovering fish. It manoeuvred slowly by gently fluttering the thin, transparent fin skirting its body. Almost faster than my eye could detect, another pair of specialised feeding tentacles shot out, and the fish disappeared in it suction cup grasp. CN

50mm macro lens Velvia 50

Right
PELAGIC OCTOPUS
Octopus sp.
Kona, Hawaii
Some suggest these are a juvenile stage of reef octopus which will later mature inshore. But I have sometimes come up from night dives in the open ocean covered with young, clinging octopus, tiny replicas of reef octopus, which have no resemblance to these subjects.

50mm f3.5 macro lens, ASA 25 film

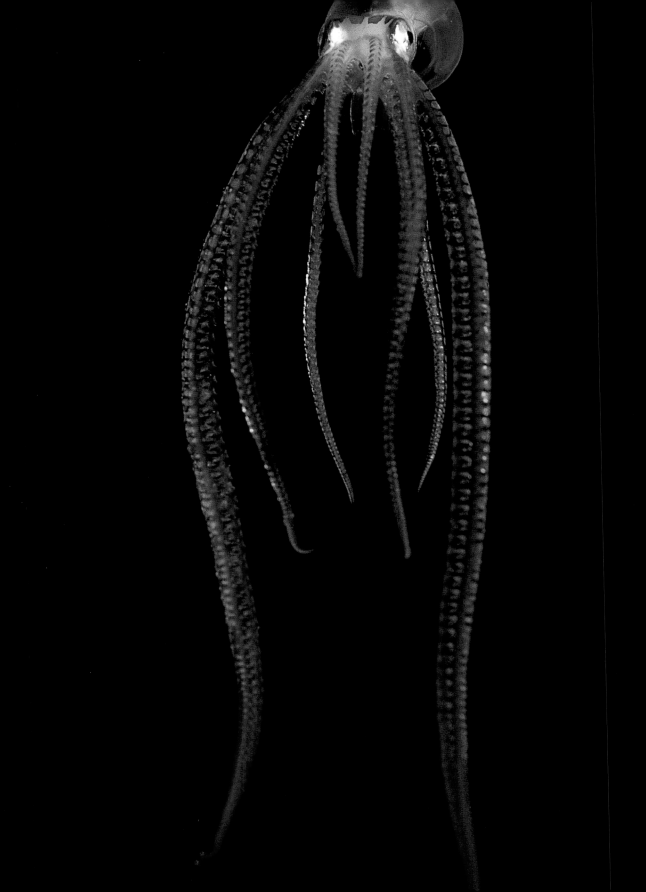

MANFRED
KRIEGELSTEIN
A PASSION FOR THE DIGITAL IMAGE

Long before he became interested in digital photography, German born Manfred Kriegelstein had amassed a formidable reputation as an outstanding photographer during the 1980s within the international print competition salons of Europe. He is the recipient of the M. Maitre title, the highest level of recognition offered by FIAP *The International Federation of Photographic Art*. Kriegelstein is also the author of three photographic books. Married and a practicing dentist in Germany, his passion for photography is boundless and his desire to extend the means to express himself eventually drew him into the world of digital photography in the early 1990s.

Kriegelstein quickly realised the potential of this new medium to offer whole new avenues of expression. But he also understood that it would take time to learn how to use the technology and so he 'retired' temporarily from salon competition to work intensely with his computer until he mastered the digital medium. The endless possibilities of variation offered by digital photography, particularly suited Kriegelstein's desire to use strong colours (he never works in black and white) and mystical themes. Moreover, the tireless response of the computer to command after command also suited Kriegelstein's practice of working intensively for long "creative periods" at the computer. Thus, he would leave his dental practice to travel into the countryside of nearby Denmark for weeks at a time to concentrate completely on his work. During these creative periods, Kriegelstein will assemble the pictures he has taken with conventional cameras into new single images following a very specific plan he has previously thought through.

For Manfred Kriegelstein, photography is a passion and in his view, the digital medium is where this art form is going. As he puts it: "digital is the future of photography and the train going in that direction is now at the station".

Lange bevor er sich für die digitale Fotografie interessierte, hat sich der deutsche Fotokünstler Manfred Kriegelstein einen ausgezeichneten Ruf als herausragender Fotograf in den internationalen Fotosalons geschaffen. Er ist Träger des M.FIAP-Titels, des höchsten Ehrentitels, den die FIAP (der internationale Verband der Fotokunst) zu vergeben hat. Kriegelstein ist Autor von 3 Fotobüchern über Bildgestaltung sowie über jene beiden Plätze, wo er die meisten seiner Bilder schaffl: Berlin-Kreuzberg und Lanzarote. Er ist verheiratet und von Beruf Zahnarzt. Seine Leidenschaft fiir die Fotografie ist unbandig und seine Sehnsucht, seine Gedanken optimal fotografisch umzusetzen, führten ihn Anfang der 90iger Jahre zur digitalen Bildbearbeitung.

Kriegelstein hat sehr rasch das Potential dieses neuen Mediums und die damit verbundenen völlig neuen Ausdrucksmöglichkeiten erkannt. Um sich optimal in diese neue Technologie einzuarbeiten setzte er als erfolgreicher Salonfotograf für einige Jahre aus, bis seine ersten digitalen Meisterwerke reif waren, veröffentlicht zu werden. Die unendlichen Variationsmöglichkeiten der digitalen Fotografie kommen Kriegelsteins Vorlieben - der Verwendung starker Farben; er hat noch nie in Schwarz/Weiß gearbeitet, und mystischer Themen - entgegen. Kriegelsteins Arbeitsweise ist eigentlich untypisch; er pflegt nach Zeiten der fotografischen Abstinenz lange und überaus intensive Kreativperioden am Computer zu verbringen. Dafür verläßt er nicht nur seine Zahnarztpraxis, sondern auch sein Land, um sich in einem einsam gelegenen dänischen Bauernhaus ausschließlich auf seine kreative Arbeit zu konzentrieren. In diesen Zeiten baut Kriegelstein aus Bildteilen, die er konventionell mit seiner Kamera aufgenommen hat, neue digital erstellte Bilder. Er folgt dabei sehr strikt einem zuvor entworfenen Bildkonzept.

Für Kriegelstein ist Fotografie eine Leidenschaft und seiner Ansicht nach ist die digitale Bildbearbeitung das Medium der Zukunft. Wie sagte er anläßlich eines Vortrages so treffend: "Die digitale Fotografie ist die Zukunft, der Zug fährt jetzt ab und wer nicht einsteigt, wird am Bahnhof stehenbleiben".

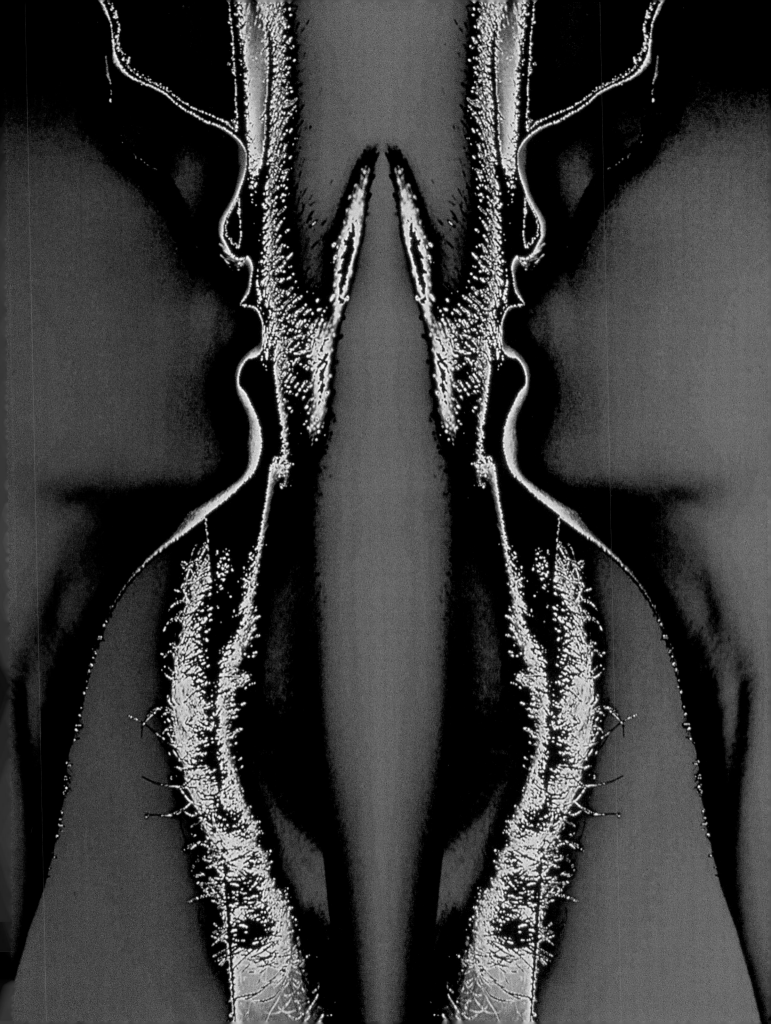

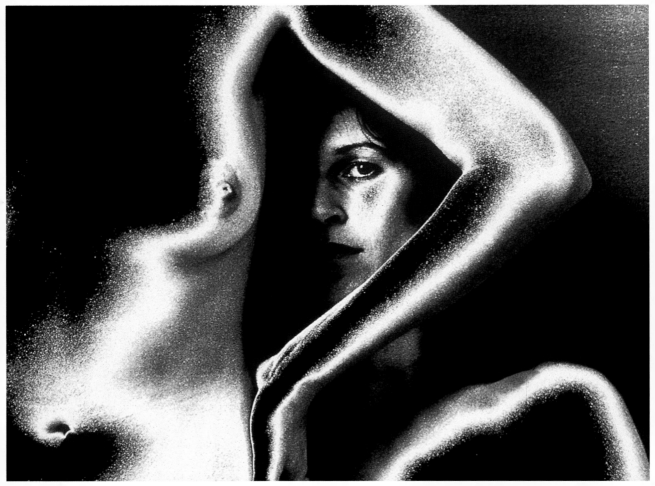

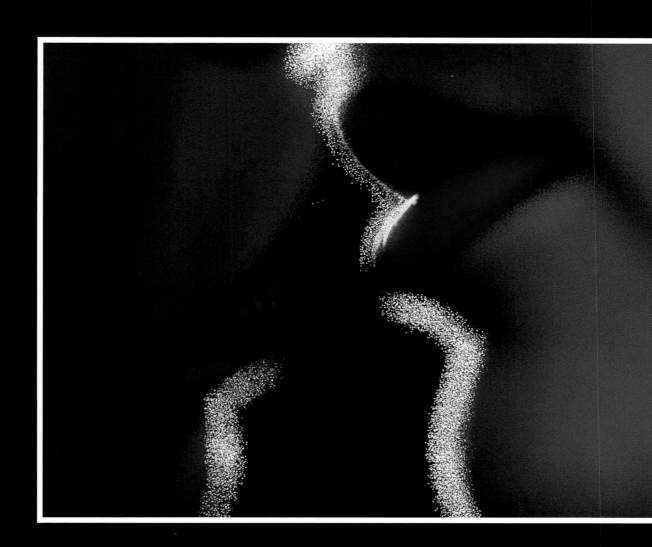

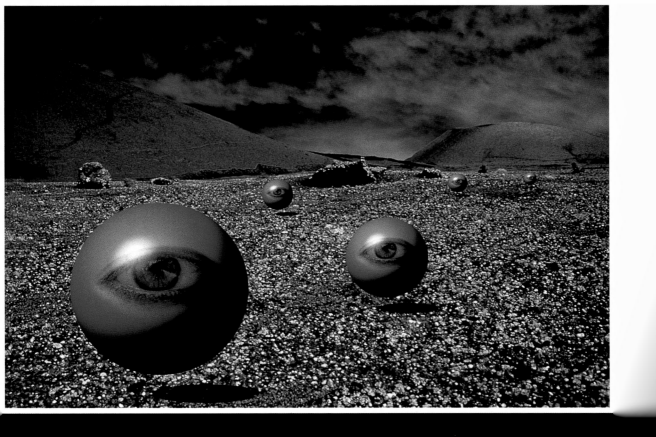

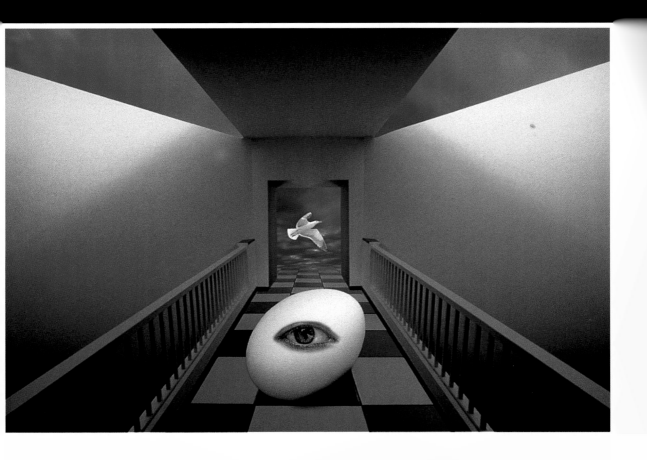

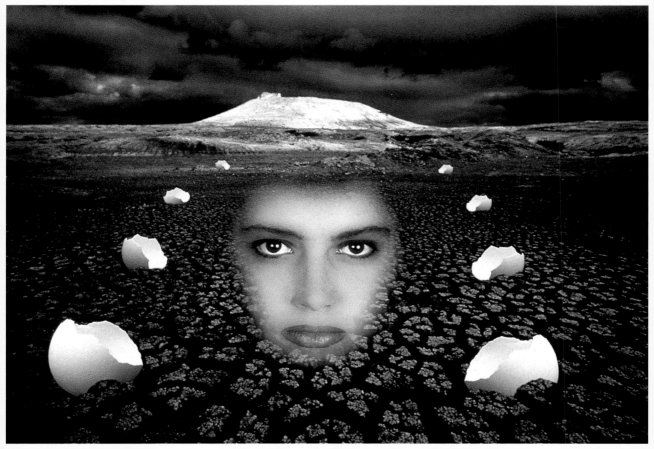

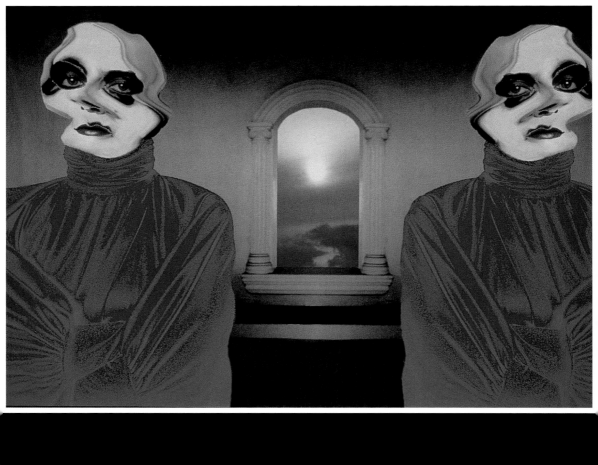

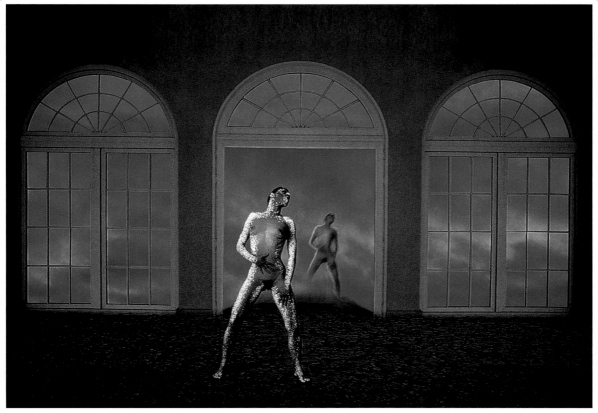

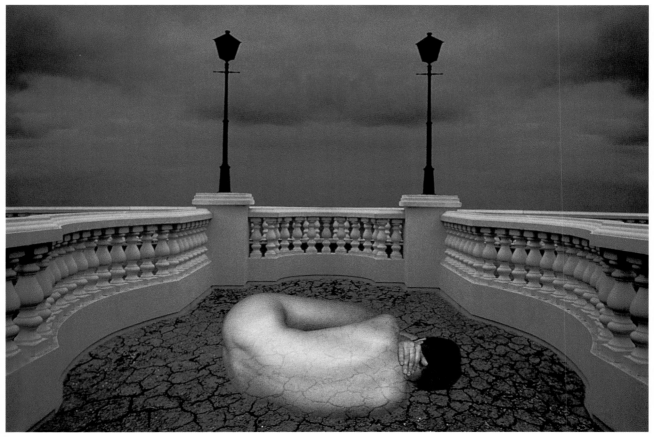

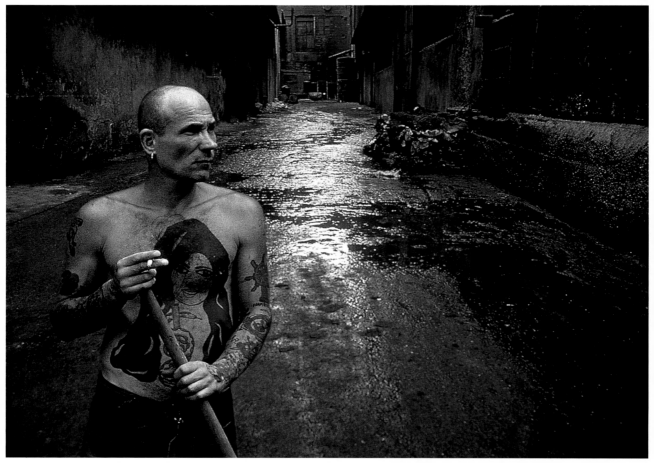

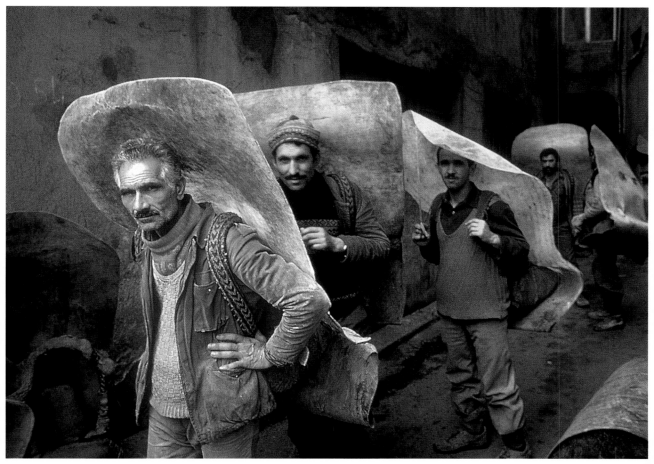

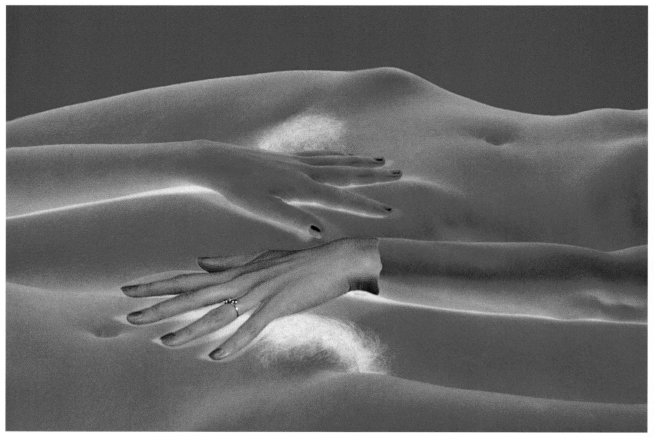

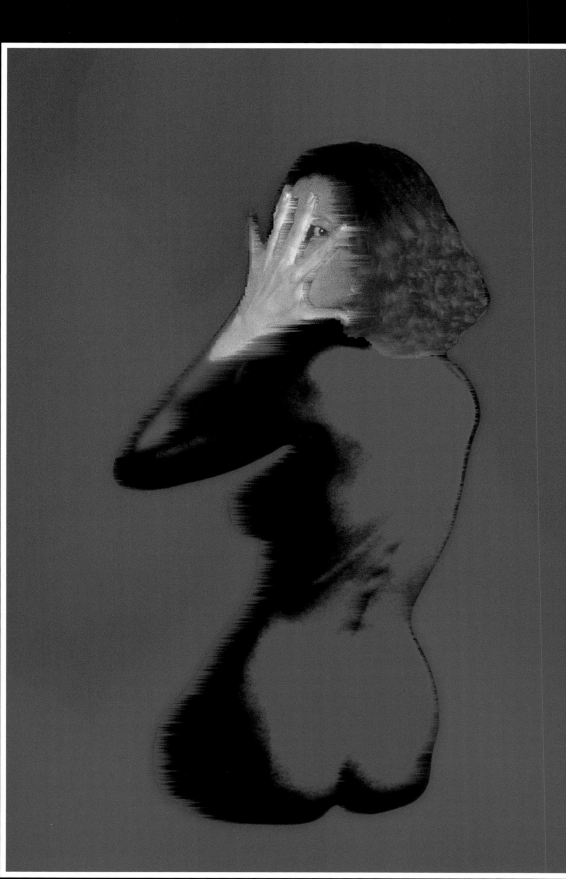

JERRY Uelsmann

Master of the Multiple Image

Jerry Uelsmann is one of America's most famous fine art photographers with a list of awards that would fill pages. His prints are in museums and galleries all over the world and he is considered a pioneer for perfecting a particular type of multi-image printing. As other photographers explore the potential of digital photography, Uelsmann remains committed to the methods and materials of conventional photography spending hours if not days at a time in his darkroom. That darkroom is equipped with as many as a dozen enlargers so that he can move the print paper from one machine to the next to expose it to different negatives. But like so much in photography, unique equipment and even high levels of technical skill can take you only so far. In the end, what makes an Uelsmann print is his visual imagination.

Born in Michigan and educated in the states of New York and Indiana, Uelsmann now teaches at the University of Florida while continuing to advance his photography. His distinct style was first formally acknowledged in a one man show at the Museum of Modern Art in New York in the 1970's. From that point on, his prints were in demand and he was formally elevated to the status of a collectable fine art photographer.

Viewing the complexity, subtleties and precision of a Uelsmann print can lead the viewer to concluded that all the individual pictures have been carefully planned and their placement in the final image worked out well in advance. Actually, the opposite is true. Uelsmann creates without a specific plan. He looks at the contact prints before him and then begins the process of merging and blending images as he feels his way along to the final image. Thus, each print is unique and he estimates that 150 or so final images are produced each year of which only a small number are considered, by him as successes.

Jerry Uelsmann ist einer der berühmtesten Fotokünstler Amerikas; die Aufleistung der ihm verliehenen Preise würde alleine Seiten in diesem Buch füllen. Seine Bilder hängen in erstklassigen Museen und Galerien der ganzen Welt und er wird als Pionier der ultraperfekten Fotomontage angesehen. Während andere Fotografen die Möglichkeiten der digitalen Fotografie ergründen, bleibt Uelsman strikt bei seiner Methode der konventionellen Fotomontage. Er bleibt fur Stunden, wenn nicht Tage ununterbrochen in der Dunkelkammer. Dieses Refugium ist mit einem Dutzend Vergrößerern ausgerüstet. Es ist sein Stil, jeden dieser Vergrößerer mit einem Negativ zu bestücken und dann mit dem Fotopapier in völliger Dunkelheit von einem Vergrößerer zum nächsten zu gehen und hier aus verschiedenen Teilen ein neues Ganzes zu komponieren. Aber wie so oft in der Fotografie genügt es nicht allein über ausgezeichnete Ausrüstung und hohes technisches Können zu verfügen, um wahre Kunst zu schaffen. Letztendlich ist es Uelsmans visuelles Vorstellungsvermögen, das seine Fotos zu Kunst werden läßt.

Geboren in Michigan und ausgebildet in New York und Indiana, lehrt Uelsman nun als Professor an der University of Florida in Gainesville, während er weiterhin überaus intensiv an der Schaffung neuer Werke arbeitet. Sein einzigartiger Stil wurde mit einer Einzelausstellung im New Yorker Museum of Modern Art in den 70iger Jahren schlagartig berühmt. Von diesem Moment an brauchte sich Uelsman nie wieder um den Verkaufserfolg seiner Bilder kümmern und er erlangte den Status eines international respektierten Künstlers.

Wenn man die Komplexität, die Subtilität und die Präzision eines Werkes von Uelsman betrachtet, dann könnte man meinen, all diese Werke seien sorgfältig geplant und würden einem strengen Konzept folgen. Tatsächlich ist das Gegenteil wahr! Uelsman arbeitet völlig planlos. Er geht durch seine Kontaktbögen und nach dem Zufallsprinzip wählt er jene Negative aus, die er in Konnex setzt und miteinander verschmilzt, was ihm letztendlich zum finalen Bild führt. Insofern ist jedes einer Bilder einzigartig und von rund 150 innerhalb eines Jahres derart gestalteter Werke verbleiben nur einige wenige, die Uelsman dann öffentlich vorstellt.

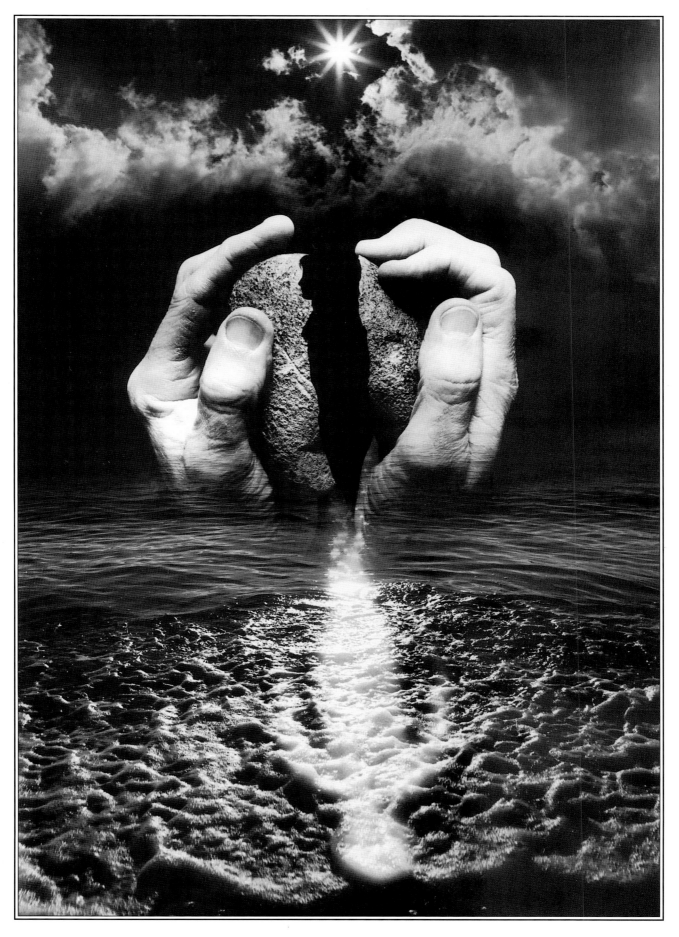

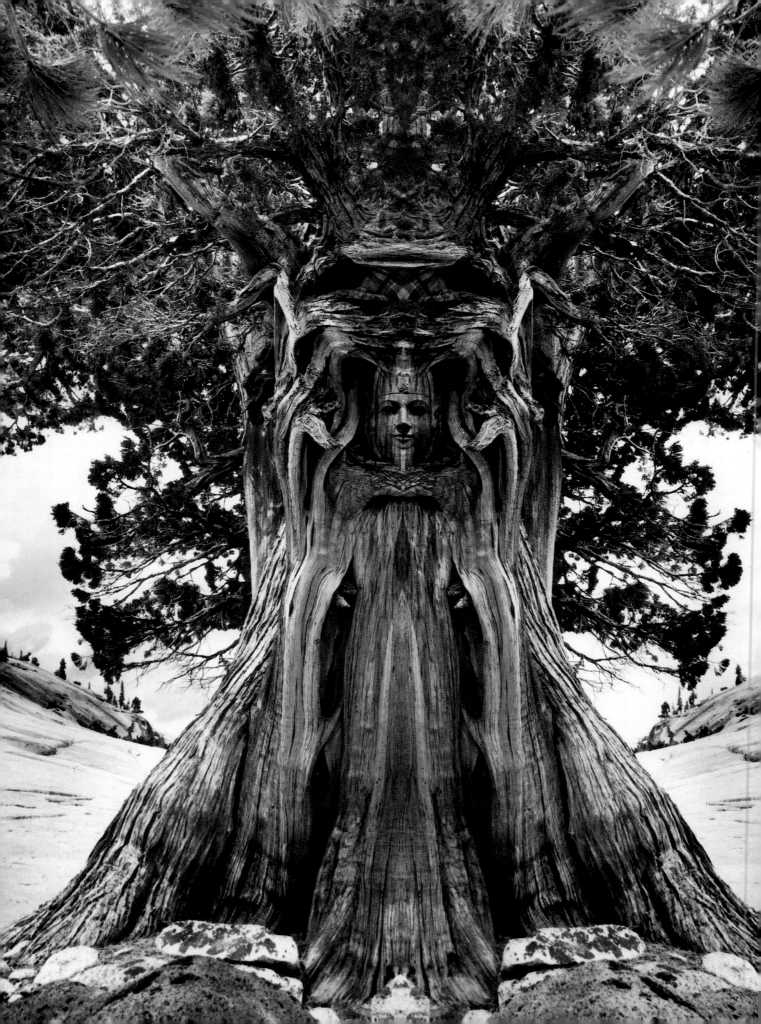

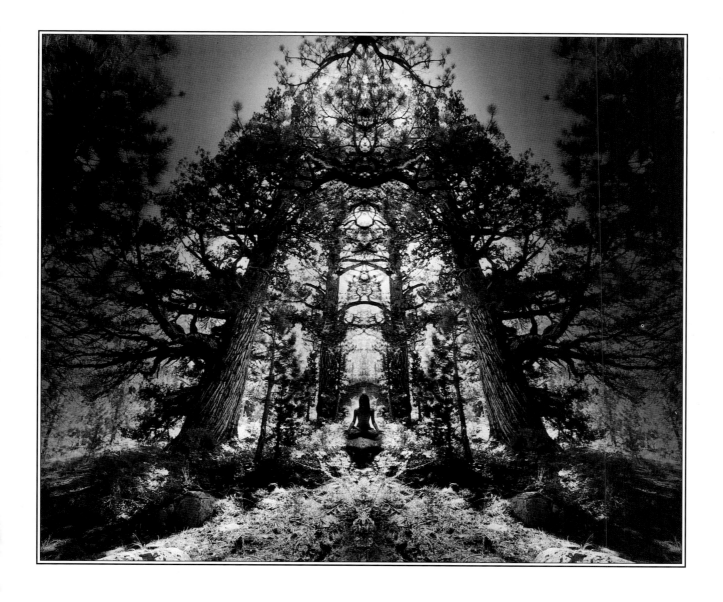

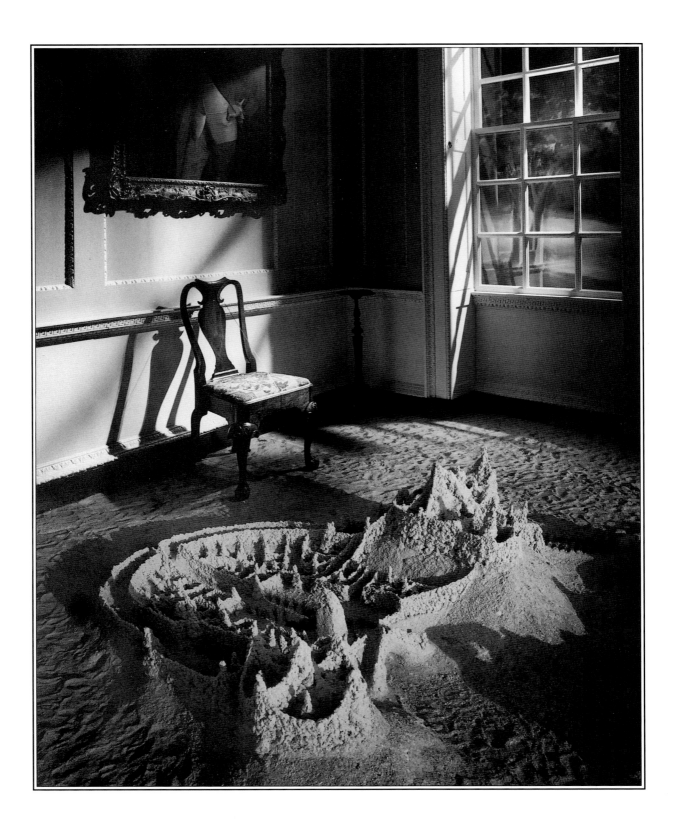

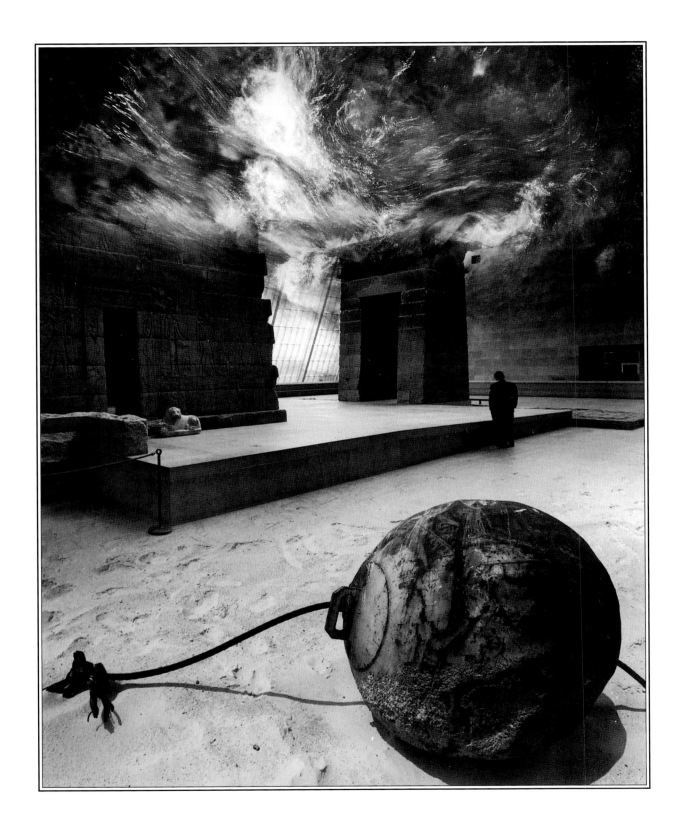

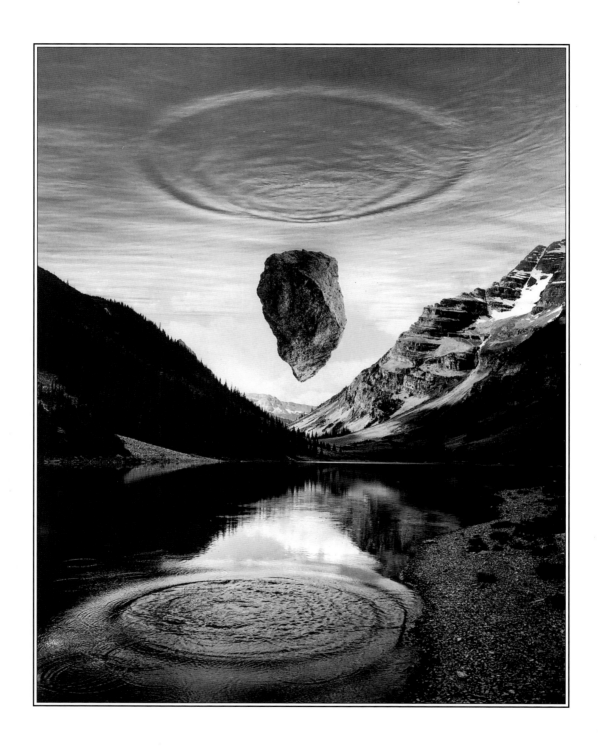

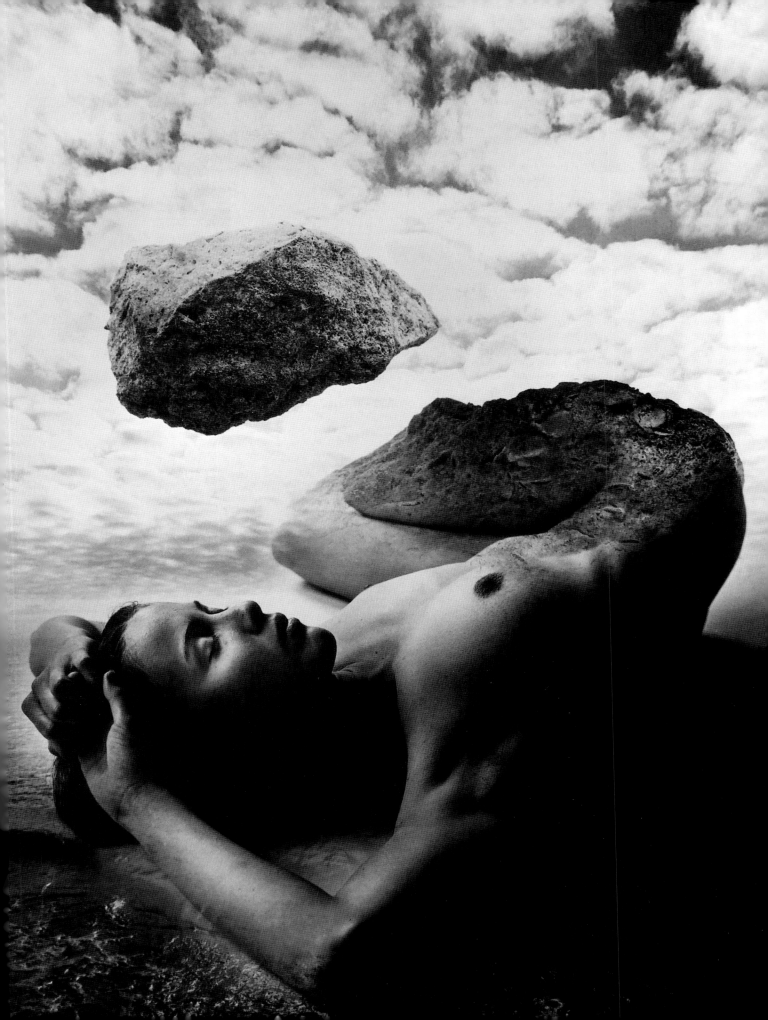

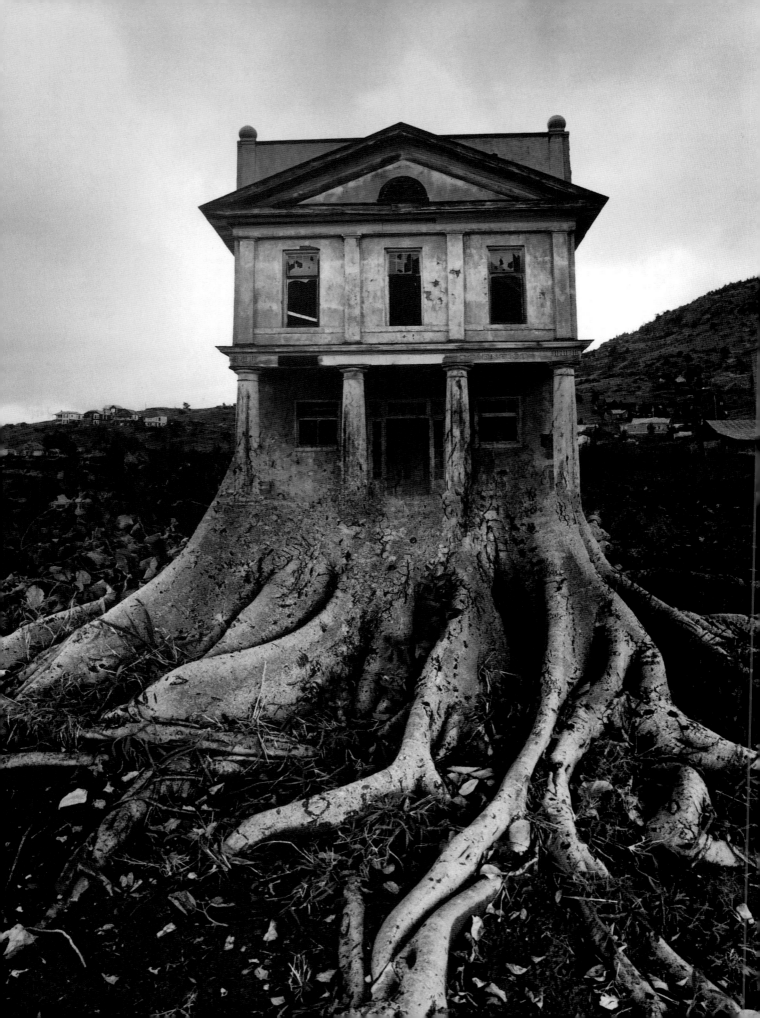

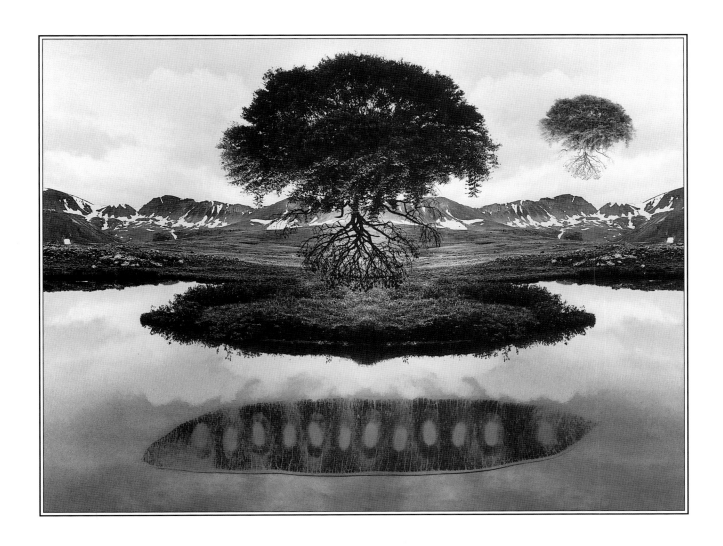

THE PHOTOGRAPHERS

Vincent Thompson
UNITED KINGDOM

Wilhelm Mikhailovsky
LATVIA

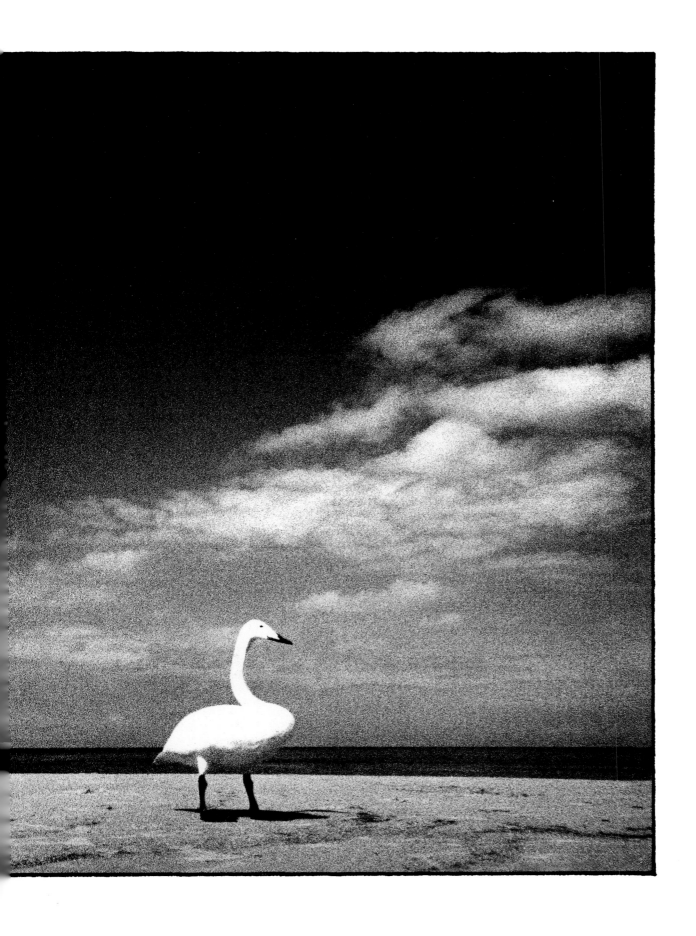

Klaus Schidniogrotzki
GERMANY

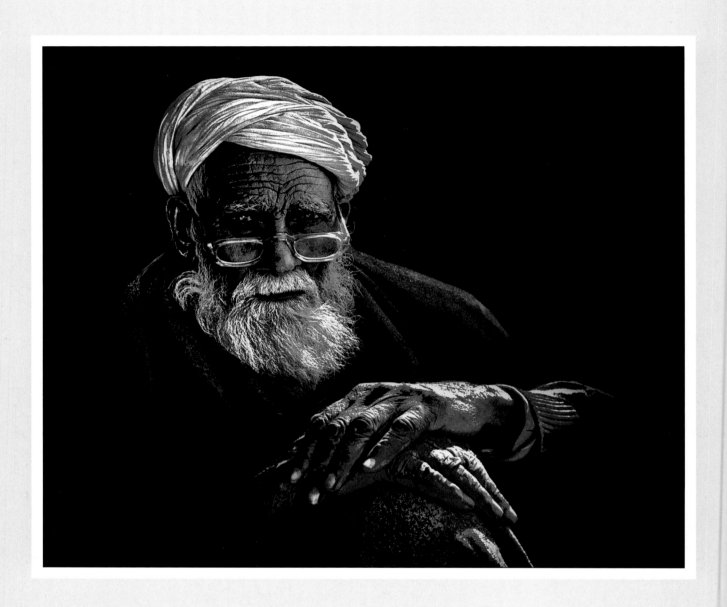

Aftab Ahmad
PAKISTAN

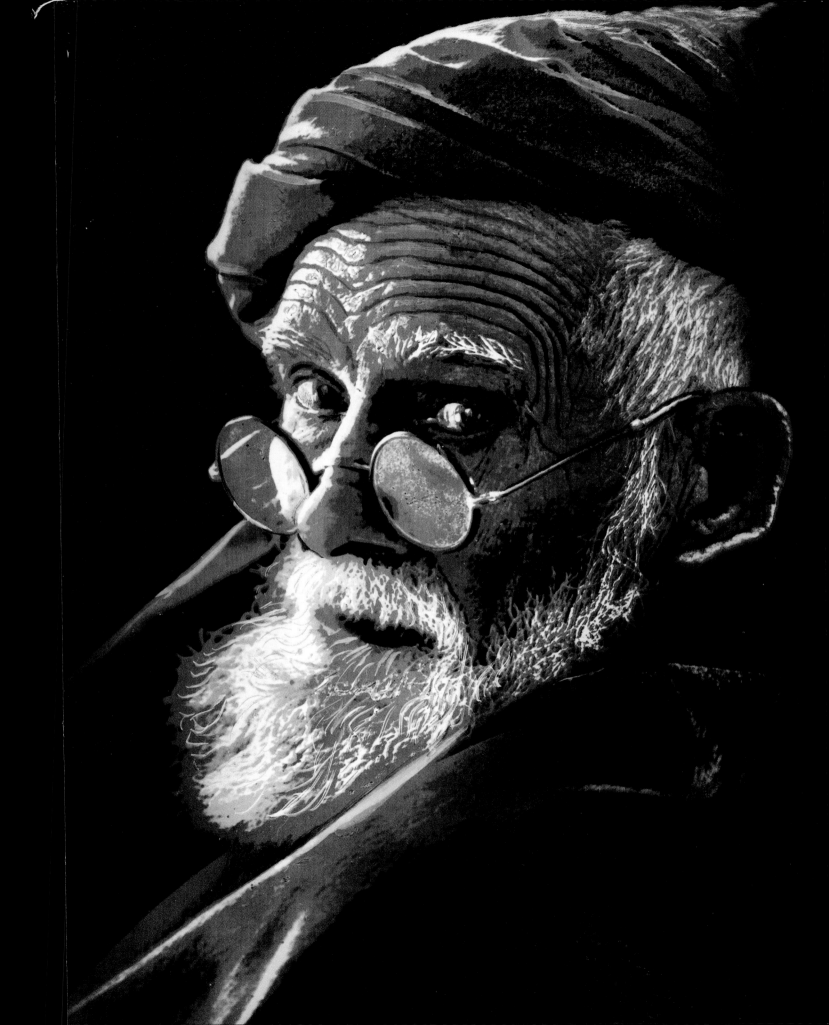

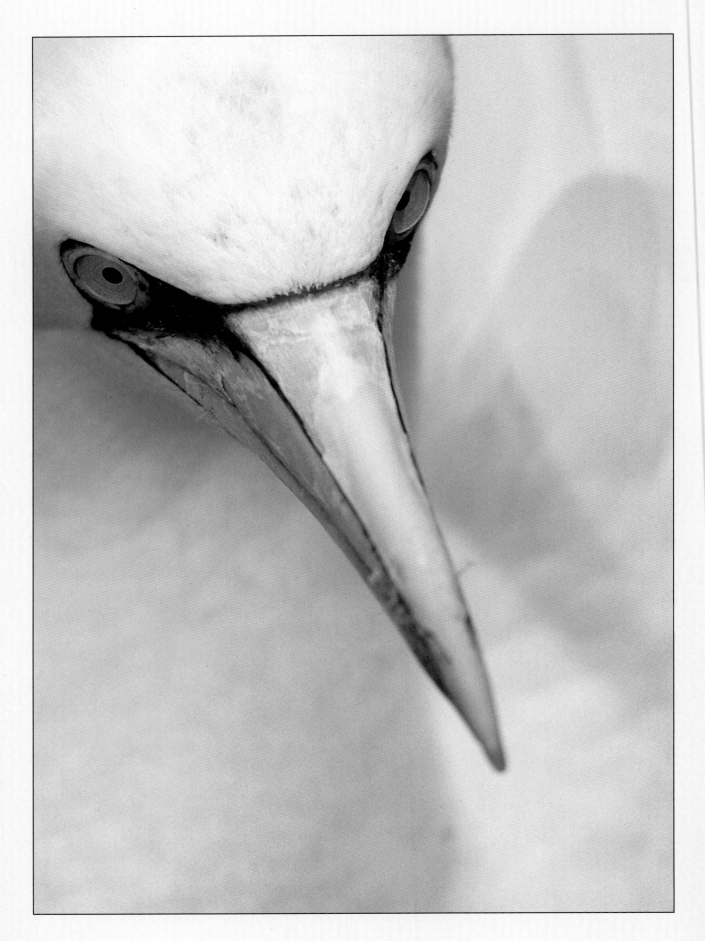

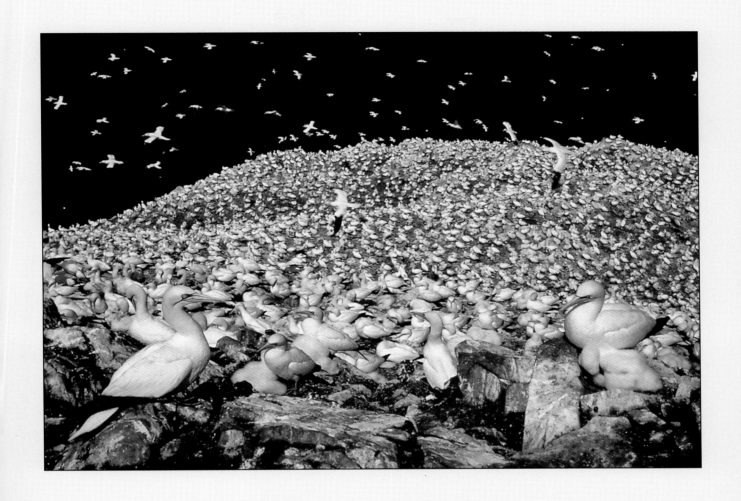

Roger Reynolds
UNITED KINGDOM

Riccardo Busi
ITALY

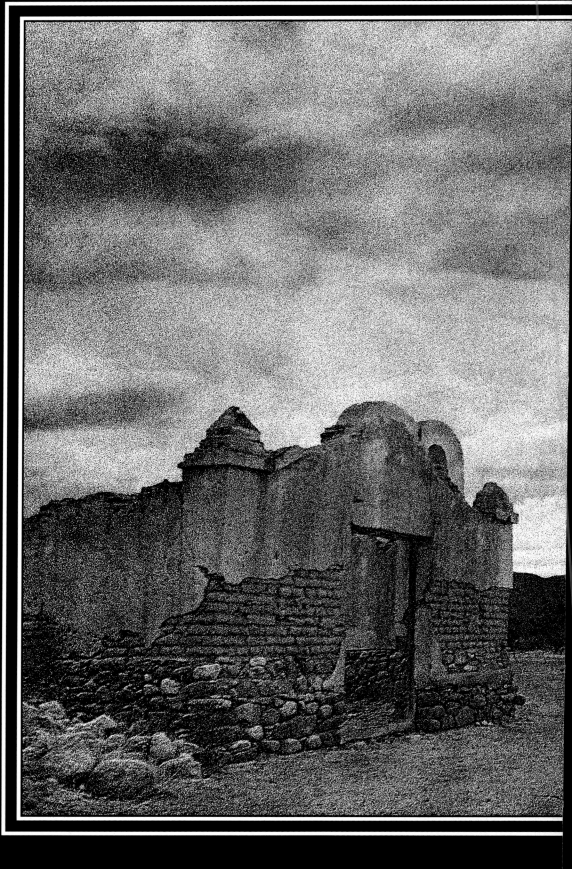

Jorge H. Mónaco
ARGENTINA

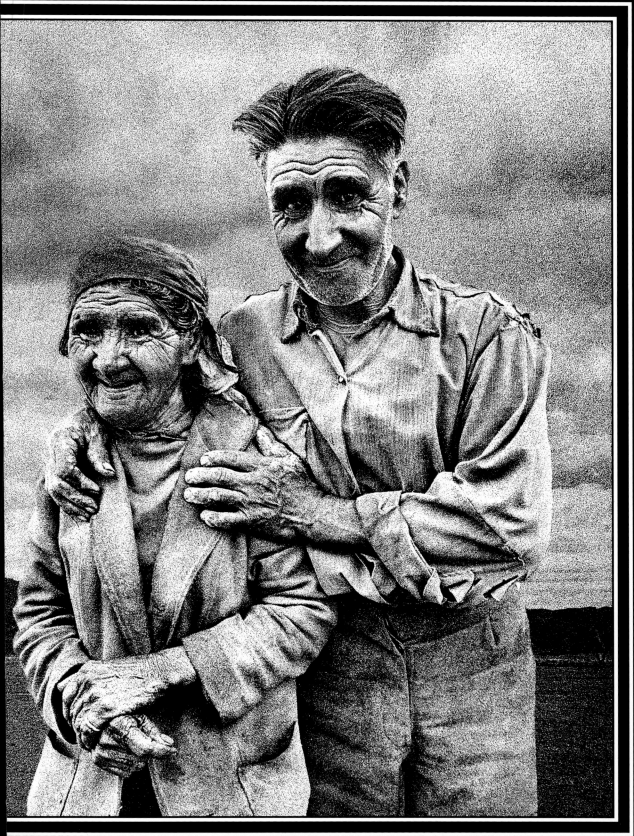

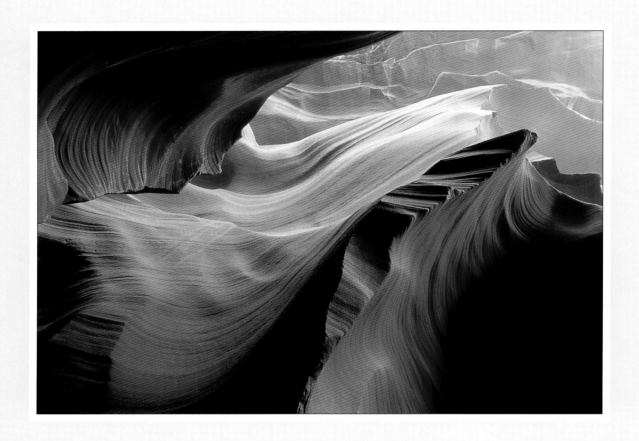

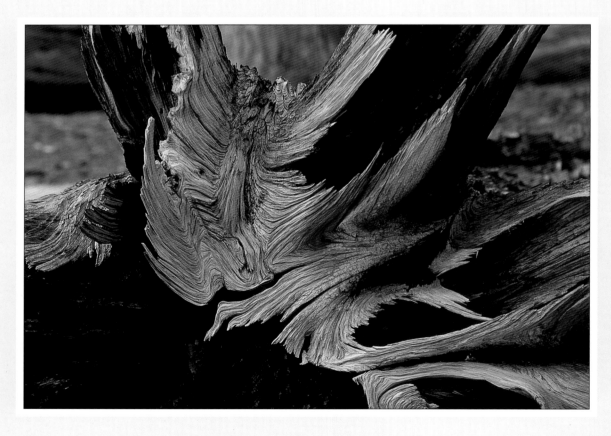

Ines Labunski Roberts

UNITED STATES

108

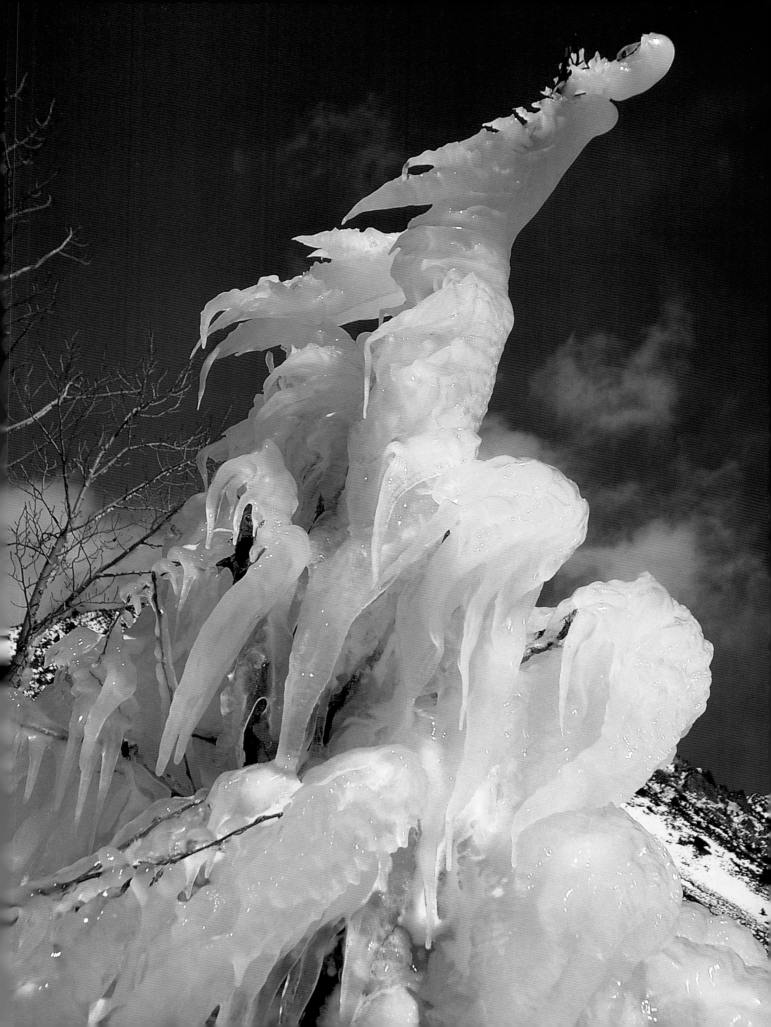

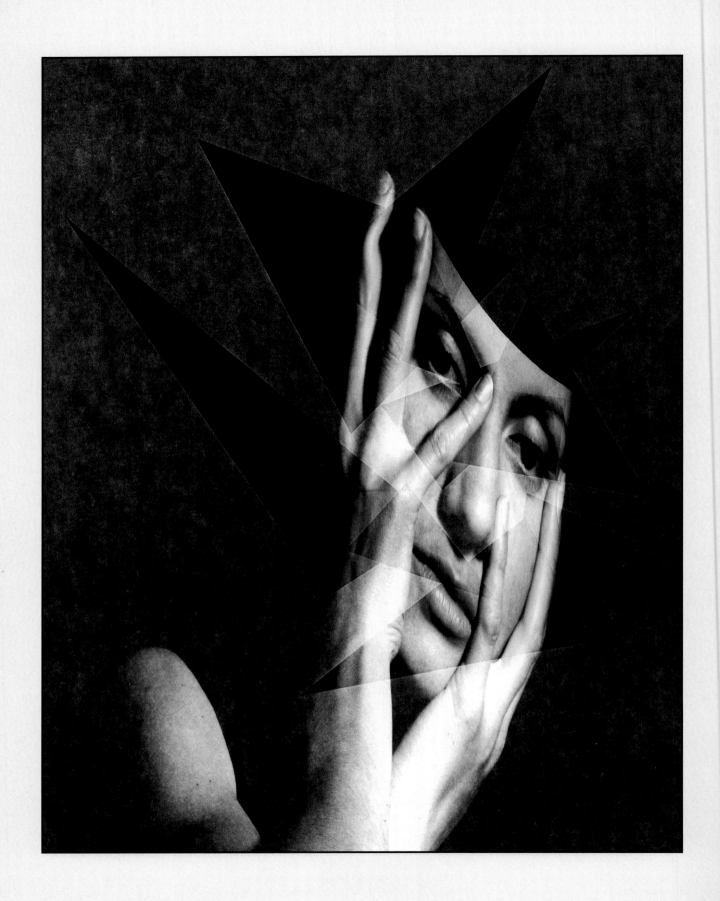

Franco Donaggio
ITALY

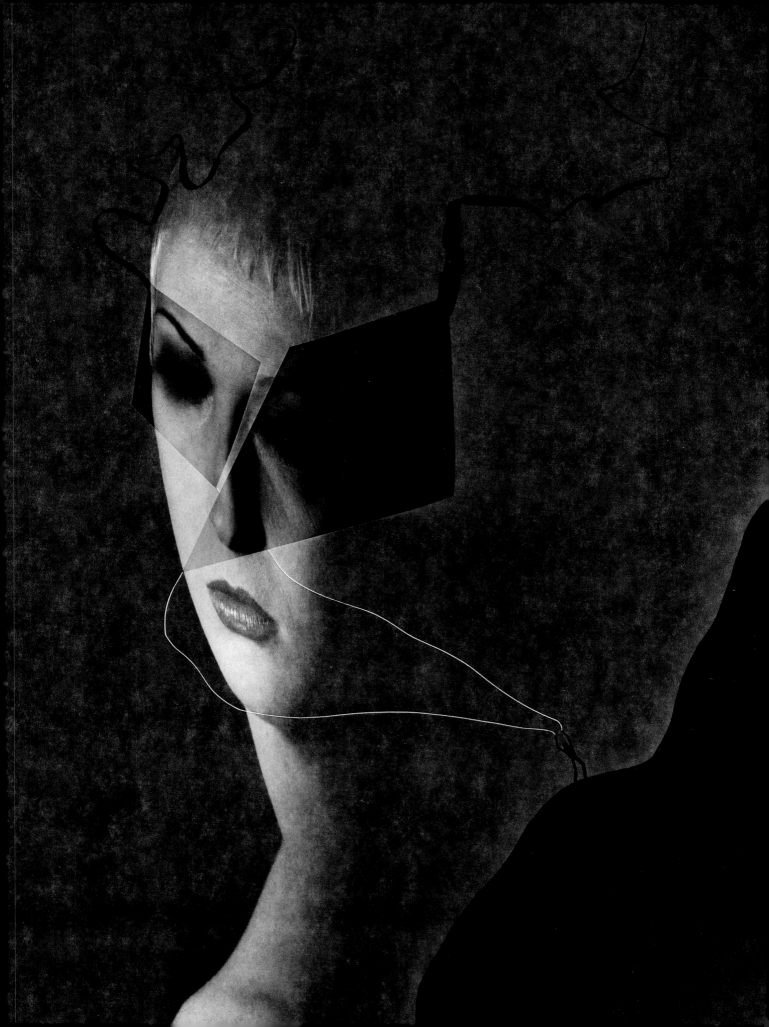

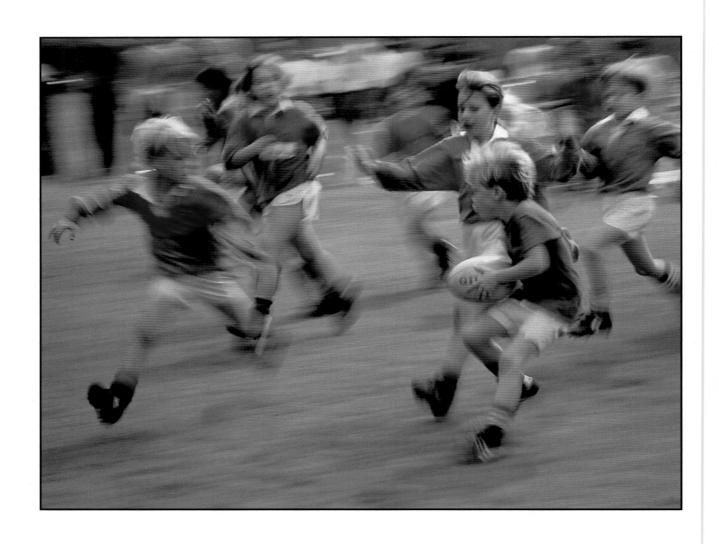

Chung Yin Lam
HONG KONG

Sergej Pozharskij
UKRAINE

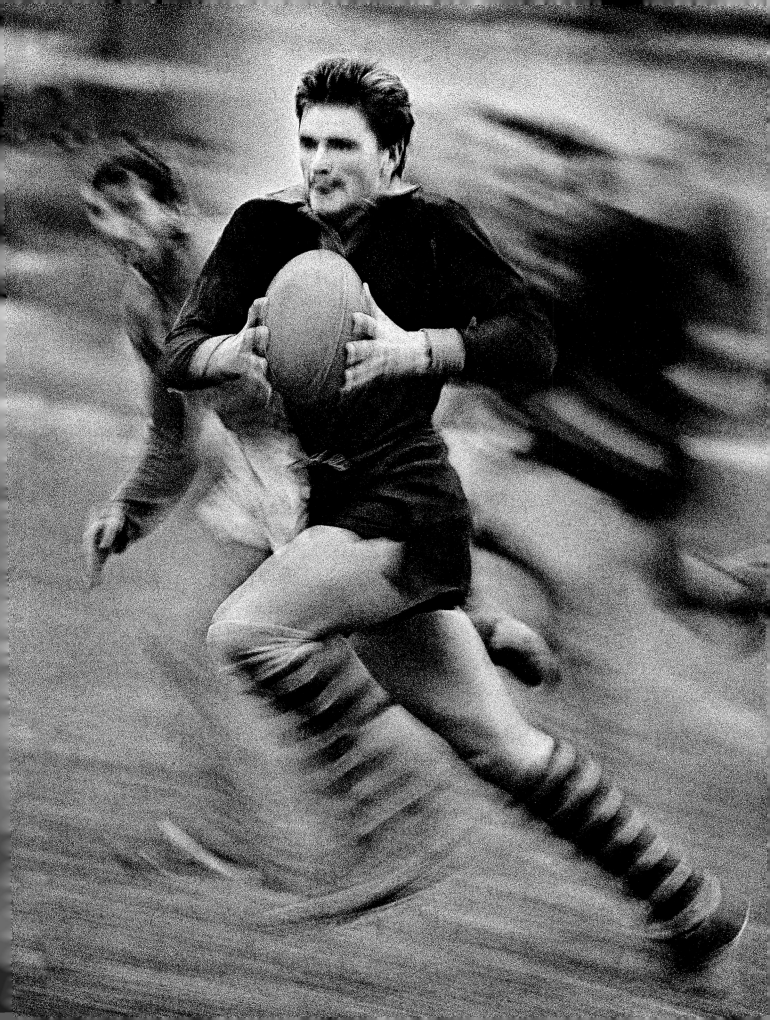

Michael Webber

GERMANY

114

Jürgen Gottschick
GERMANY

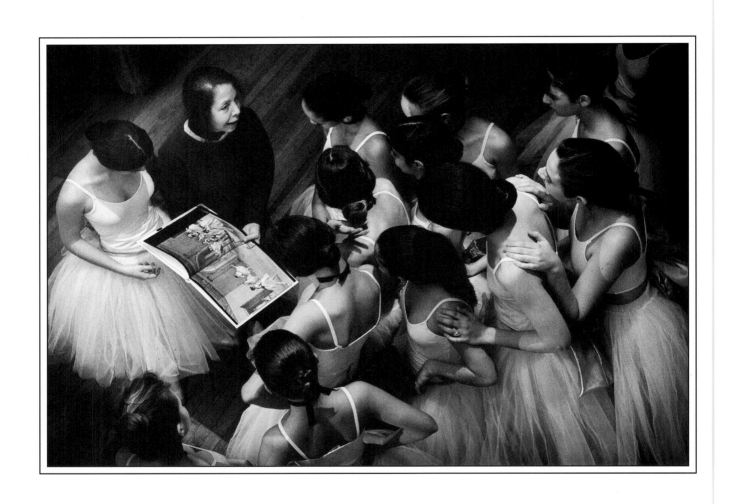

Jean-Michel Leverne
FRANCE

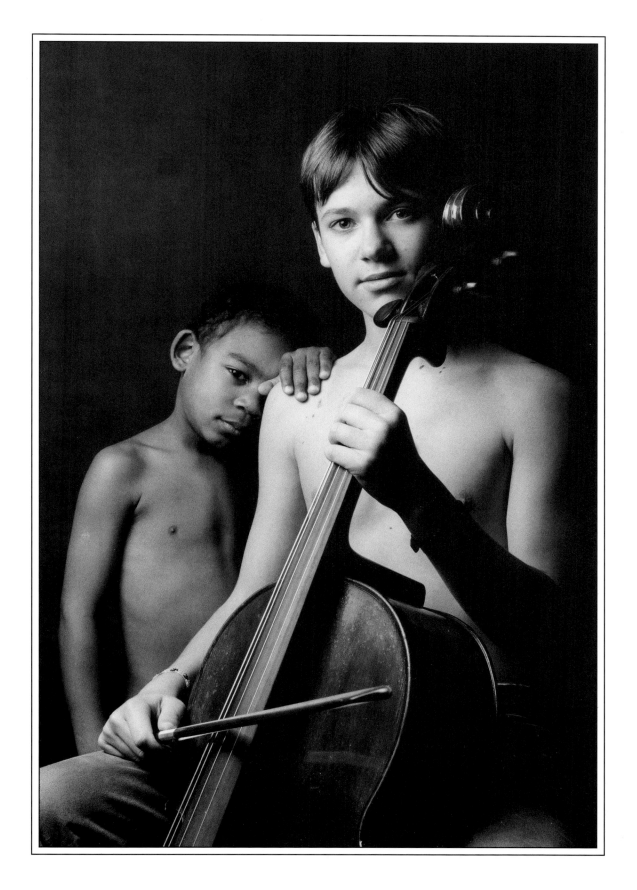

Jacques Jourdain
FRANCE

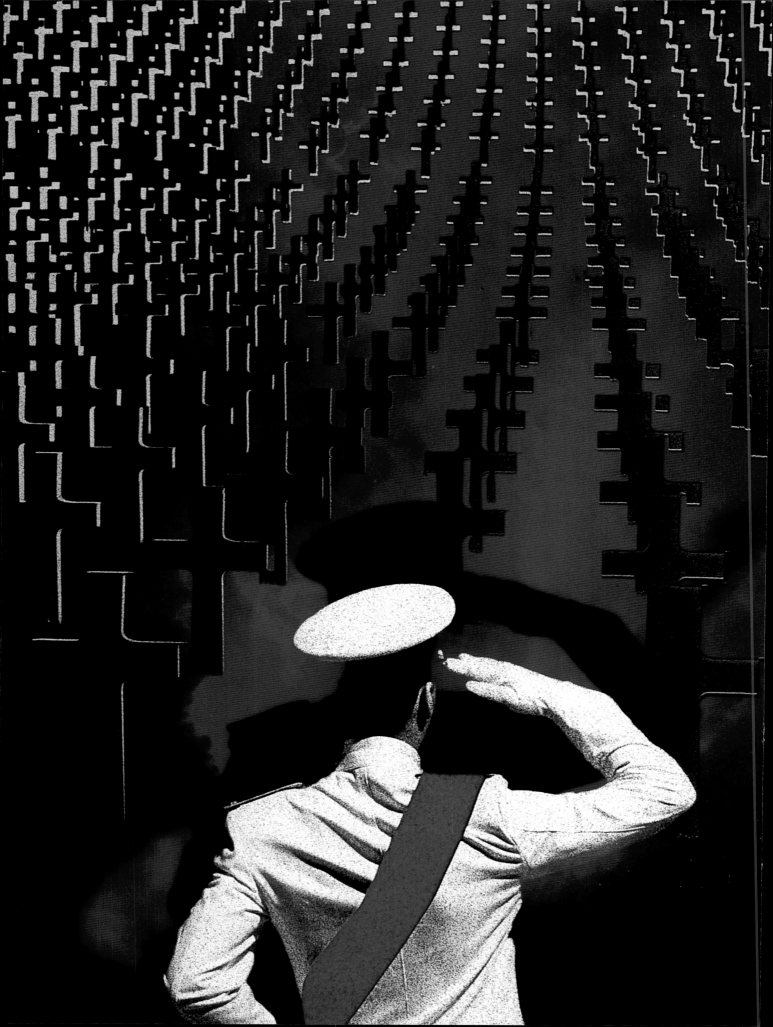

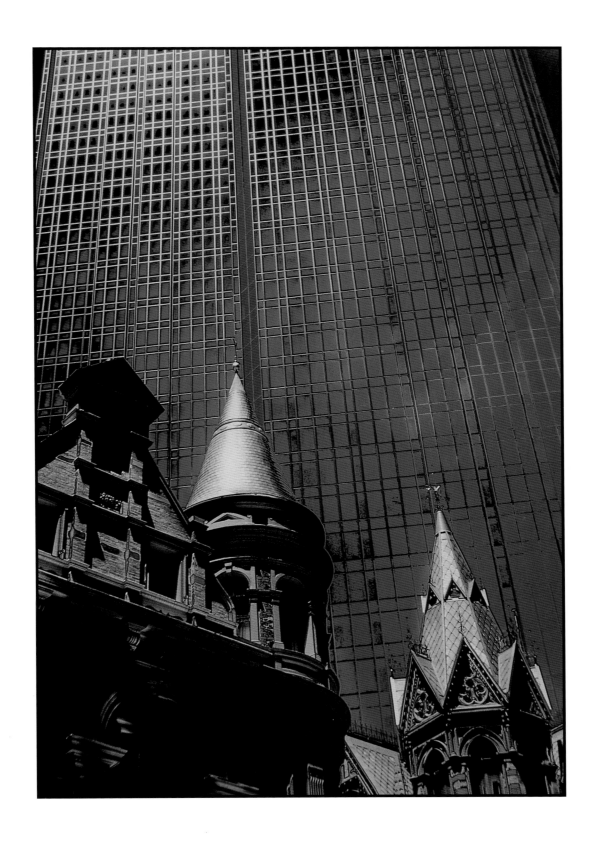

Daniele Susini
ITALY

Hans Kawitzki
AUSTRALIA

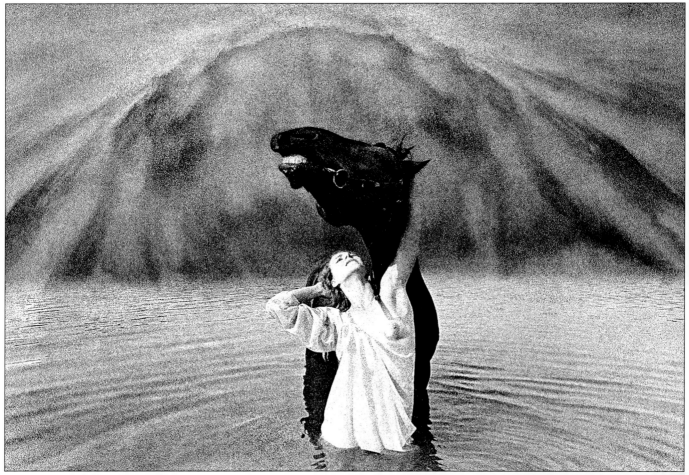

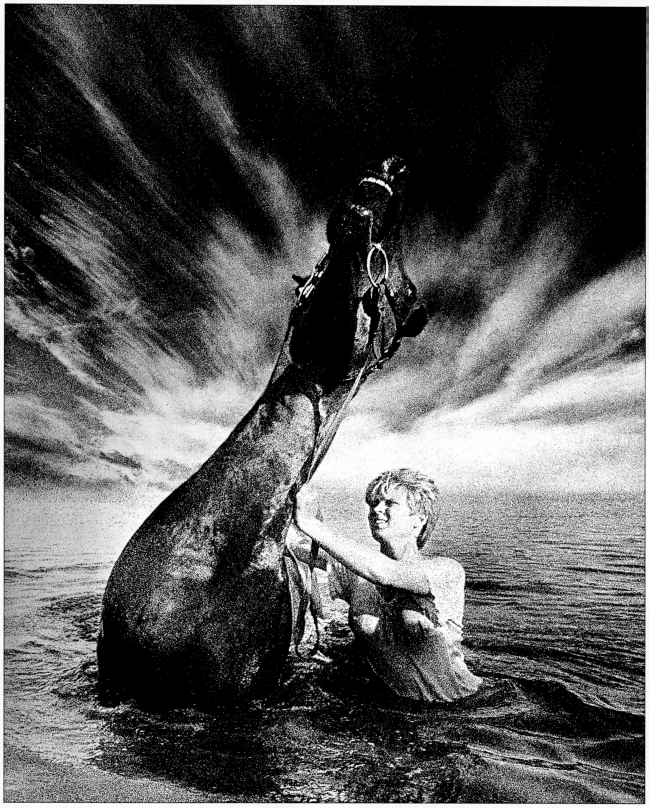

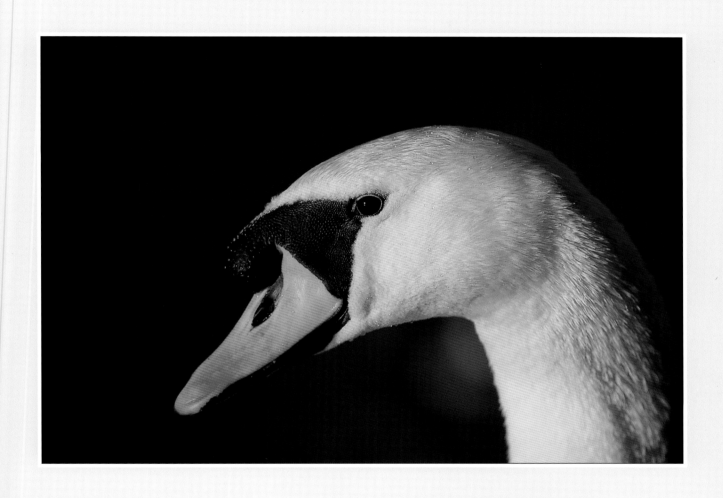

Andy Rouse
UNITED KINGDOM

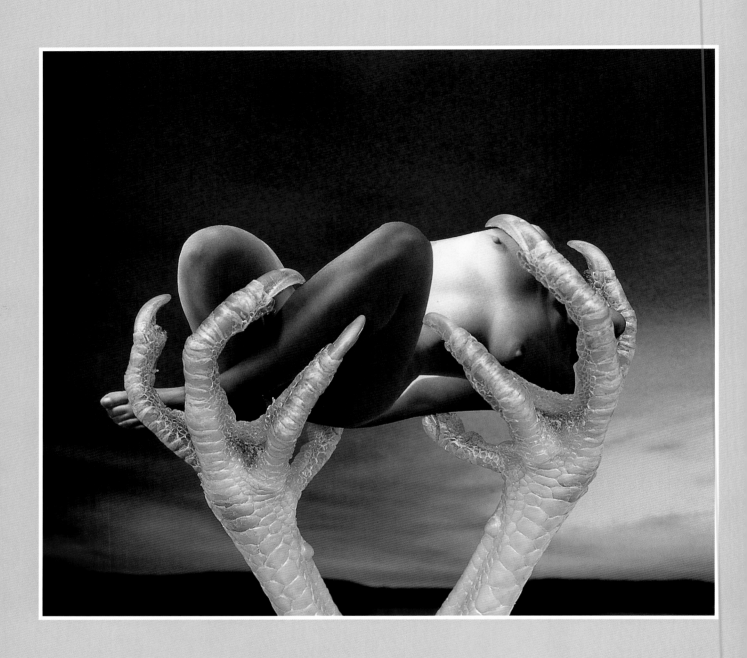

PREVIOUS PAGE
Willy Hengl
AUSTRIA

Edmund Steigerwald
GERMANY

126

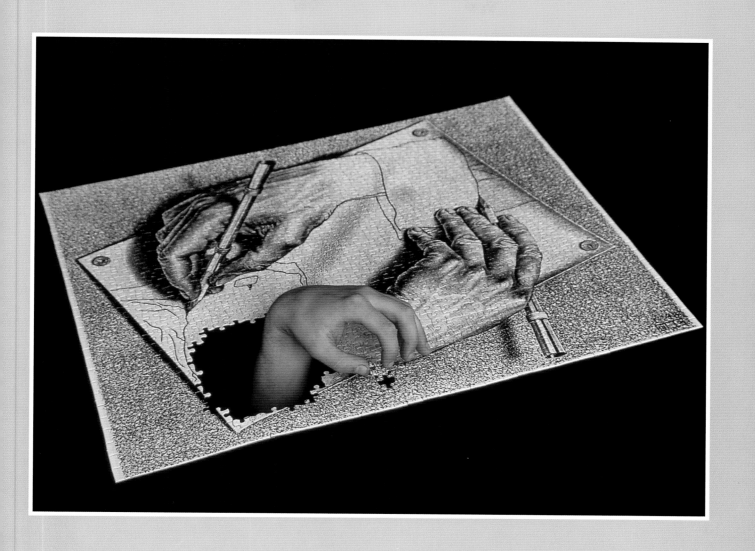

Guilio Montini

ITALY

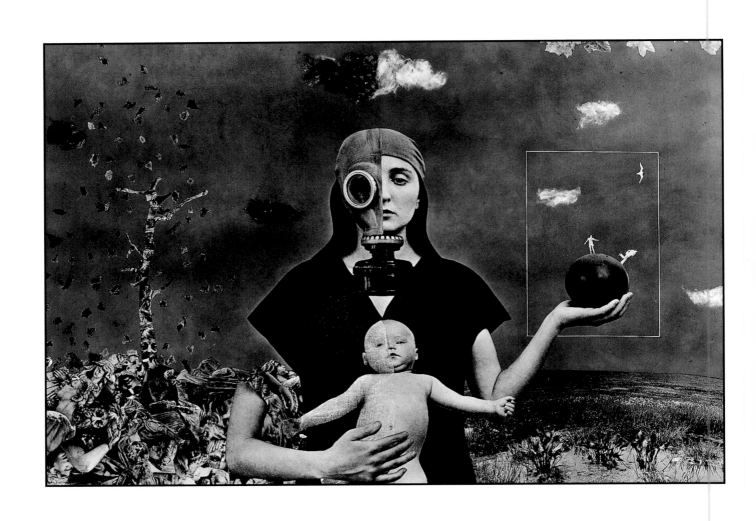

Evgeny Pavlov
UKRAINE

Delvin Stonehill
UNITED KINGDOM

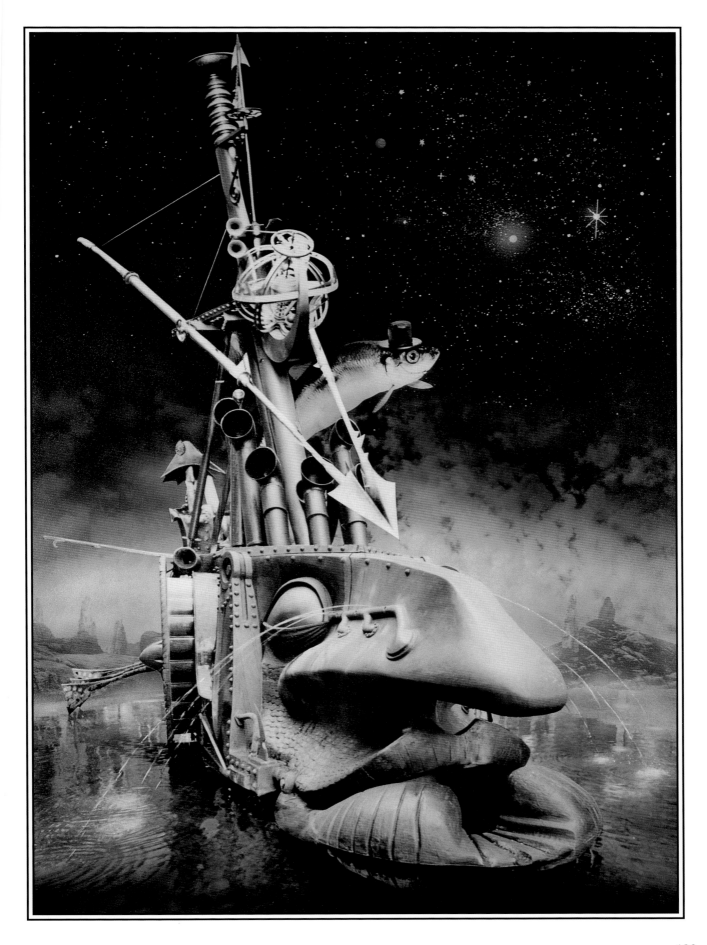

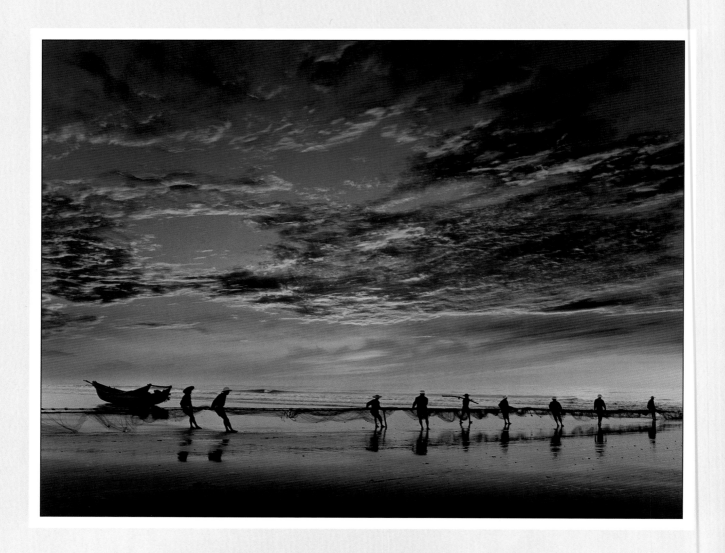

Man Kuen Ng
HONG KONG

Kin-Choy Wong
HONG KONG

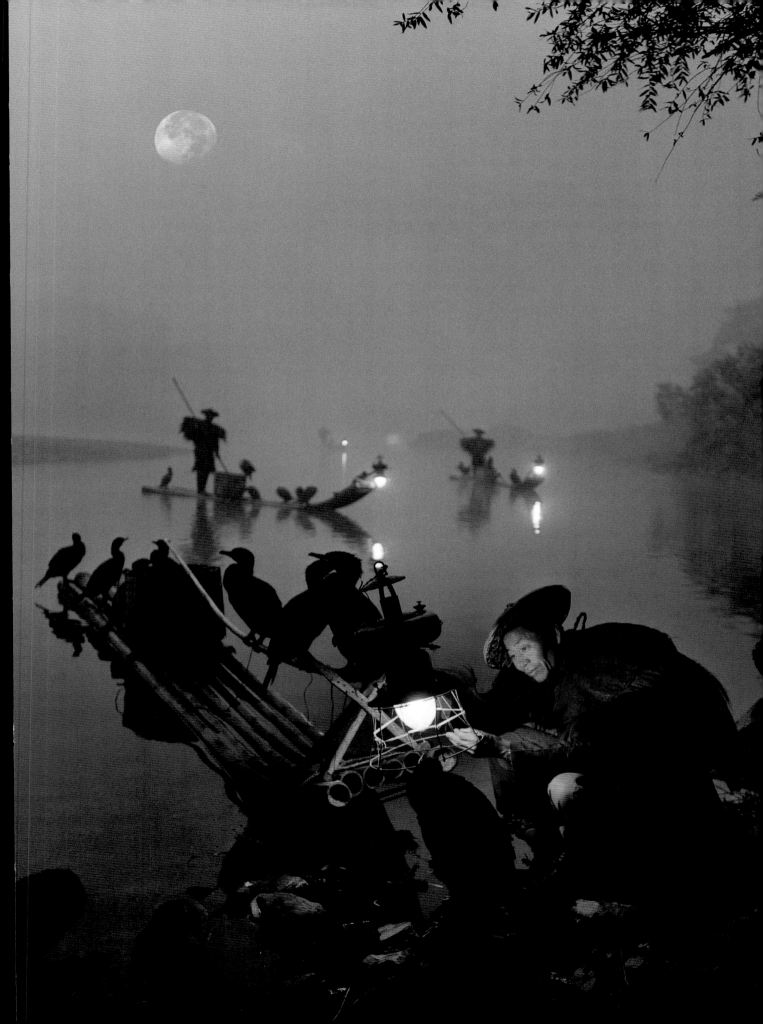

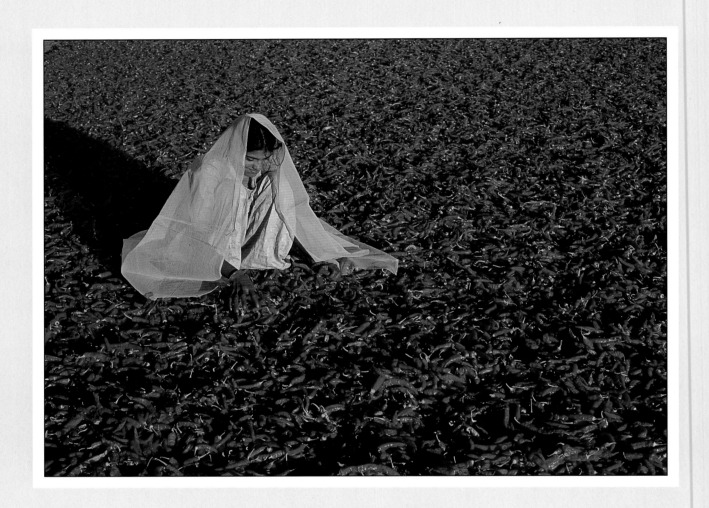

Shivji
INDIA

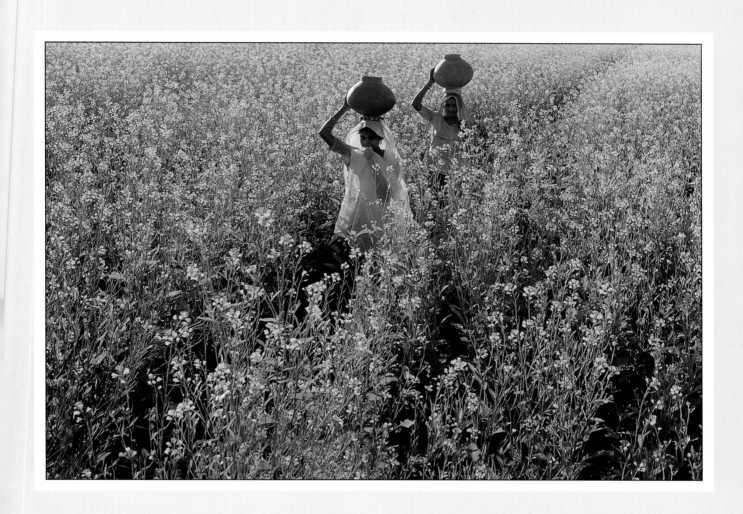

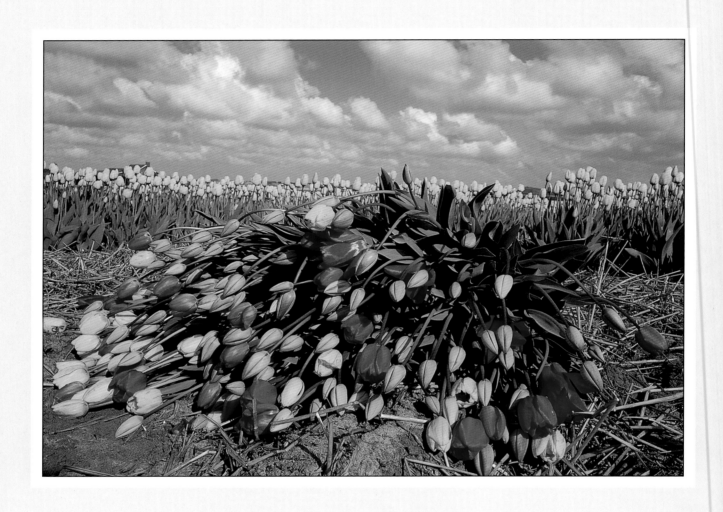

Rosemary Calvert
UNITED KINGDOM

Lennart Edvinson
UNITED STATES

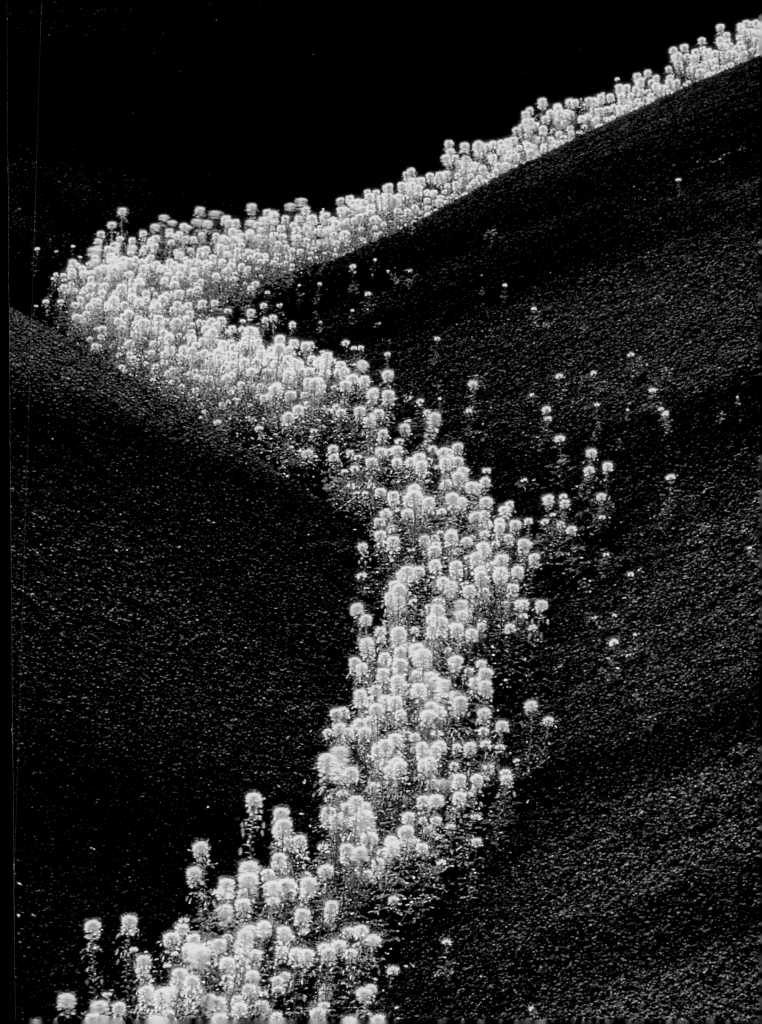

Peter Dazeley
UNITED KINGDOM

136

Roger Reynolds

UNITED KINGDOM

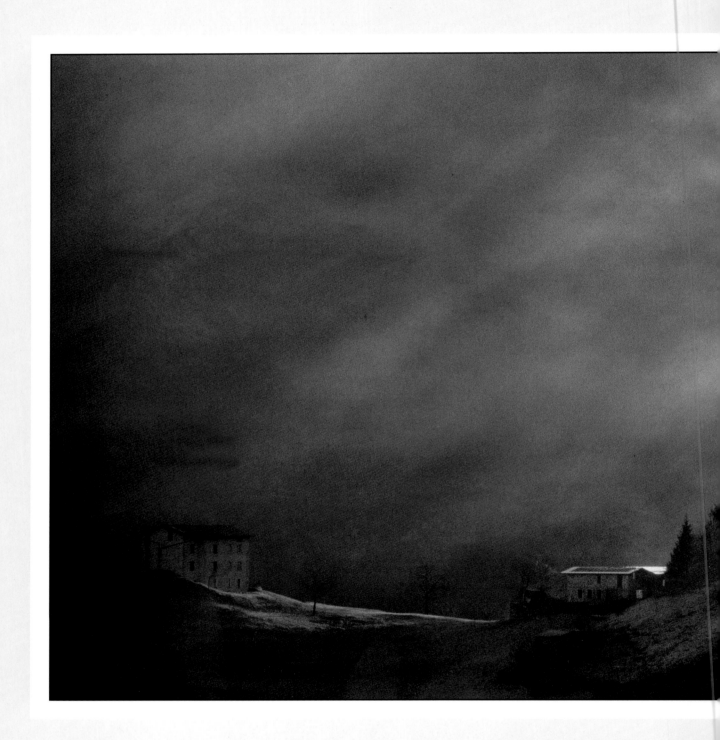

Maurizio Stacchi
ITALY

140

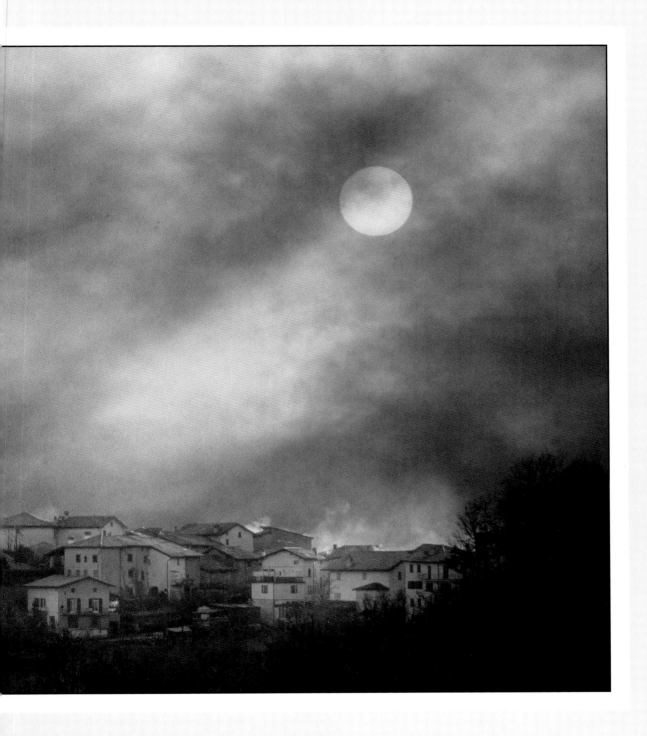

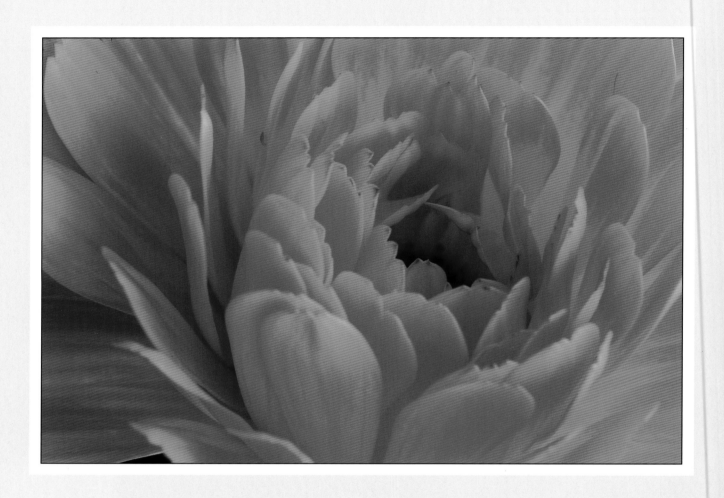

Rosemary Calvert
UNITED KINGDOM

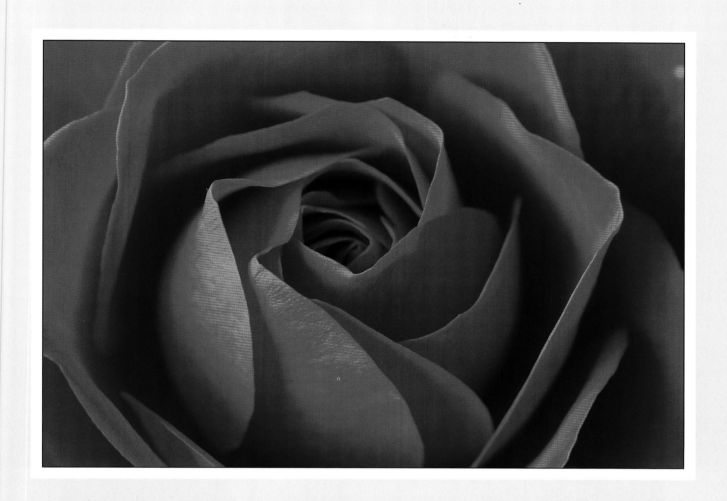

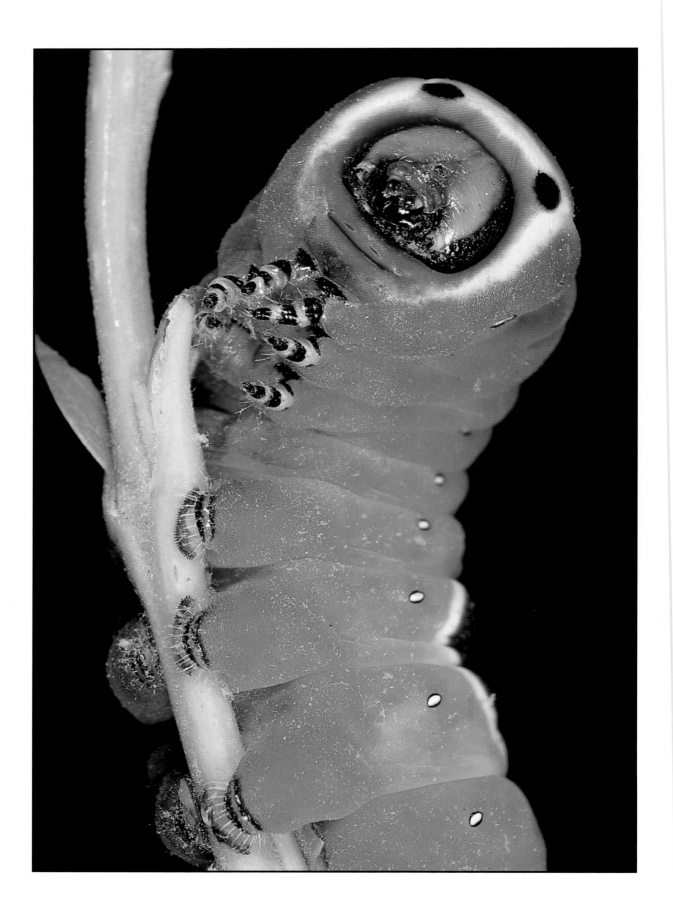

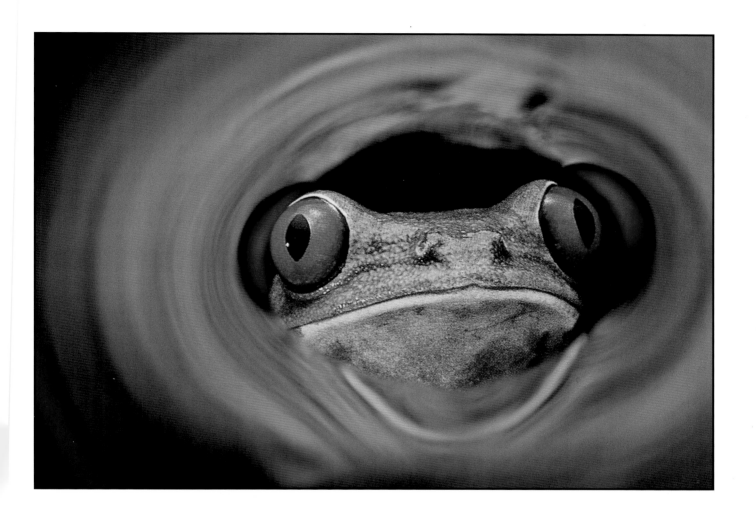

Josef Sauter
GERMANY

Lydia Snellen
CANADA

Klaus Rössner
GERMANY

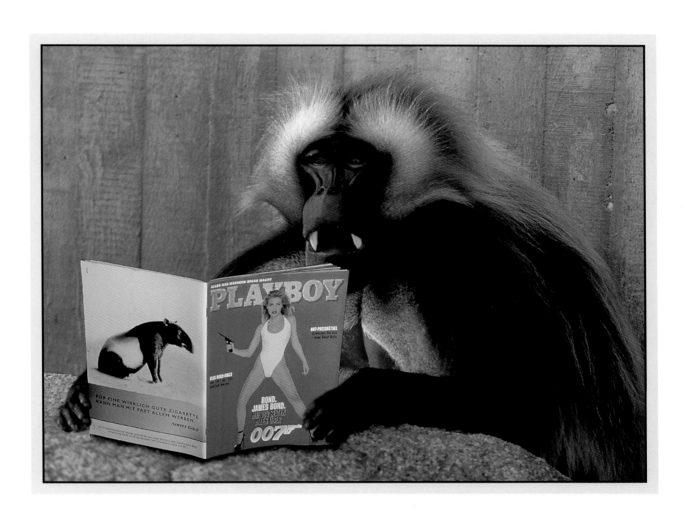

Michael Weber
GERMANY

Jane Mann
UNITED STATES

Detlef Zille
GERMANY

Frank Reuvers
SOUTH AFRICA

Michael Weber
GERMANY

151

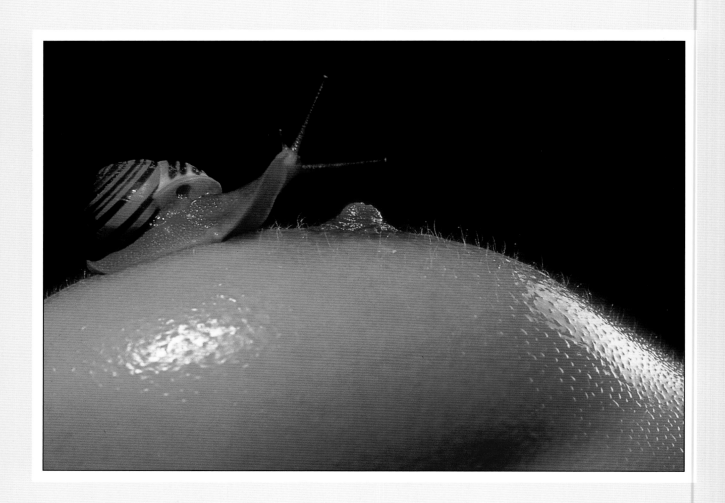

Walter Hintermaier
AUSTRIA

Manfred Zweimuller
AUSTRIA

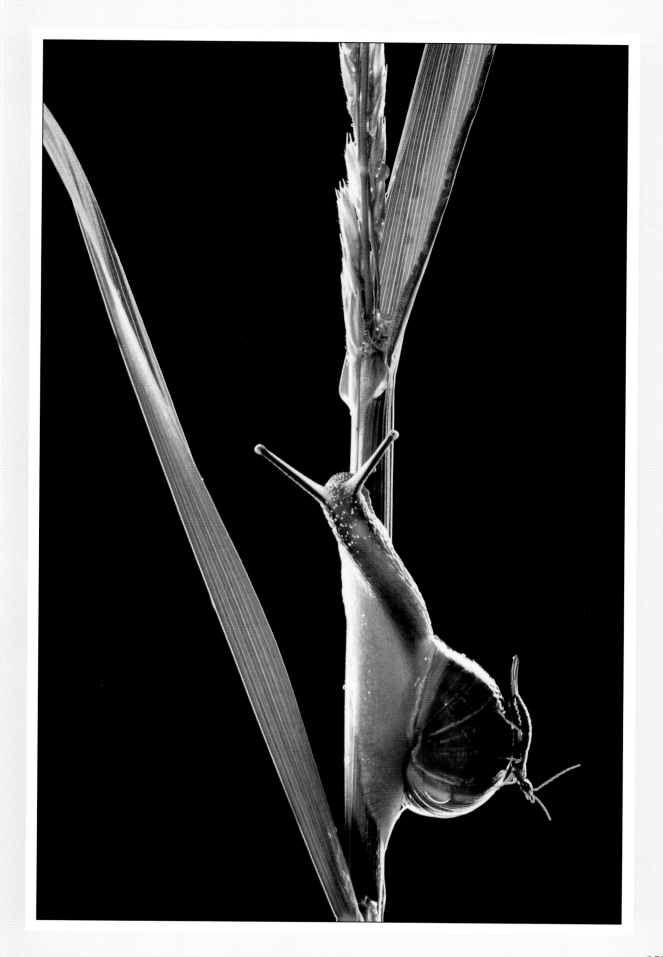

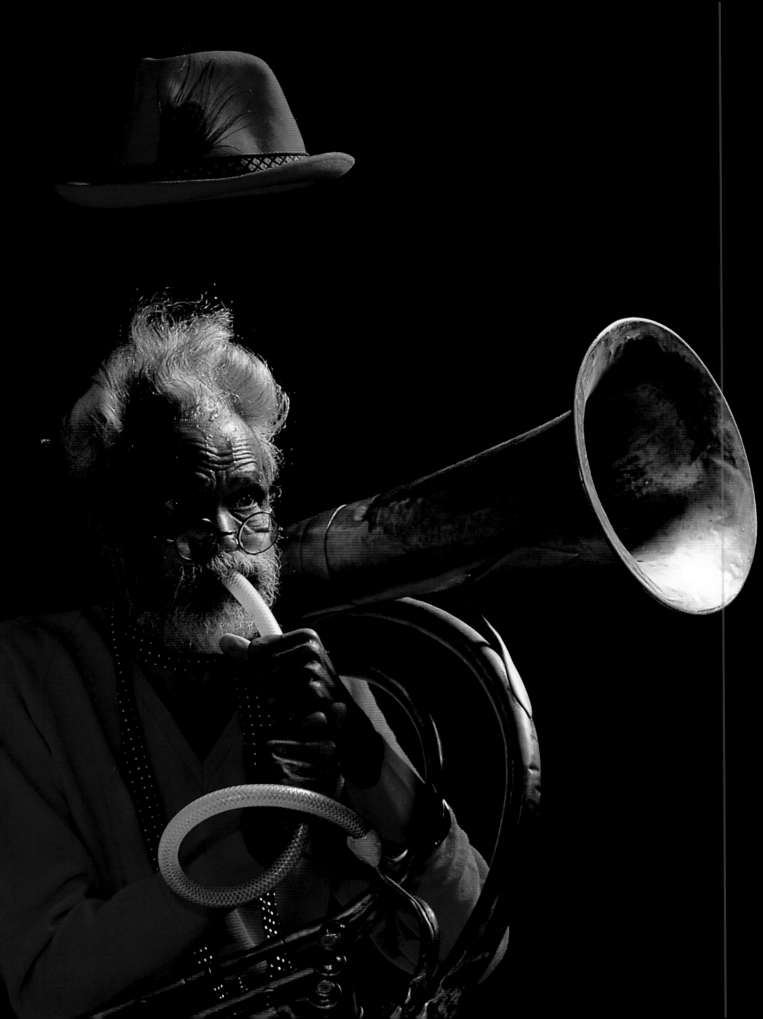

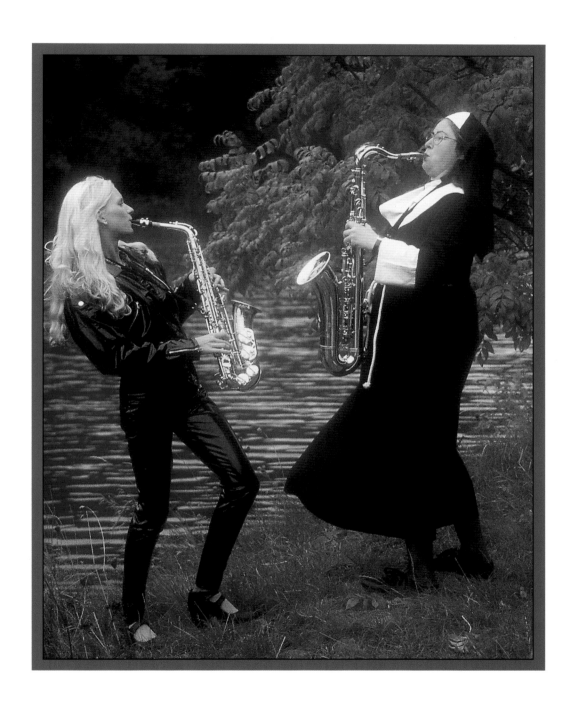

Onny Tatang
INDONESIA

Rudi Eckhardt
GERMANY

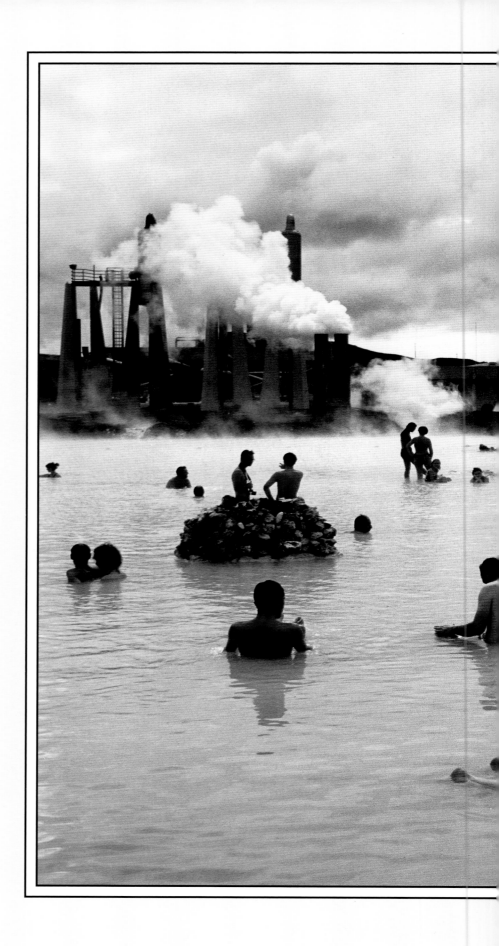

Franz Retteneger
AUSTRIA

156

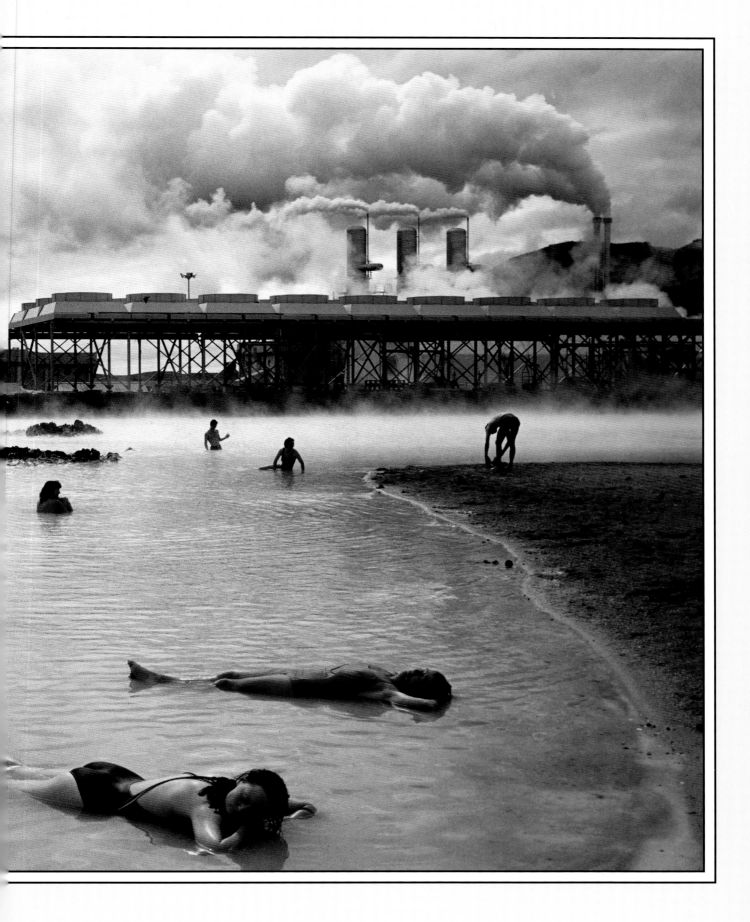

Bernd Amesreiter
GERMANY

Erik Jorgensen
DENMARK

Per Odd Svenberg
NORWAY

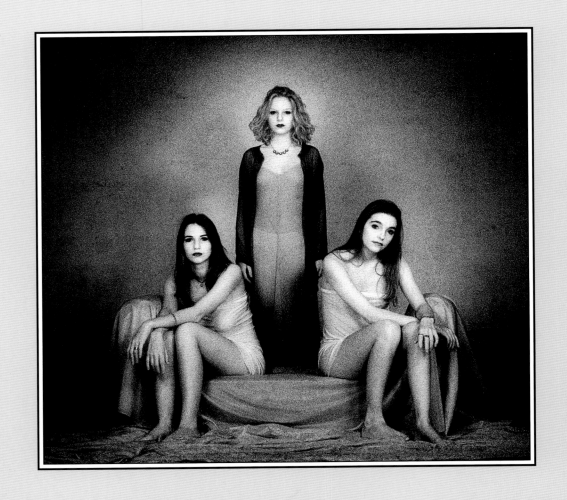

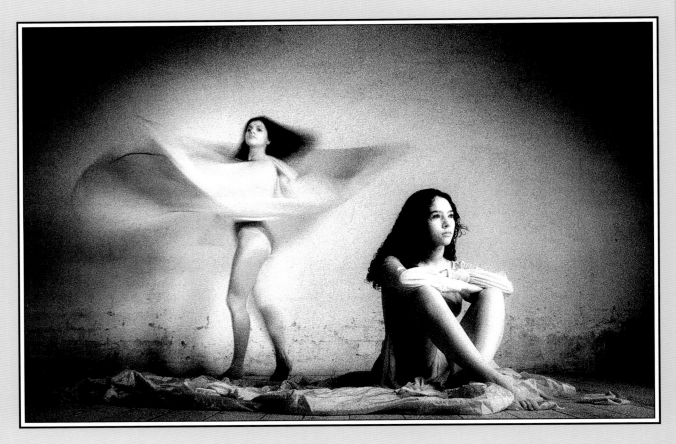

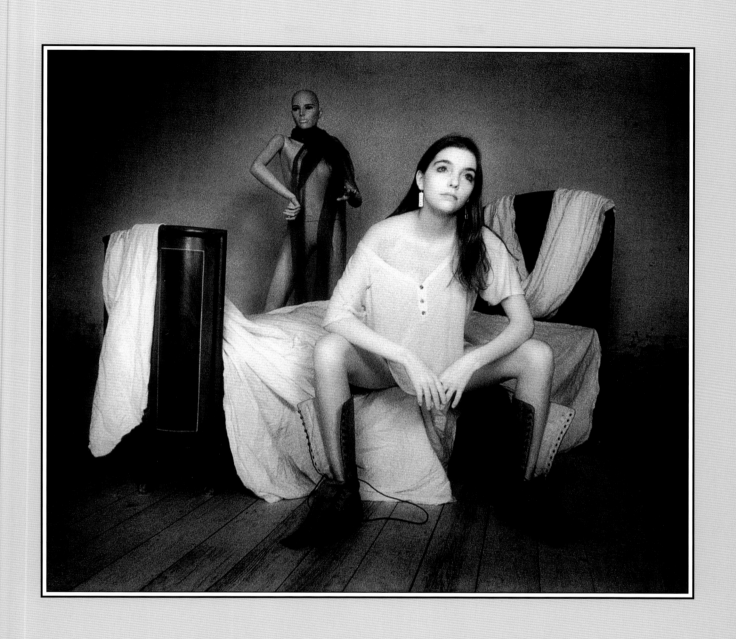

Leon Heylen
BELGIUM

163

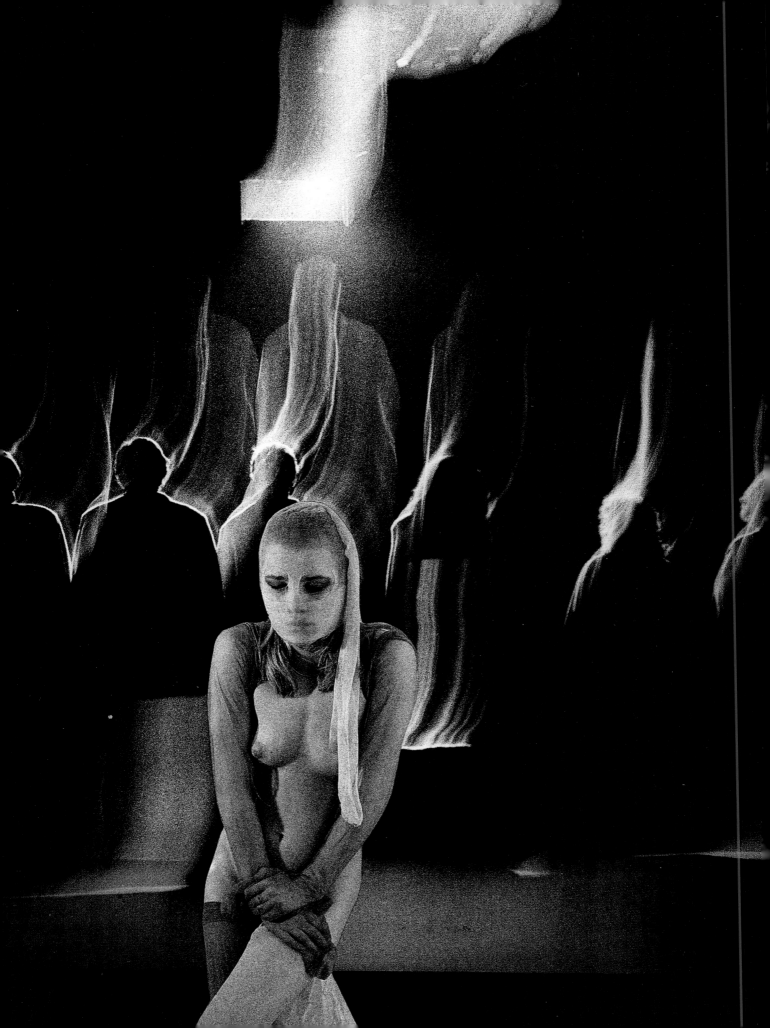

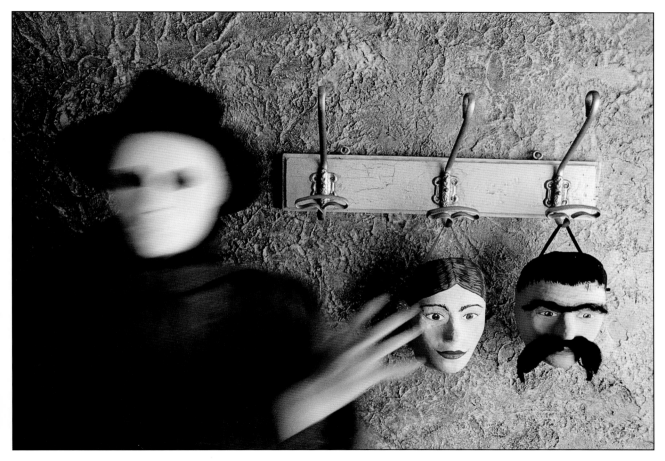

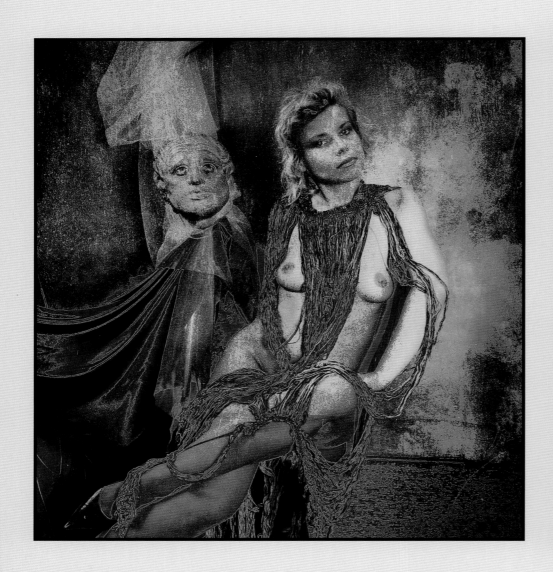

Valentin Sichinskiy
UKRAINE

166

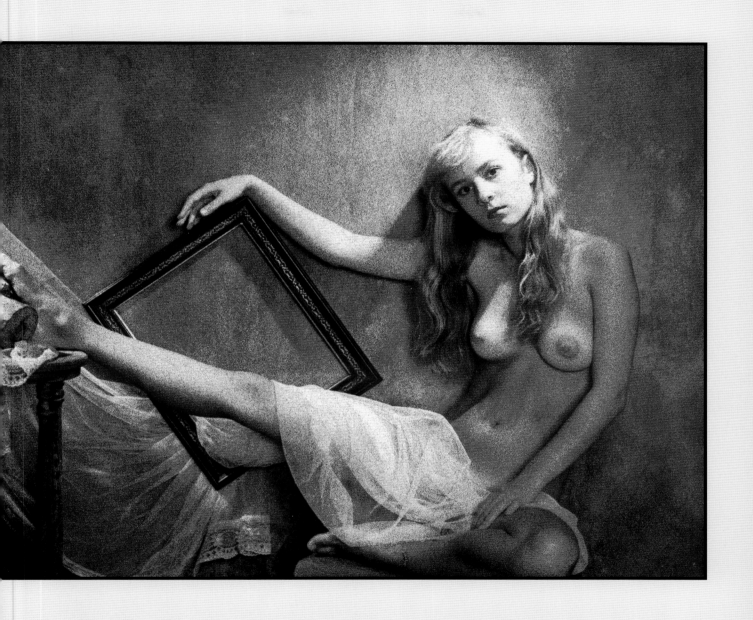

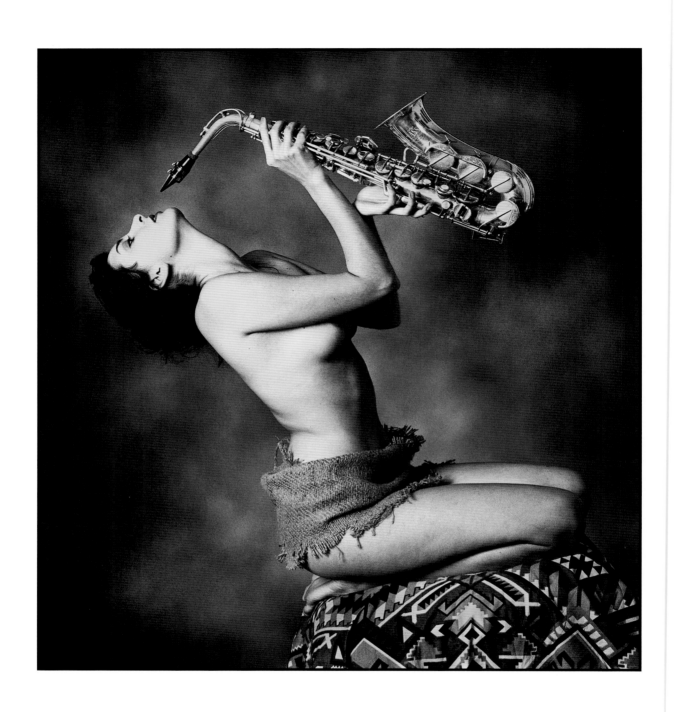

Jose Arias
SPAIN

168

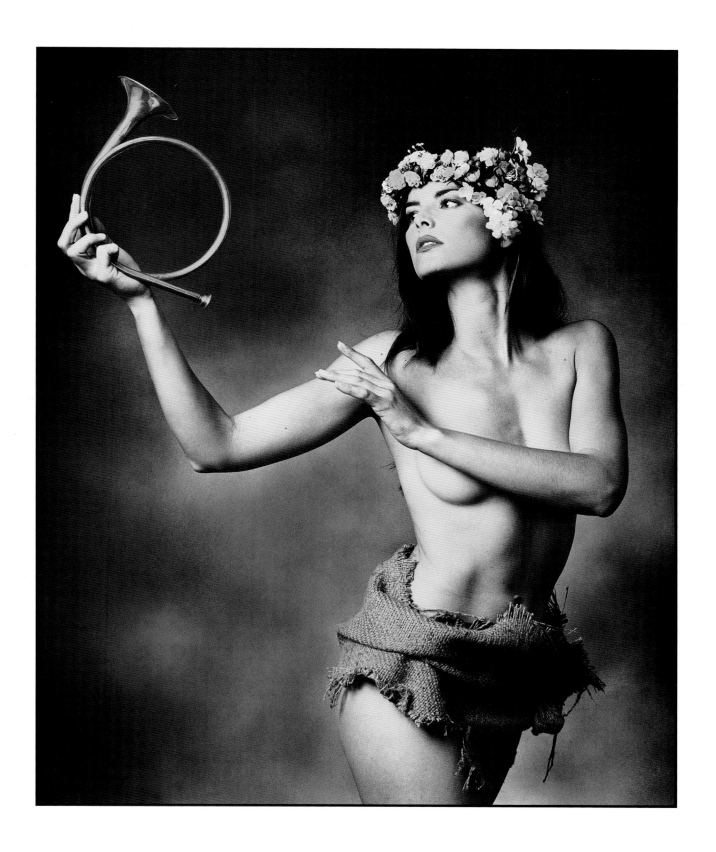

Ramon Serras
SPAIN

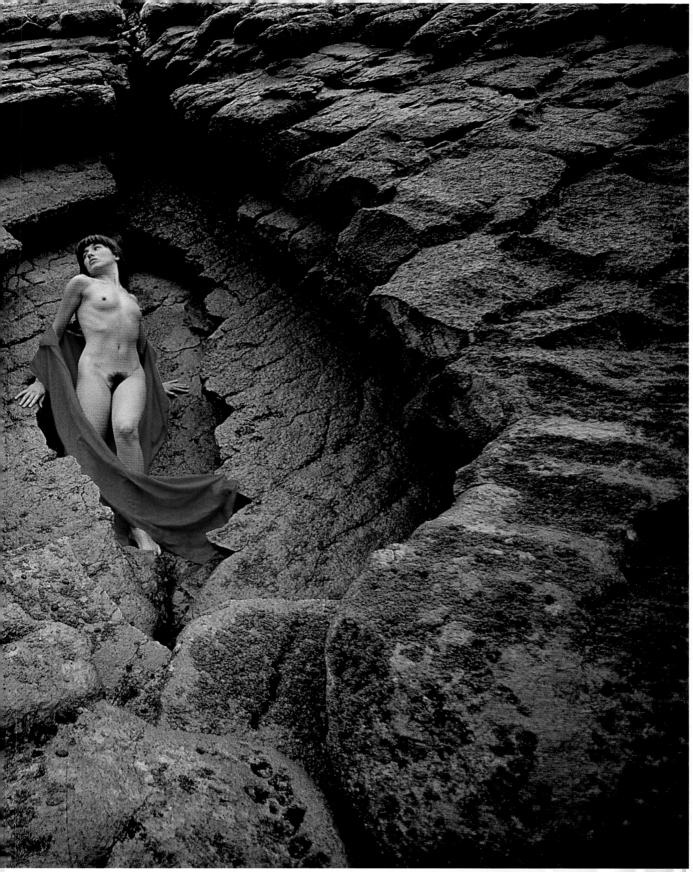

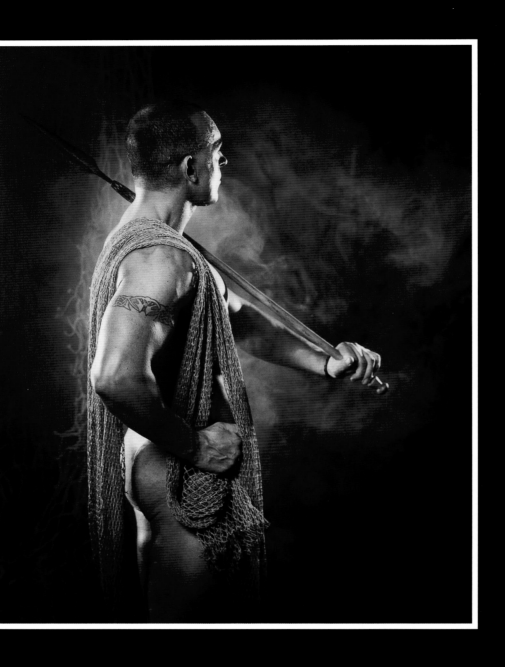

eter Trenchard

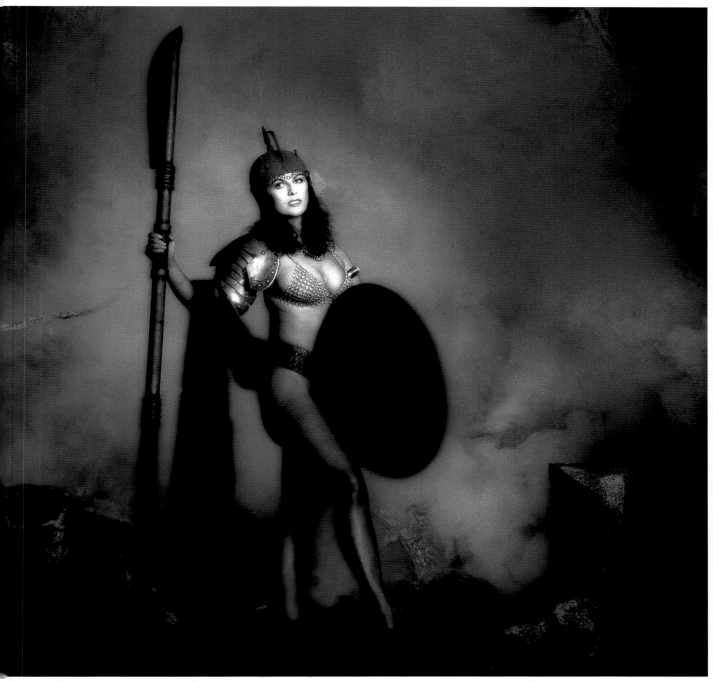

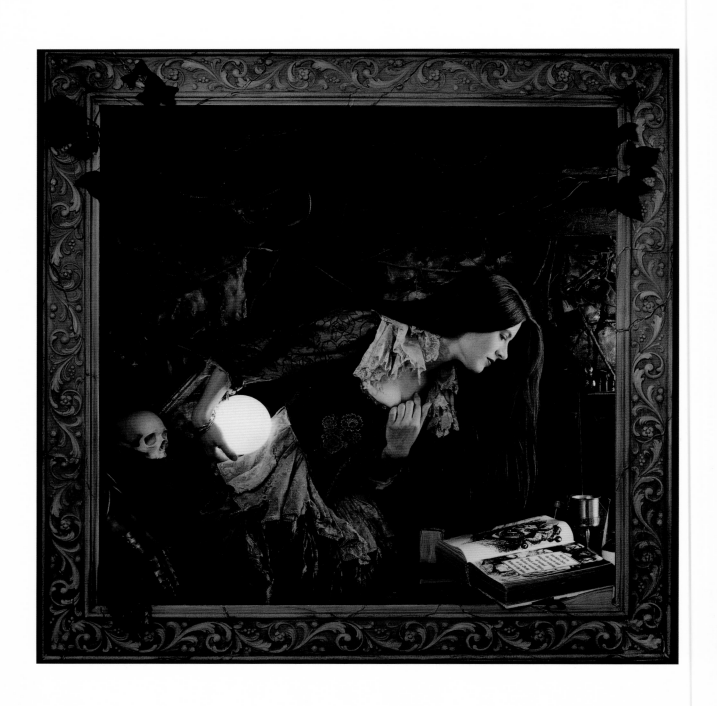

David Anthony Williams
AUSTRALIA

Anita Nutter
UNITED KINGDOM

174

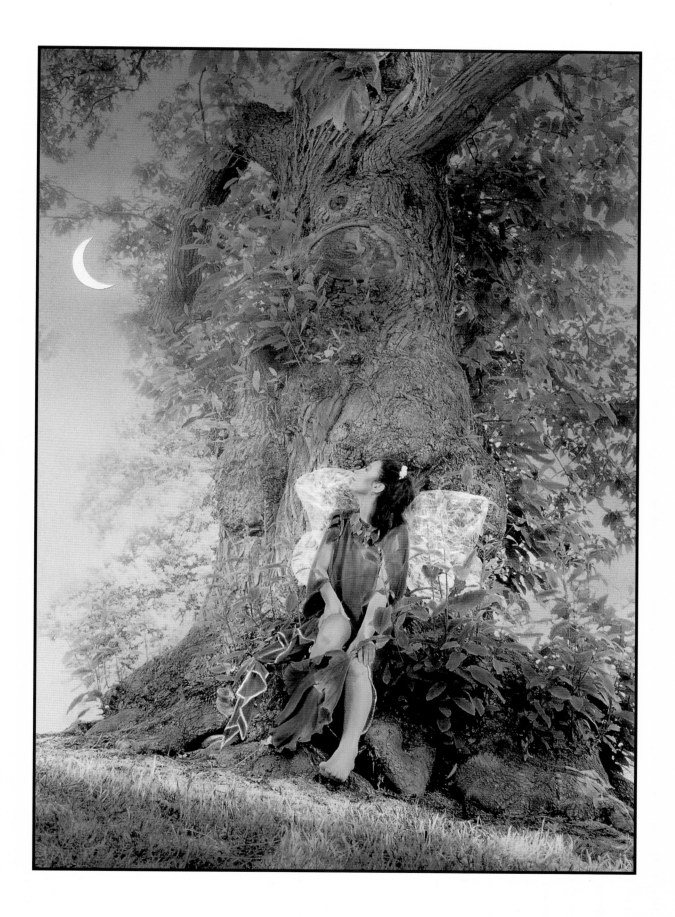

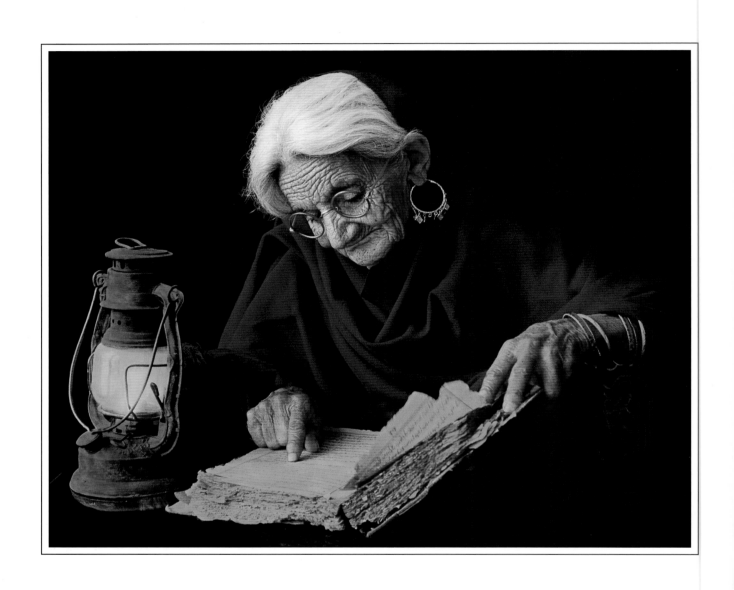

Sayyed Nayyer Reza
PAKISTAN

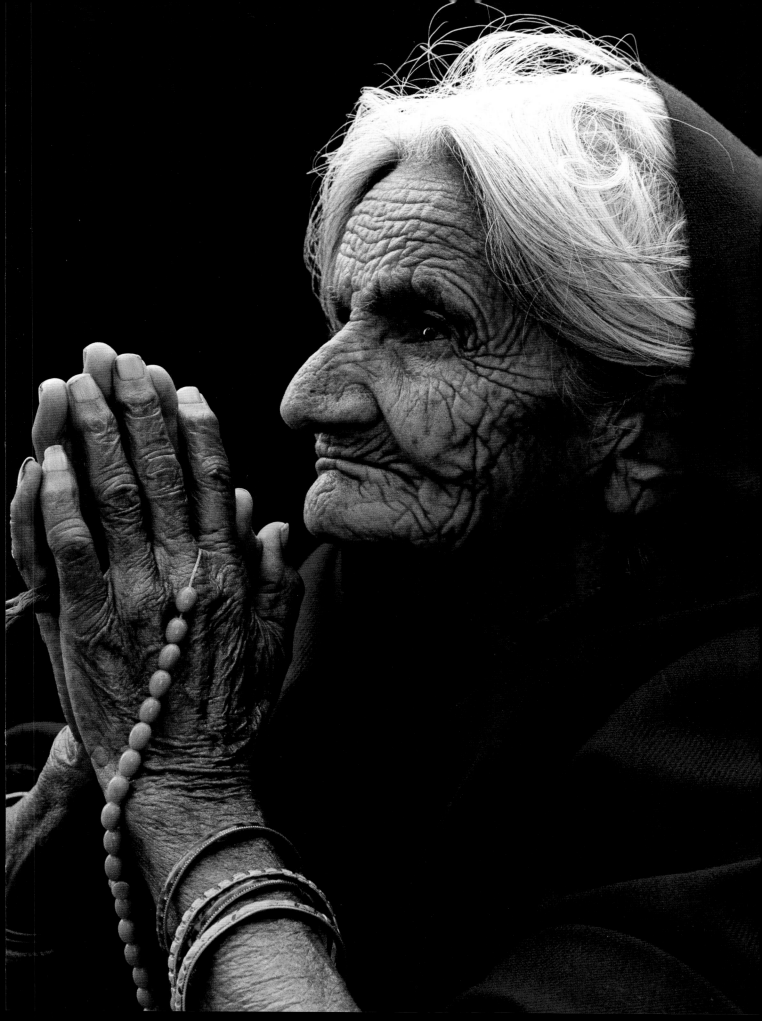

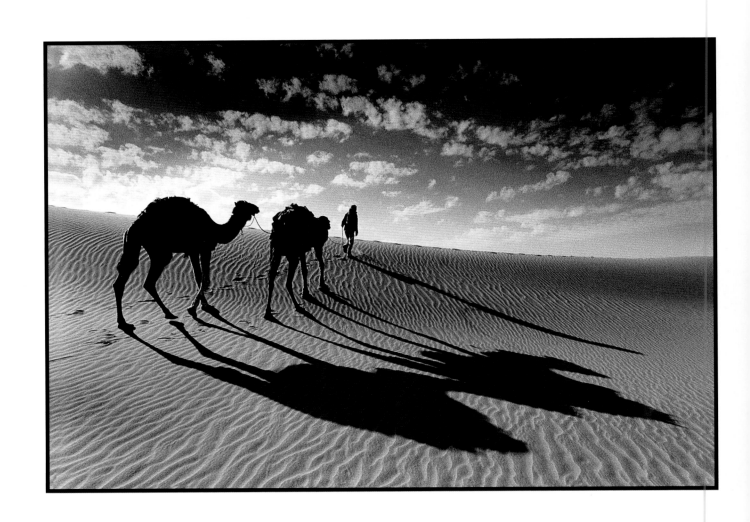

Lorne Resnick
CANADA

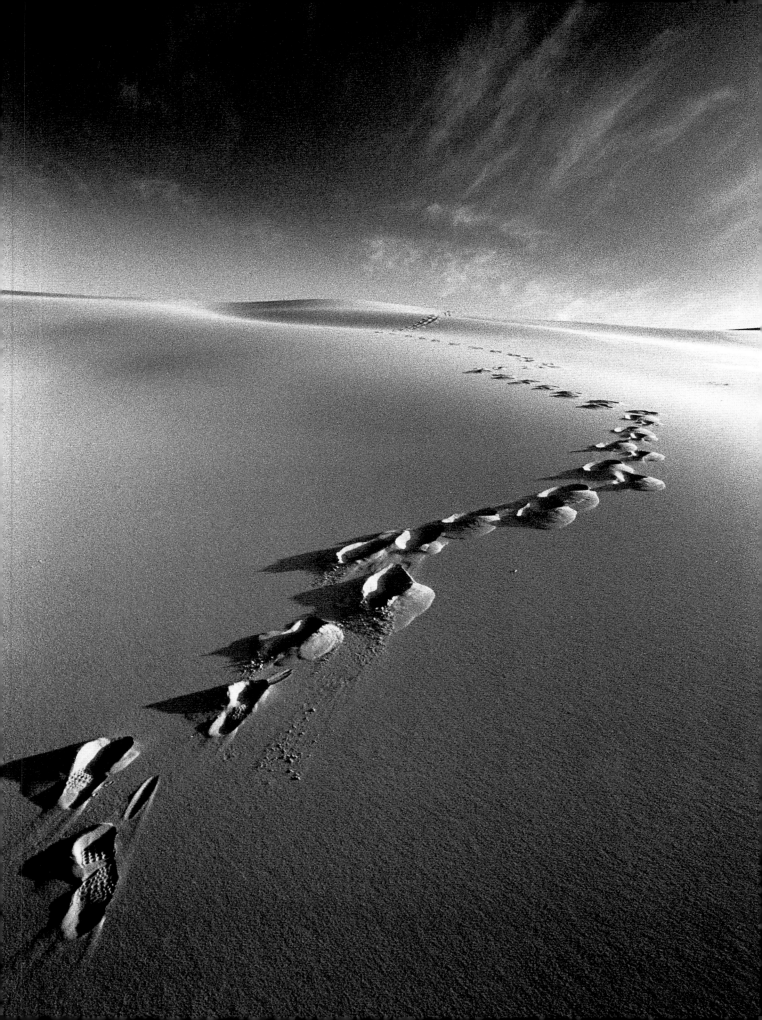

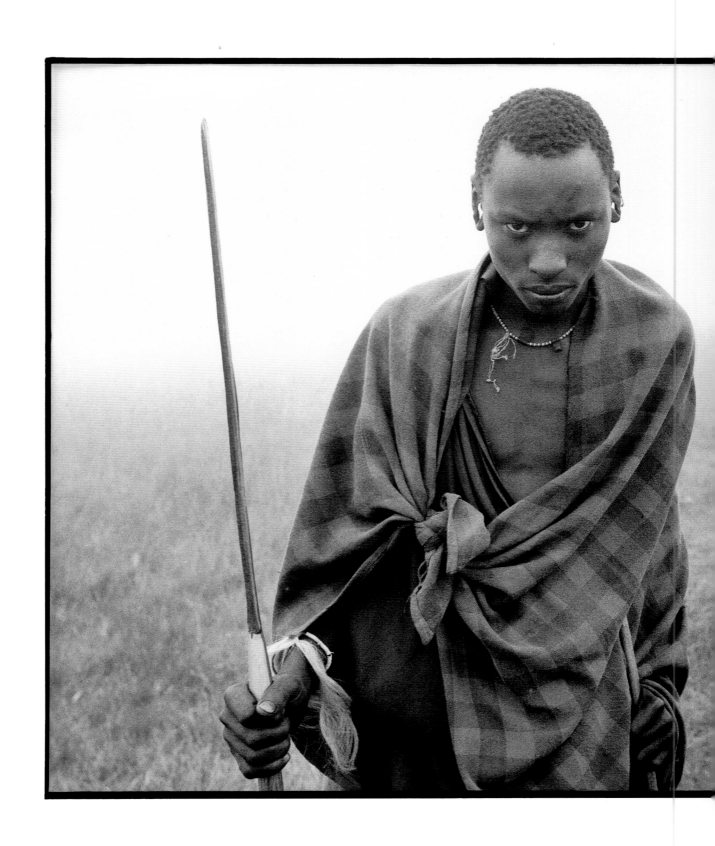

Jose Jaime Mota
SPAIN

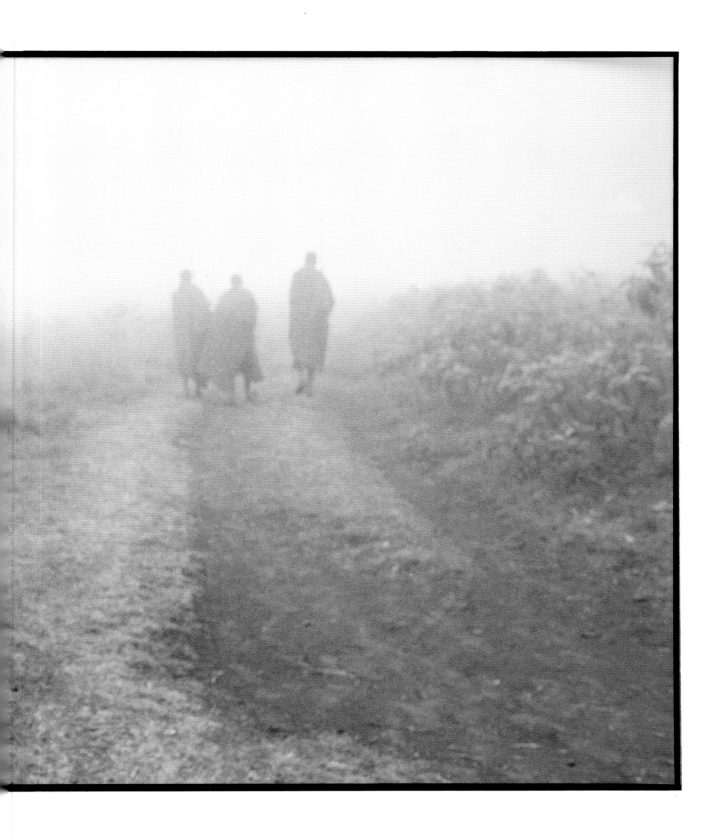

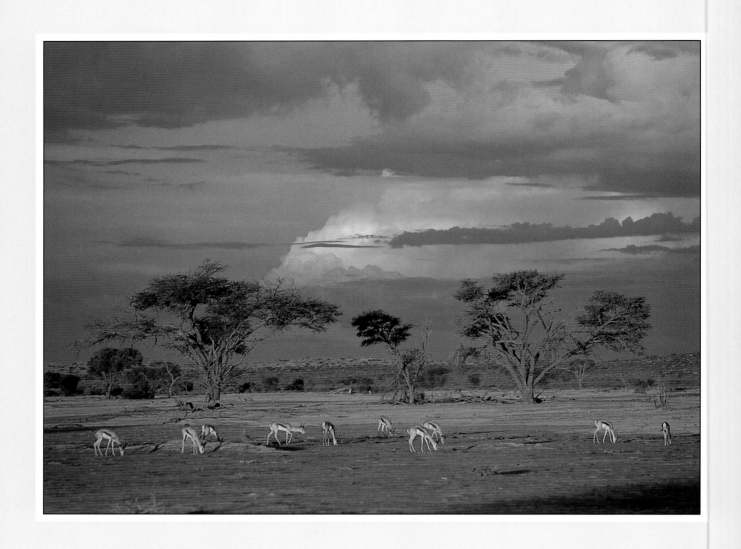

Tim Jackson
SOUTH AFRICA

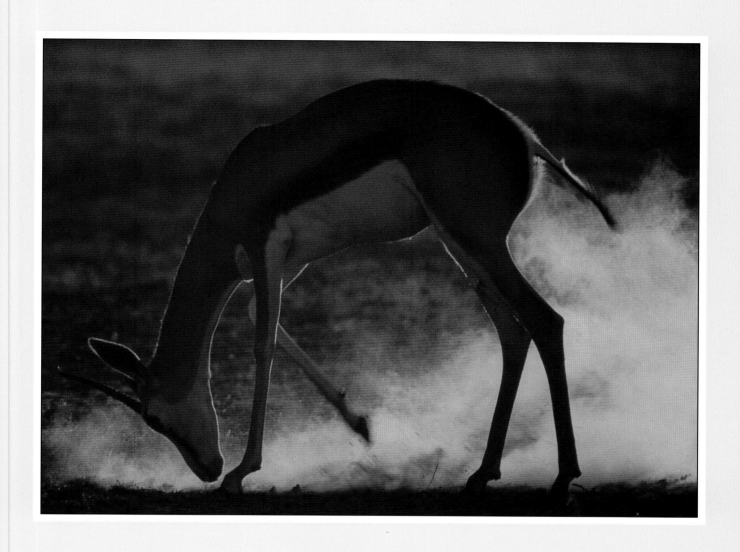

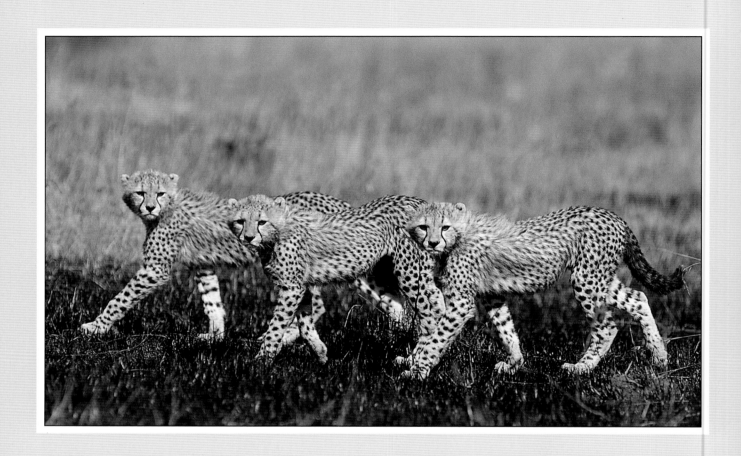

Anup Shah
UNITED KINGDOM

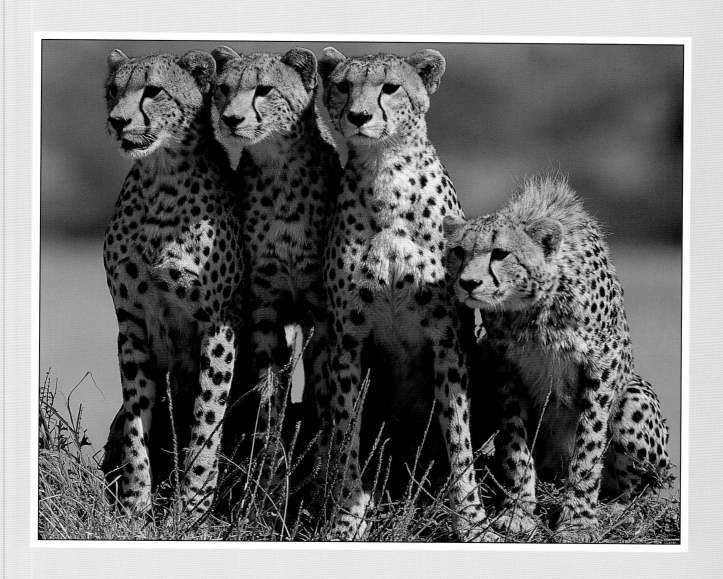

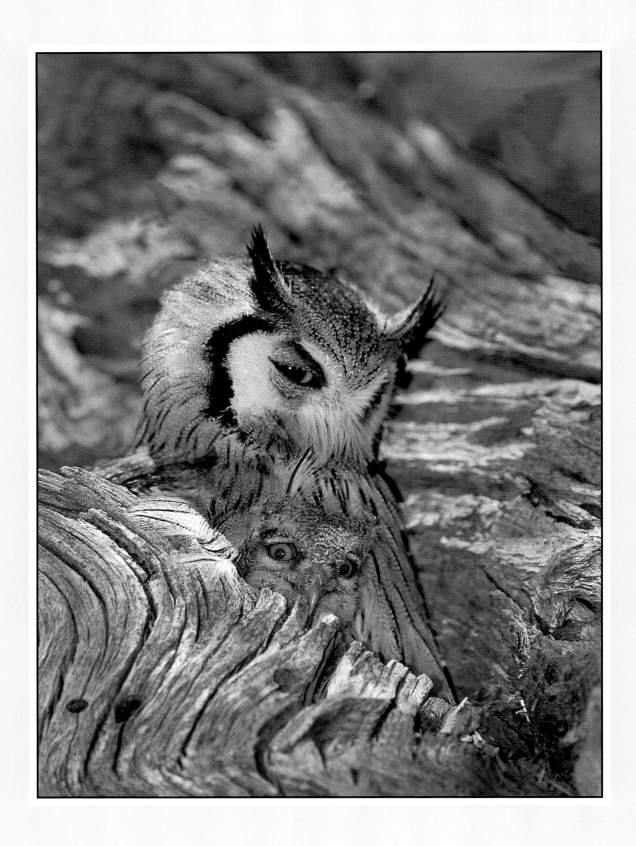

Tim Jackson
SOUTH AFRICA

186

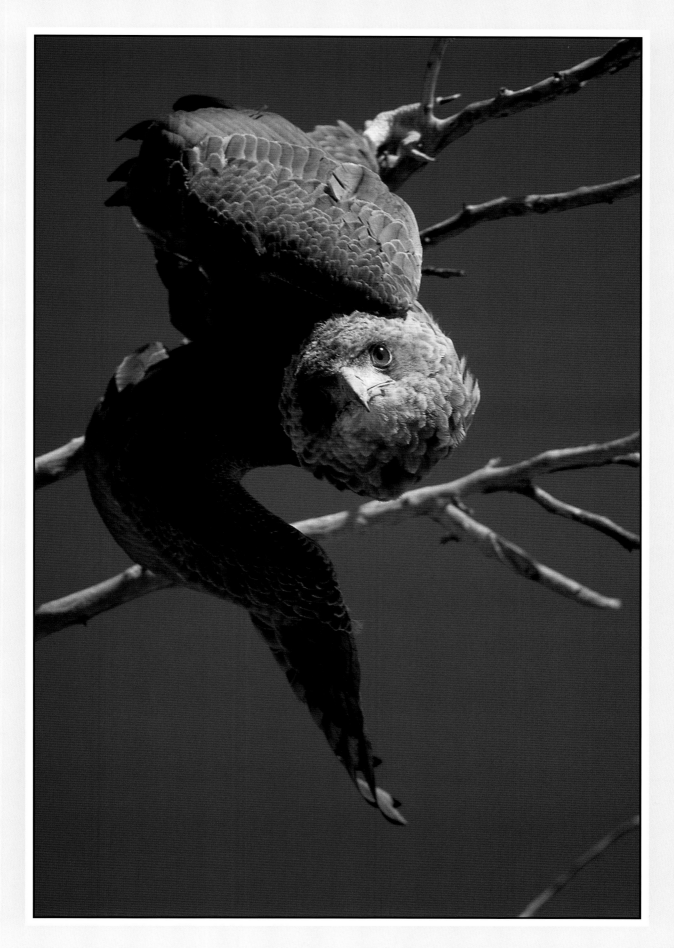

Kevin Coulton
UNITED STATES

Ueli Leuenberger
SWITZERLAND

Paavo Merikukka
FINLAND

Kazunori Sanbonmatsu
JAPAN

Bernd Amesreiter
GERMANY

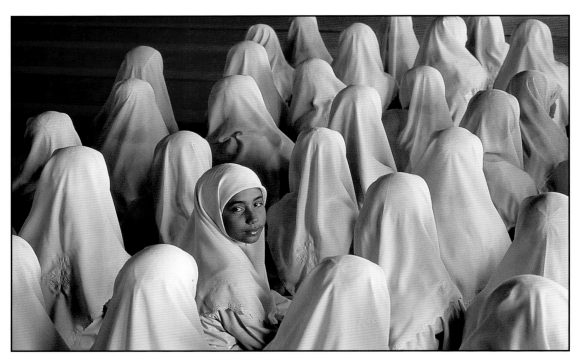

Waranun Chutchawantipakorn
THAILAND

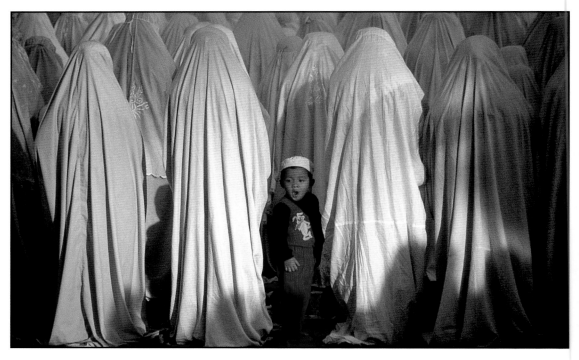

Dieter Behrens
GERMANY

Yong-Kang Teo
SINGAPORE

194

Franco Bonanomi
ITALY

196

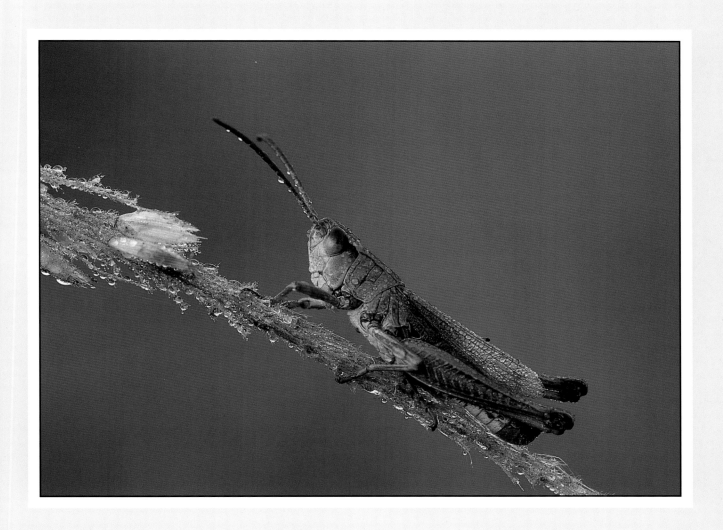

Paul Hicks
UNITED KINGDOM

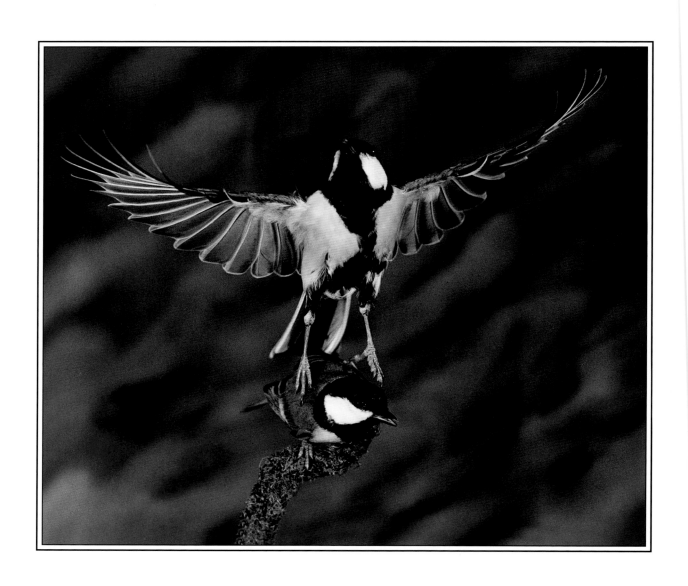

Dre van Mensel
BELGIUM

Jacques Adida
FRANCE

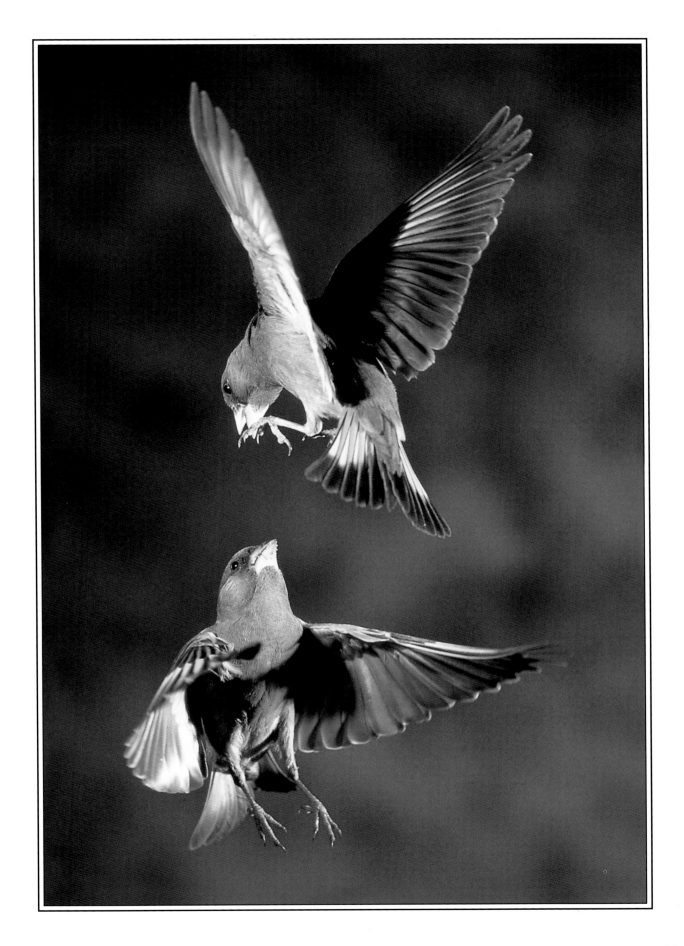

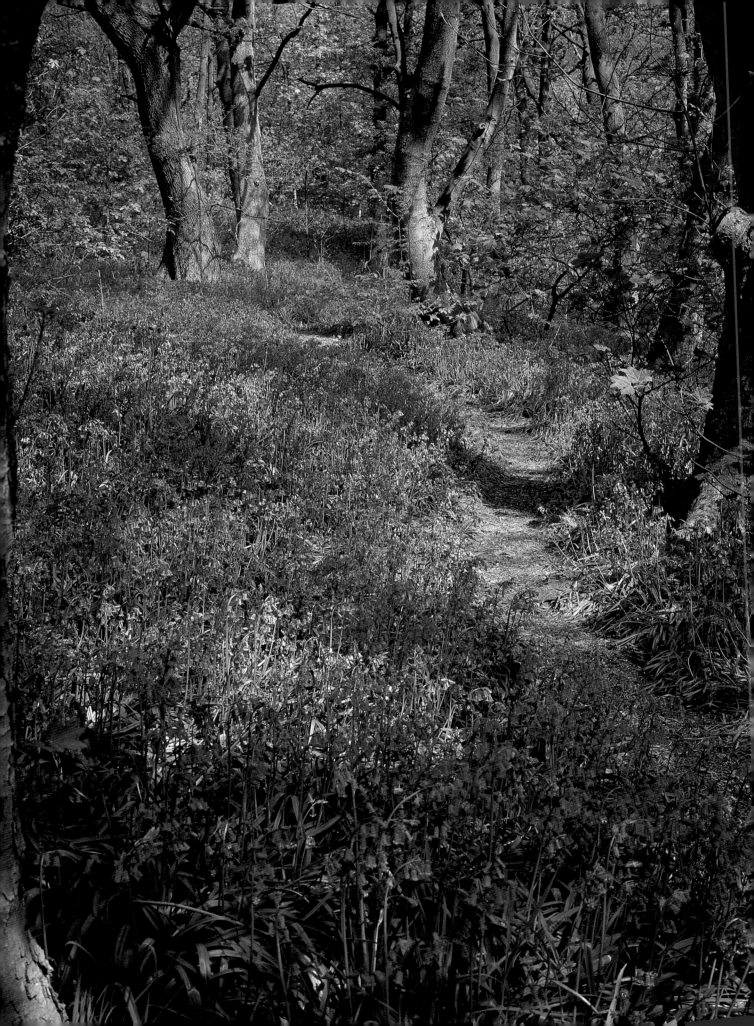

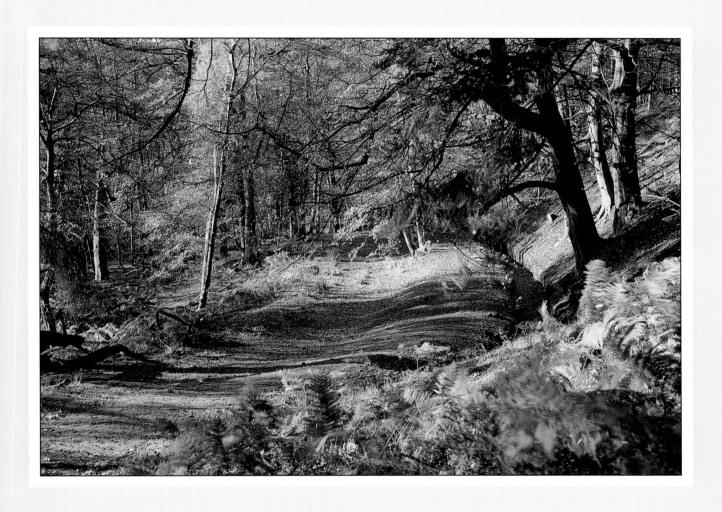

Arnold Wilson
UNITED KINGDOM

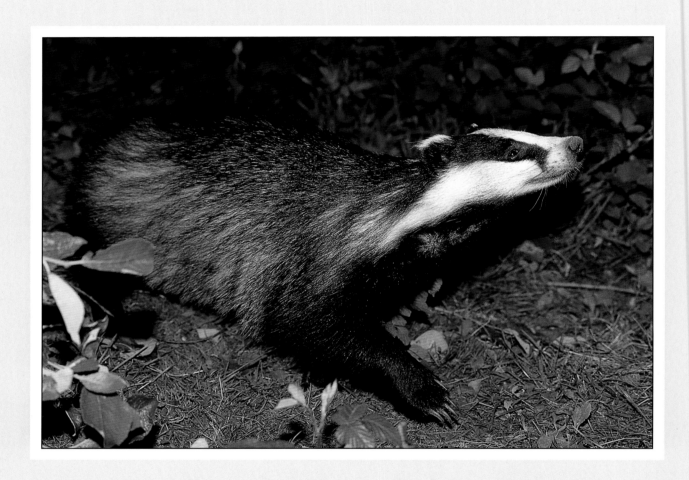

Andy Rouse
UNITED KINGDOM

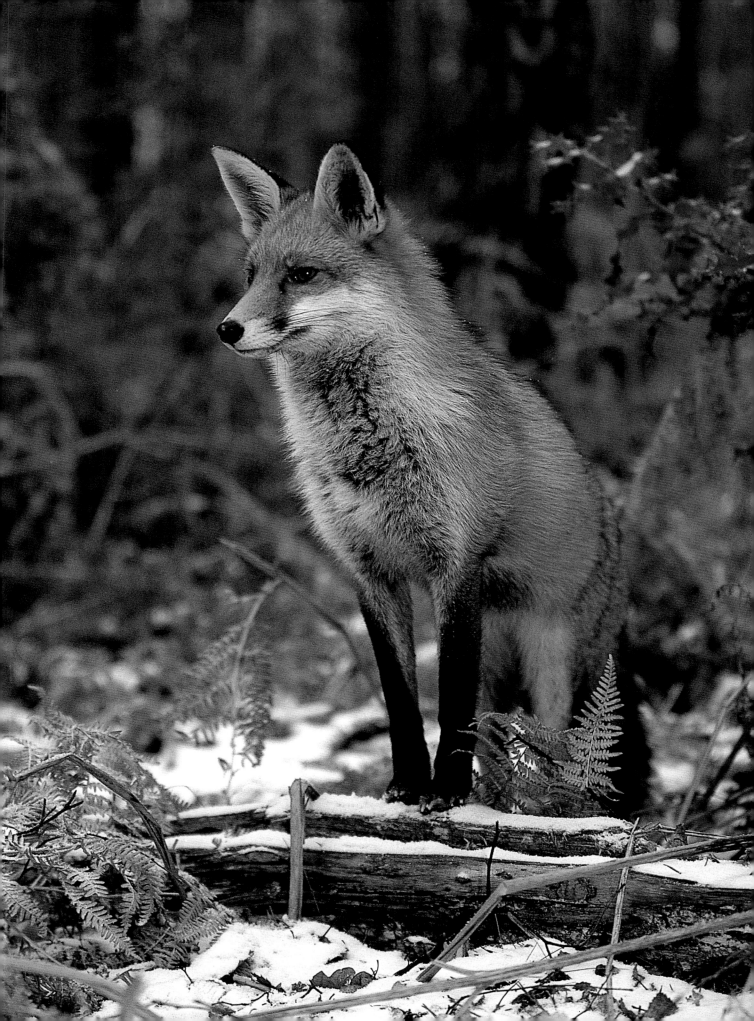

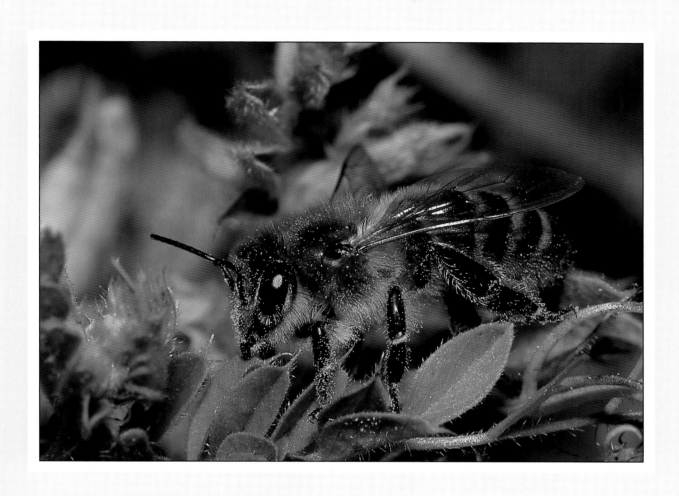

Paul Hicks
UNITED KINGDOM

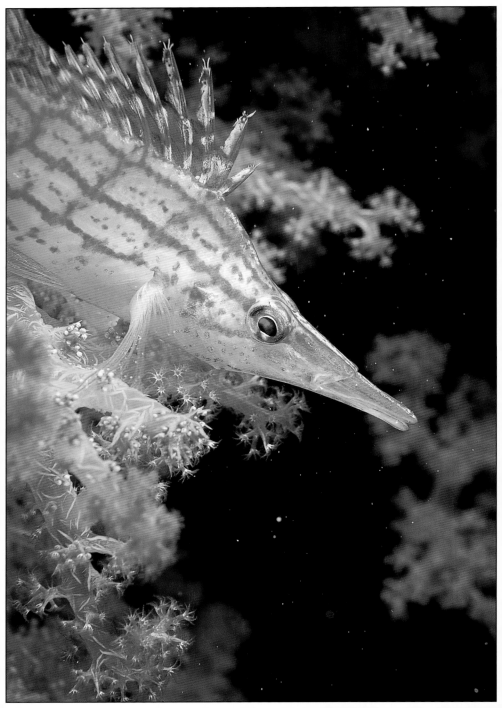

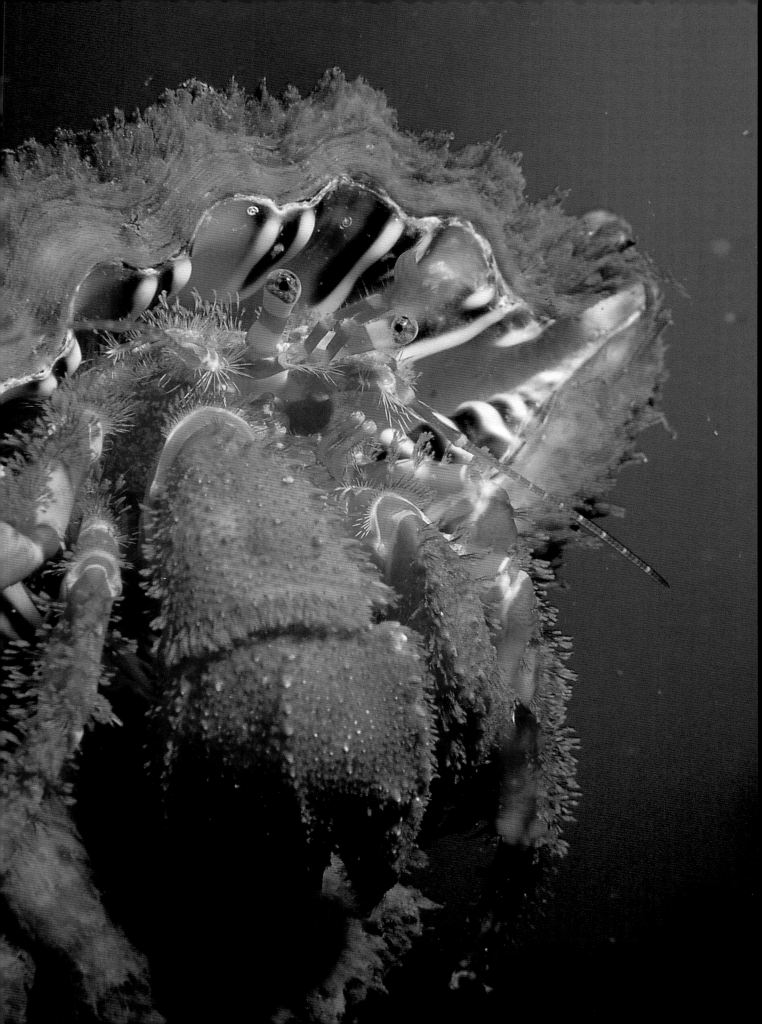

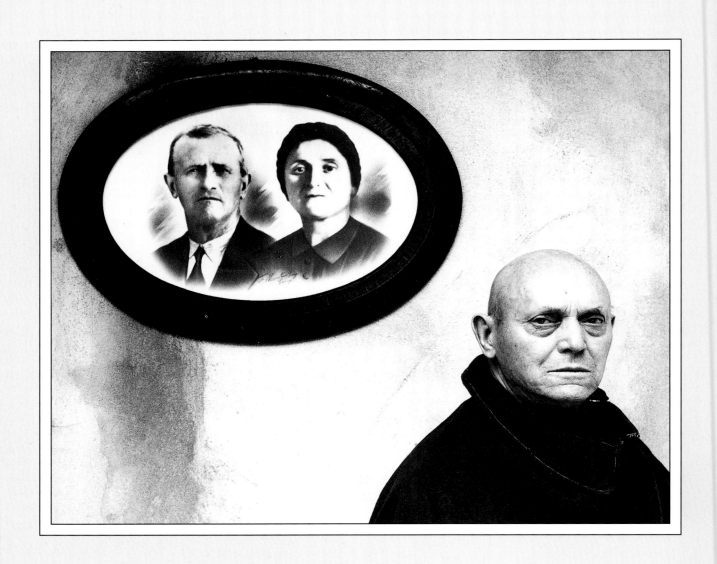

Giovanni Brighente
ITALY

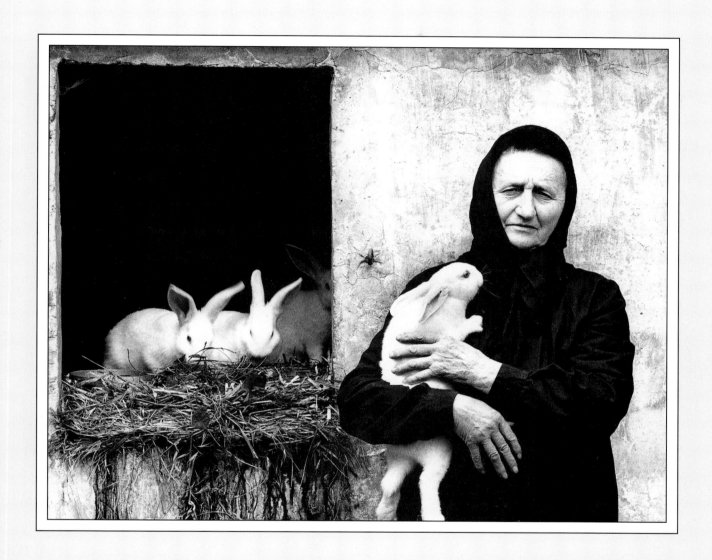

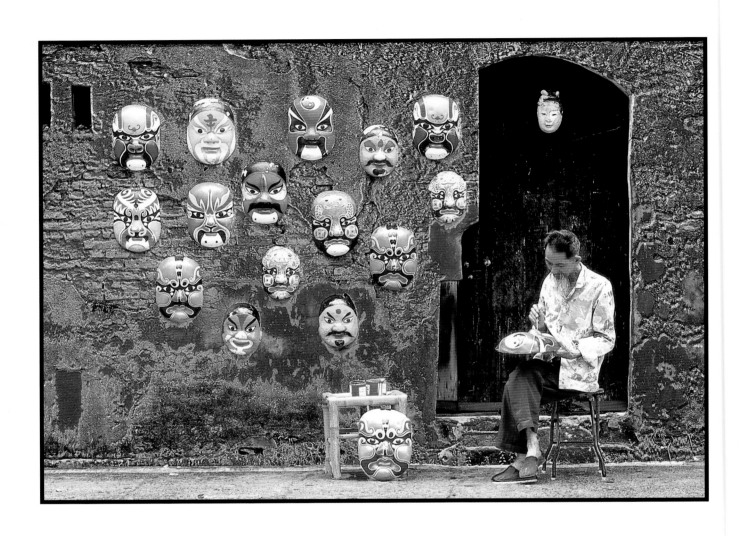

Adrian Tan
SINGAPORE

212

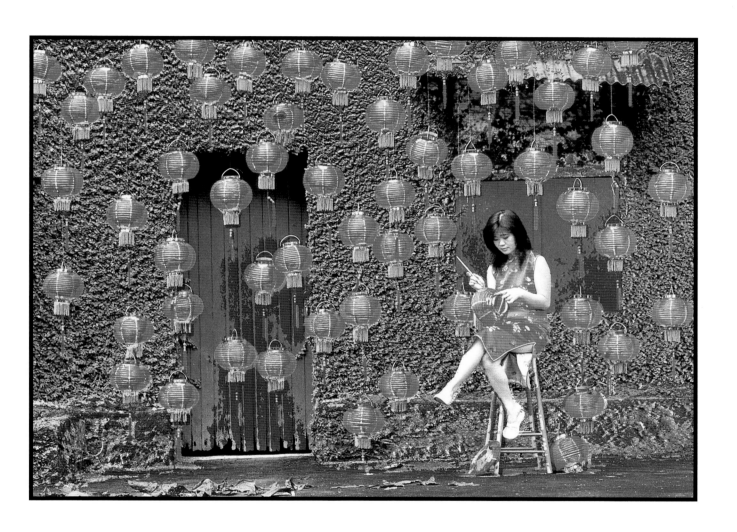

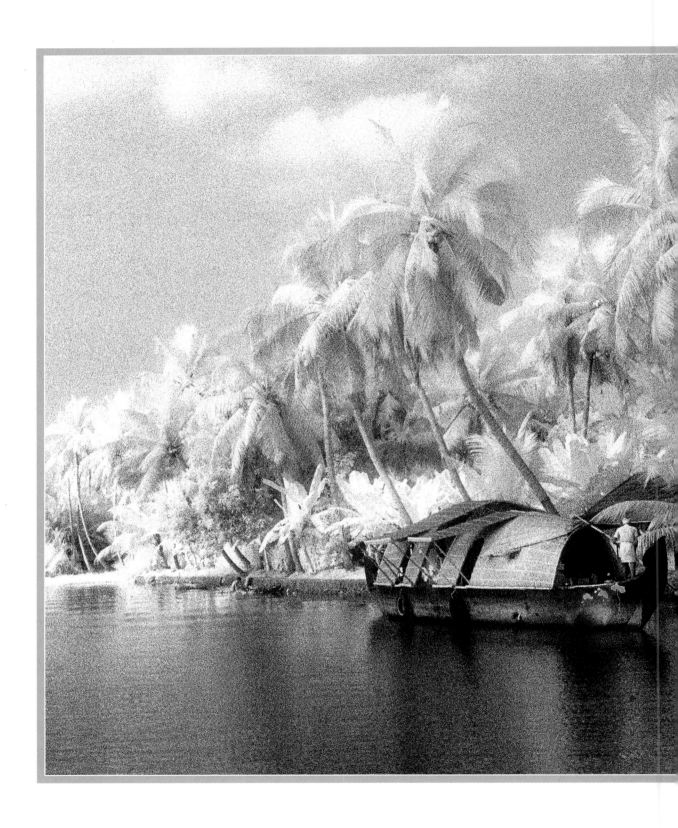

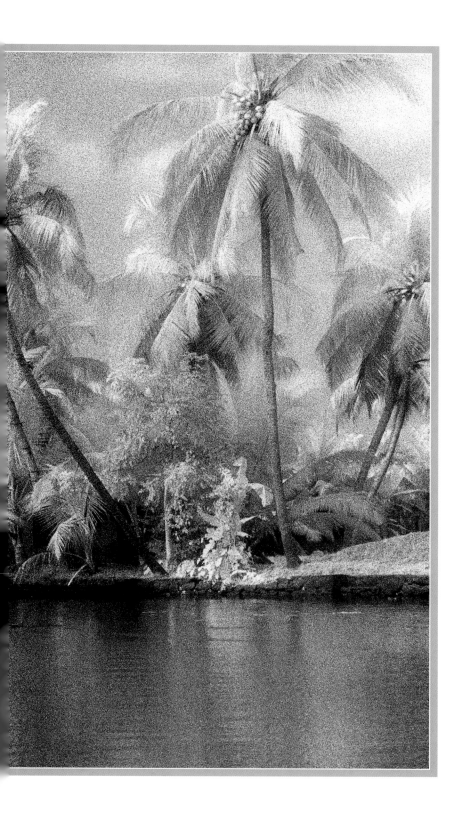

Roger Beau
FRANCE

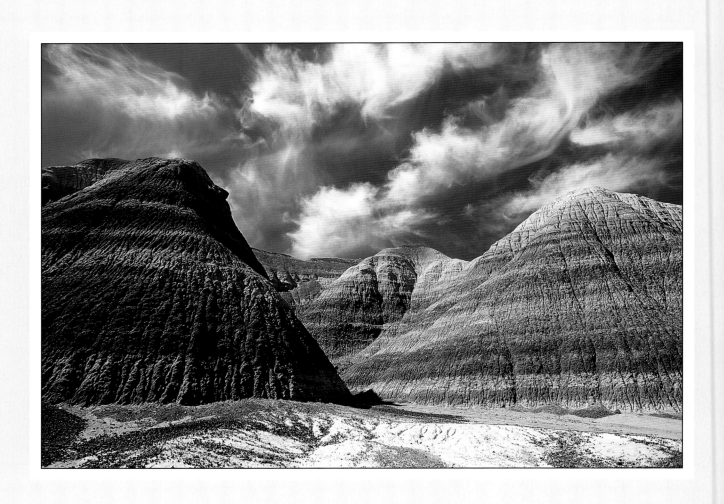

Chris Coe
UNITED KINGDOM

216

Karl Darnhofer
AUSTRIA

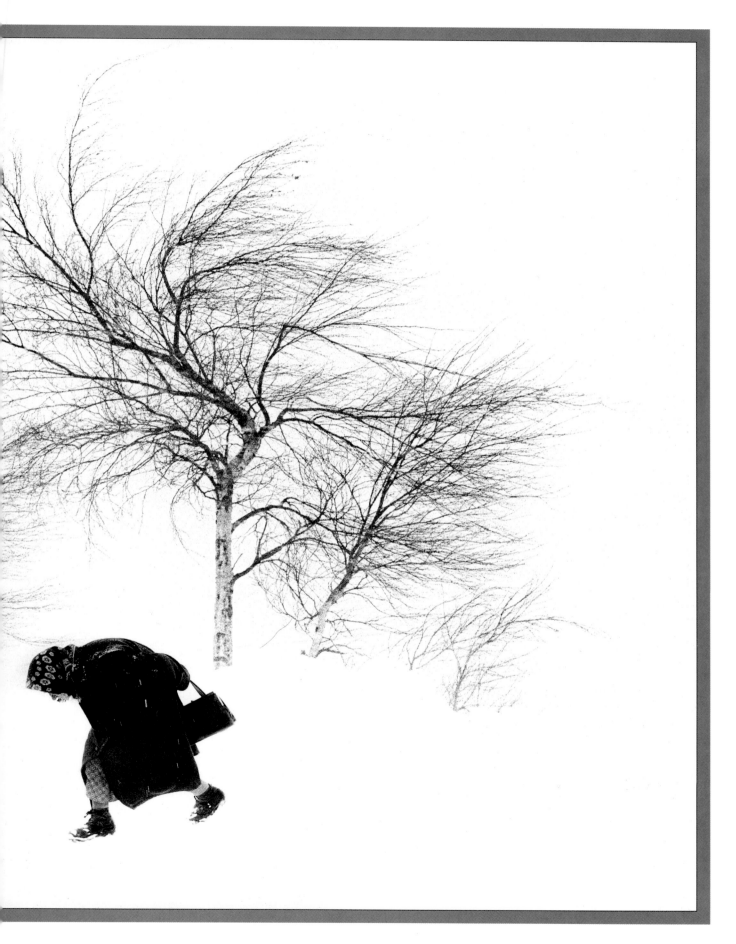

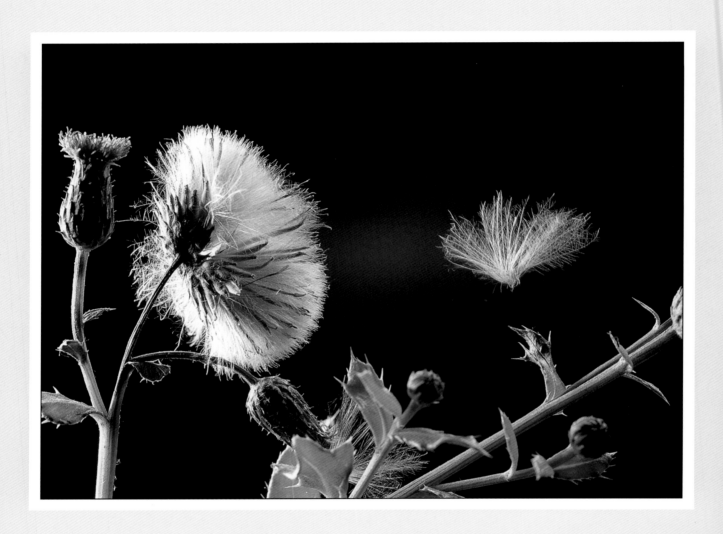

Arnold Wilson
UNITED KINGDOM

220

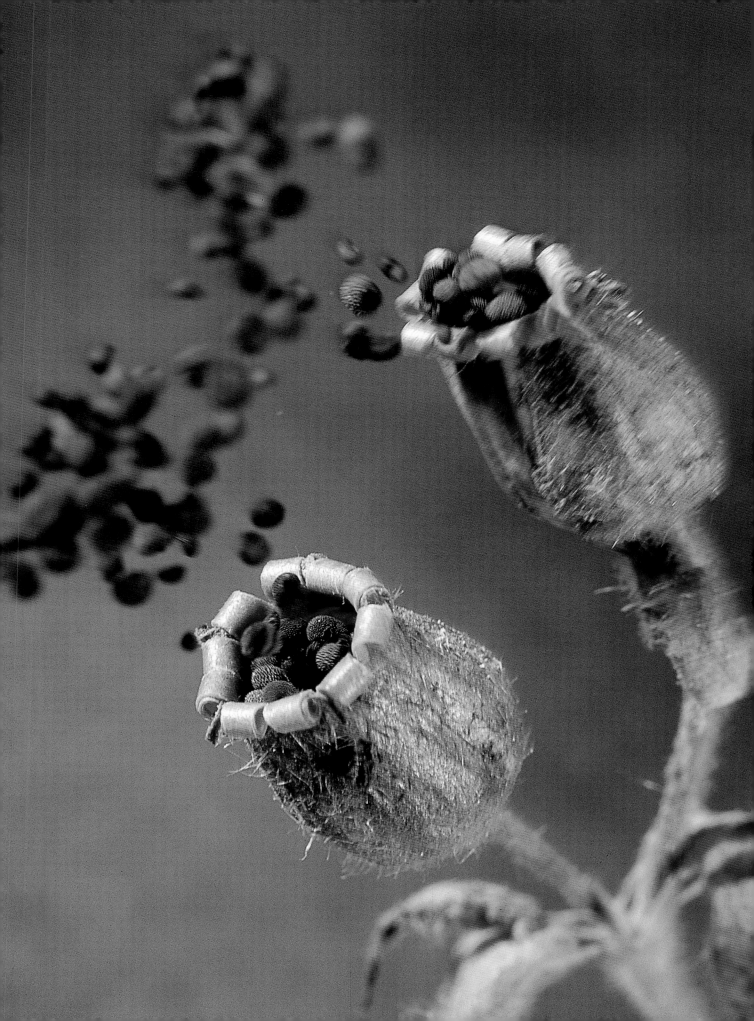

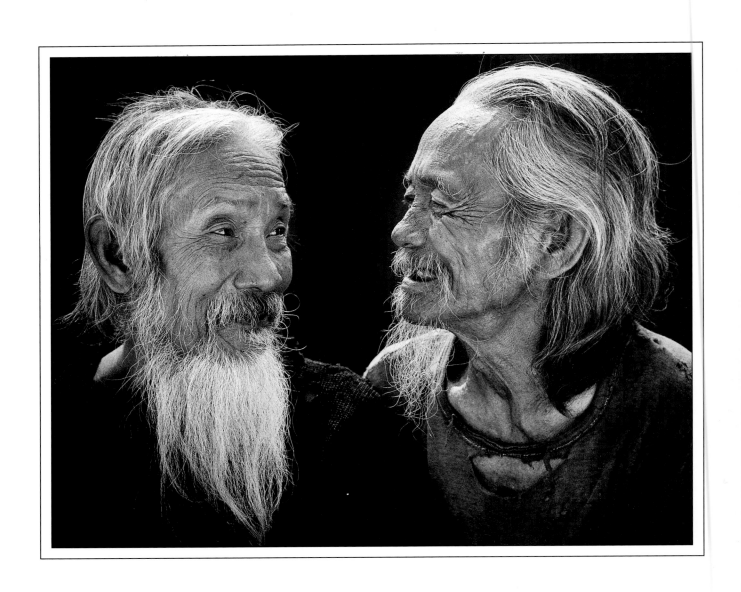

T. Angsin
PHILIPPINES

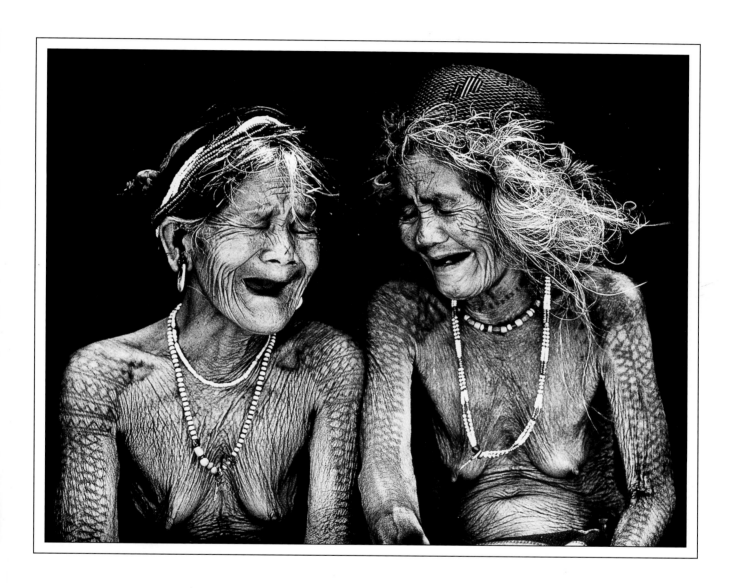

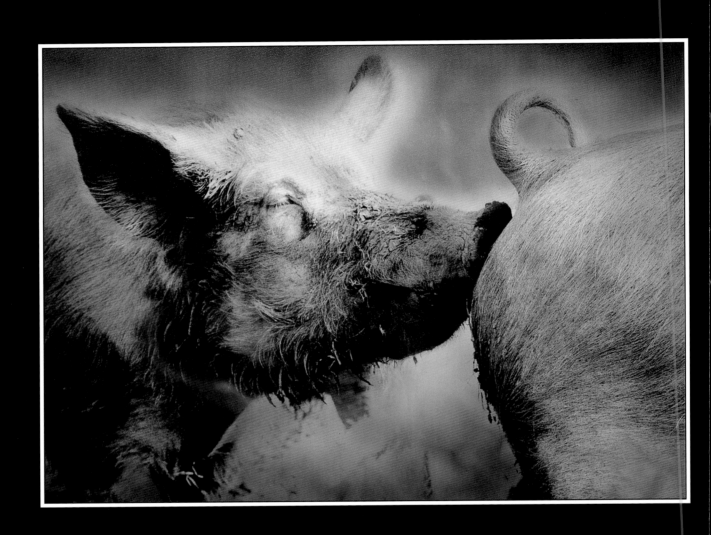

Delvin Stonehill
UNITED KINGDOM

TECHNICAL
DATA

97
Photographer Vincent Thompson (UK)
Camera Nikon FA
Lens Nikkor 100mm
Film Fujichrome Provia
Subject/Location Studio, Smethwick

98/99
Photographer Wilhem Mikhailovsky (Latvia)

100
Photographer Klaus Schidniogrotzky (Germany)
Camera Minolta Dynax 700si
Lens Rokkor 100-300mm
Film Fujichrome Velvia
Subject/Location Südeiffel, Germany

101
Photographer Klaus Schidniogrotzky (Germany)
Camera Minolta Dynax 700si
Lens Rokkor 100-300mm
Film Fujichrome Velvia
Subject/Location Lanzarote, Spain

102, 103
Photographer Aftab Ahmad (Pakistan)

104
Photographer Roger Reynolds (UK)
Camera Canon T90
Lens Zoom 70-210mm plus extension tube 300TL
Subject/Location Gannet, Bass Rock

105
Photographer Riccardo Busi (Italy)
Camera Canon T 90
Lens Canon 20mm FD
Film Kodak Ektachrome 64P
Subject/Location Bass Rock, Scotland

106/107
Photographer Jorge H Mónaco (Argentina)
Camera Nikon FE
Lens Nikkor 18mm
Film Ilford
Subject/Location La Rioja, Argentina

108
Photographer Ines Labunski Roberts (USA)
Camera Nikon F8008s/Nikon F801
Lens Zoom 35-135mm
Film Fujichrome Velvia
Subject/Location Bristle Cone Pine, Sierra Nevada, USA

109
Photographer Ines Labunski Roberts (USA)
Camera Minolta XD5
Lens Zoom 70-210mm
Film Kodachrome
Subject/Location Ice Formation, Convict Lake, Sierra Nevada, USA

110
Photographer Franco Donnagio (Italy)
Camera Mamiya RZ 6x7
Lens 250mm
Film Kodak EPR 120
Subject/Location Studio, Milan

111
Photographer Franco Donnagio (Italy)
Camera Sinar P2 4 x 5
Lens 240mm Apo Ronar
Film Kodak T Max 100 4 x 5
Subject/Location Studio, Milan

112
Photographer Chung Yin Lam (Hong Kong)

113
Photographer Sergej Pozharskij (Ukraine)

114
Photographer Michael Weber (Germany)
Camera Canon F1 N
Lens Canon FD 500mm
Film Kodak Ektachrome Panther 100 ASA
Subject/Location Bretagne, France

115
Photographer Jürgen Gottschick (Germany)
Camera Leicaflex S4
Lens Zeiss 60mm
Film Ektachrome Elite II
Subject/Location Bretagne, France

116
Photographer Jean Michel Leverne (France)
Camera Nikon FE2
Lens Tamron 90mm
Film Kodak Tri X 800 ASA
Subject/Location Lyon, France

117
Photographer Jacques Jourdain (France)

118
Photographer Daniele Susini (Italy)
Camera Contax ST
Lens Contax 21mm
Film Kodak Tri X
Subject/Location Firenze, Italy

119
Photographer Hans Kawitzki (Australia)
Camera Minolta X500
Lens 35-105mm Rokkor
Film Fujichrome RD 100
Subject/Location Melbourne, Australia

	120
Photographer	Irina Kolpakova (Latvia)
Camera	Kiev camera
Lens	Rusar 20mm
Film	A-2 film, 400 ASA
Subject/Location	Grobinya, Latvia

	121
Photographer	Viktor Kolpakov (Latvia)
Camera	Kiev camera
Lens	Rusar 20mm
Film	A-2 film, 400 ASA
Subject/Location	Grobinya, Latvia

	122, 123
Photographer	Andy Rouse (UK)

	124/125
Photographer	Willy Hengl (Austria)
Camera	Minolta SRT 101
Lens	Rokkor 90mm
Film	Ilford HP 5
Subject/Location	Vienna Airport

	126
Photographer	Edmund Steigerwald (Germany)
Camera	Canon EOS 5
Lens	Canon 50mm
Film	Kodachrome 100
Subject/Location	Studio, Hannover

	127
Photographer	Giulio Montini (Italy)
Camera	Minolta 7000 Dynax
Lens	Rokkor 20mm
Film	Fujichrome Velvia
Subject/Location	Casnate, Italy

	128
Photographer	Evgeny Pavlov (Ukraine)
Camera	Kiev camera
Film	A-2 film 100 ASA
Subject/Location	Kharkov, Ukraine

	129
Photographer	Delvin Stonehill (UK)
Camera	Bronica ETRS
Film	XP 2
Subject/Location	Photomontage in the darkroom, 16 negatives (no digital) selectively toned with some hand colouring.

	130
Photographer	Man-Kuen Ng (Hong Kong)
Camera	Hasselblad
Lens	Planar 60mm
Film	Fujichrome
Subject/Location	Southern China

	131
Photographer	Kin-Choy Wong (Hong Kong)

	132, 133
Photographer	Shivji, India
Camera	Pentax MX
Lens	50mm/135mm
Film	Kodak Ektachrome Elite
Subject/Location	Drying red chillies, Mustard field, Jodhpur

	134
Photographer	Rosemary Calvert (UK)
Camera	Canon EOS 10s
Lens	Canon 20-35mm
Film	Fujichrome Velvia
Subject/Location	Bunch of rogue tulips, Holland

	135
Photographer	Lennart Edvinson (USA)
Camera	Contax 167 MT
Lens	Tamron 80-200mm
Film	Kodachrome 25
Subject/Location	Beds, Oregon

	136
Photographer	Peter Dazeley (UK)

	137
Photographer	John Philpott (UK)

	138, 139
Photographer	Roger Reynolds (UK)
Camera	Canon EOS 600
Lens	Tamron Macro 90mm
Subject/Location	Flowers arranged in shallow water and frozen

	140/141
Photographer	Maurizio Stacchi (Italy)
Camera	Minolta 9000 AF
Lens	80-200mm
Film	Fujichrome Velvia 50 ASA
Subject/Location	Trompia, Italy

	142, 143
Photographer	Rosemary Calvert (UK)
Camera	Canon EOS 10s
Lens	Canon 20-35mm
Film	Fujichrome Velvia
Subject/Location	Marigold and Red Rose in close-up

	144
Photographer	Josef Sauter (Germany)
Camera	Olympus OM4 Ti
Lens	Vivitar Macro 100mm
Film	Fuhichrome Sensia
Subject/Location	Ulm, Germany

	145
Photographer	Lydia Snellen (Canada)
Camera	Olympus OM 1
Lens	Vivitar Macro 100 plus Mylar tube
Film	Kodachrome 64
Subject/Location	St. John's, Canada

	146
Photographer	Klaus Rössner (Germany)
Camera	Nikon F4
Lens	Sigma 90mm
Film	Kodak Elite II
Subject/Location	Stadtstainach, Germany

	147
Photographer	Michael Weber (Germany)
Camera	Canon F1 N
Lens	Canon FD 500mm
Film	Kodak Ektachrome Panther 100 ASA
Subject/Location	Stuttgart Zoo, Germany

	148
Photographer	Jane Mann (USA)
Camera	Pentax LX
Film	Fujichrome 100
Subject/Location	Composition of 3 photos, Palm Beach, USA

	149
Photographer	Detlef Zille (Germany)
Camera	Nikon F 801s
Lens	AF Nikkor 70-210mm
Film	Kodak EC 100
Subject/Location	Dresden, Germany

	150
Photographer	Frank J. Reuvers (South Africa)
Camera	Canon A1
Lens	Tamron Zoom 200-500mm
Film	Agfa Professional RDP
Subject/Location	Mabula, Johannesburg, South Africa

	151
Photographer	Michael Weber (Germany)
Camera	Canon F1 N
Lens	Canon FD 500mm
Film	Kodak Ektachrome Panther 100 ASA
Subject/Location	Stuttgart Zoo, Germany

	152
Photographer	Walter Hintermaier (Austria)
Camera	Nikon F4
Lens	Nikkor Macro
Film	Kodak Elite 100
Subject/Location	Braunau, Austria

	153
Photographer	Manfred Zweimüller (Austria)
Camera	Canon T90
Lens	Canon FD 50mm Macro
Film	Kodachrome
Subject/Location	Salzburg, Austria

	154
Photographer	Onny Tatang (Indonesia)
Camera	Nikon F3
Lens	Nikkor 50-300mm
Film	Fujichrome 135
Subject/Location	Malang City, Indonesia

	155
Photographer	Rudi Eckhardt (Germany)
Camera	Canon EOS 100
Lens	Canon 35-135mm
Film	Fujichrome Sensia 100 ASA
Subject/Location	Herborn, Germany

	156/157
Photographer	Franz Rettenegger (Austria)
Camera	Leica R7
Lens	Leitz Super Angulon
Film	Fujichrome RFP 50 ASA
Subject/Location	Grindavik, Iceland

	158/159
Photographer	Bernd Amesreiter (Germany)
Camera	Nikon FE
Lens	Nikkor Objectives
Film	Kodak Ektachrome 100
Subject/Location	Montage of 2 prints, Australia and Germany

	160
Photographer	Erik Jorgensen (Denmark)
Camera	Nikon 801 S
Lens	Nikkor 24-50mm
Film	Fujicolor 200
Subject/Location	Rudkobing, Denmark

	161
Photographer	Per Odd Svenberg (Norway)

	162, 163
Photographer	Leon Heylen (Belgium)
Camera	Pentax SP F
Lens	Pentax 50mm
Film	Kodak Infrared
Subject/Location	Studio, Beringen, Belgium

	164
Photographer	Valdis Brauns (Latvia)

	165			**180/181**
Photographer	Giulio Montini (Italy)		*Photographer*	Jose Jaime Mota (Spain)
Camera	Pentax ME Super		*Camera*	Asahi Pentax 6x7
Lens	Pentax 28mm		*Lens*	Pentax 55mm
Film	Kodak Gold 100		*Film*	Kodak T-Max 400 ASA
Subject/Location	Casnate, Italy		*Subject/Location*	Ngorongoro, Tanzania
	166			**182, 183**
Photographer	Valentin Sichinskiy (Ukraine)		*Photographer*	Tim Jackson (South Africa)
Camera	Kiev 88		*Subject/Location*	Photographs from a study of
Lens	Vega 12V 90mm			the Kalahari
Film	Svema film 130			
Subject/Location	Odessa, Ukraine			**184, 185**
			Photographer	Anup Shah (UK)
	167			
Photographer	Valentin Sichinskiy (Ukraine)			**186, 187**
Camera	Zenit EM		*Photographer*	Tim Jackson (South Africa)
Lens	Industar 61 50mm		*Subject/Location*	Photographs from a study of
Film	Svema film 400			the Kalahari
Subject/Location	Odessa, Ukraine			
				188, 189
	168, 169		*Photographer*	Kevin Coulton (USA)
Photographer	Jose Arias (Spain)		*Camera*	Nikon FM2
Camera	Hasselblad 503 Cxi		*Lens*	135mm
Lens	Planar 120mm		*Film*	Fujichrome Velvia/Kodachrome 25
Film	Ilford FP4		*Subject/Location*	From the series *Pollution in Abstract*
Subject/Location	Malaga, Spain			for public environmental education
	170/171			**190**
Photographer	Ramon Serras (Spain)		*Photographer*	Ueli Leuenberger (Switzerland)
Camera	Nikon F3		*Camera*	Minolta
Lens	Tamron 17mm		*Lens*	Rokkor 105mm
Film	Fujichrome 50 Professinal		*Film*	Kodachrome 50 ASA
Subject/Location	Itzurungo Ondartza, Basque County,		*Subject/Location*	Zürich, Switzerland
	Spain			
				191
	172, 173		*Photographer*	Paavo Merrikukka (Finland)
Photographer	Peter Trenchard (UK)		*Camera*	Canon T90
			Lens	Tamron 90mm Macro
	174		*Film*	Fujichrome Velvia
Photographer	David Anthony Williams (Australia)		*Subject/Location*	Helsinki, Finland
Camera	Hasselbald			
Lens	Sonnar 120 mm			**192**
Film	Ilford FP4		*Photographer*	Kazunori Sanbonmatsu (Japan)
Subject/Location	Ashburton, Australia			
				193
	175		*Photographer*	Bernd Amesreiter (Germany)
Photographer	Anita Nutter (UK)		*Camera*	Nikon FE
Camera	Canon EOS		*Lens*	Nikkor 50mm
Film	XP 2		*Film*	Kodak Ektachrome 100
Subject/Location	Twinkle at Twilight, toned and tinted		*Subject/Location*	Surfers Paradise, Australia
	176, 177			**194**
Photographer	Sayyer Nayyer Reza (Pakistan)		*Photographer*	Dieter Behrens (Germany)
	178, 179			
Photographer	Lorne Resnick (Canada)			
Camera	Canon EOS-1			
Lens	Canon 20-35mm 2.8L			
Film	Kodak Tri-X			
Subject/Location	Sahara Desert			
Agency	Tony Stone Images			

	194
Photographer	Waranun Chutchawantipakorn (Thailand)
Camera	Nikon FM2 N
Lens	Nikkor 35-70mm
Film	Fujichrome
Subject/Location	Lumpoon Province, Thailand

	195
Photographer	Yong-Kang Teo (Singapore)
Camera	Nikon FM2
Lens	Nikkor Objective
Film	Fujichrome
Subject/Location	Studio, Singapore

	196/197
Photographer	Franco Bonanomi (Italy)

	198, 199
Photographer	Paul Hicks (UK) Photographs from *Photographing Butterflies and Other Insects* published by Fountain Press

	200
Photographer	Dre van Mensel (Begium)
Camera	Nikon 801 S
Lens	Nikkor 105 mm
Film	Fujichrome Super Plus 200 ASA
Subject/Location	Studio, Tielen, Belgium

	201
Photographer	Jacques Adida (France)
Camera	Nikon 90
Lens	Nikkor 80-200mm
Film	Fujichrome 100 ASA
Subject/Location	France

	202, 203
Photographer	Arnold Wilson (UK)
Subject/Location	Photographs from *Nature Photography Through Four Seasons* published by Fountain Press

	204, 205
Photographer	Andy Rouse (UK)
Subject/Location	Photographs from the forthcoming book *Photographing Animals in the Wild* published by Fountain Press

	206, 207
Photographer	Paul Hicks (UK)
Subject/Location	Photographs from *Photographing Butterflies and Other Insects* published by Fountain Press

	208, 209
Photographer	Mark Webster (UK)
Subject/Location	Photographs from the forthcoming book *The Art & Technique of Underwater Photography* published by Fountain Press

	210, 211
Photographer	Giovanni Brighente (Italy)

	212
Photographer	Adrian S.S. Tan (Singapore)
Camera	Nikon F3
Lens	Nikkor 105mm Macro
Film	Kodak Elite 400 ASA
Subject/Location	Singapore

	213
Photographer	Adrian S.S. Tan (Singapore)
Camera	Nikon F3
Lens	Nikkor 80-200mm
Film	Kodachrome 100 ASA
Subject/Location	Singapore

	214/215
Photographer	Roger Beau (France)
Camera	Minolta 9 Xi
Lens	Angenieux 28-70mm
Film	Kodak Infrared
Subject/Location	Kerala, India

	216, 217
Photographer	Chris Coe (UK)
Subject/Location	Photographs from *The Art of Landscape Photography* published by Fountain Press

	218/219
Photographer	Karl Darnhofer (Austria)
Camera	Nikon FE
Lens	Nikkor 135mm
Film	Kodak Tri X
Subject/Location	Dobl, Austria

	220, 221
Photographer	Arnold Wilson (UK)
Subject/Location	Photographs from *Nature Photography Through Four Seasons* published by Fountain Press

	222, 223
Photographer	T. Angsin (Philippines)

	224
Photographer	Delvin Stonehill (UK)
Camera	Nikon F3
Film	XP 2
Subject/Location	The Kiss, vaseline on lens to give 'smelly effect'.

DON'T HIDE your best prints and slides!

SHOW it to the world and WIN!

HASSELBLAD **AUSTRIAN SUPER CIRCUIT 1998**

The world's largest annual salon of photography,
recognized by FIAP and PSA!

It offers a superb 224 page catalogue with more than
350 reproductions for every entrant! Really a collector's item!

And of course awards, awards, awards for all types of photography!
Cameras, medals, trophies and US$ 30.000 cash money!

So HURRY UP - CLOSING DATE: 3rd of August 98

Entry forms are available at:

HASSELBLAD **AUSTRIAN SUPER CIRCUIT 1998**
Postfach 364
A - 4010 Linz / Austria

Or fax: Austria/732 750 100